Neat and Tidy

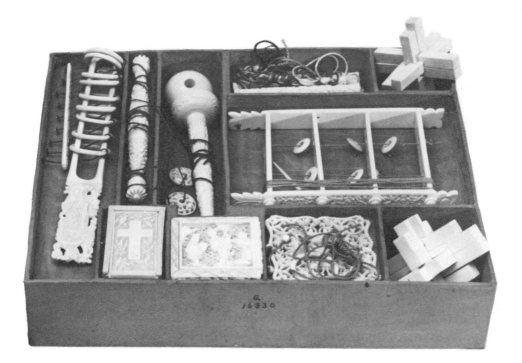

E. P. Dutton

Neat and Tidy

Boxes and Their Contents Used in Early American Households

Nina Fletcher Little

New York

For information contact: E.P. Dutton, 2 Park Avenue, New York, N.Y. 10016
Library of Congress Catalog Card Number: 79-53349

ISBN: 0-525-16455-3 (cloth) 0-525-47641-5 (DP)
Published simultaneously in Canada by Clarke, Irwin & Company Limited,
Toronto and Vancouver
Designed by Mary Beth Bosco
10 9 8 7 6 5 4 3 2 1
First Edition

Contents

Color insert follows page 110.

Illustrations

DECORATED IN FANCY PAINTERS' TECHNIQUES

Plate
Figure

FASHIONED OF LEATHER AND HIDE

Figure

CRAFTED BY AMERICAN INDIANS

Figure

GENTLEMEN'S SHAVING EQUIPMENT

Figure

TO HOLD SPECTACLES

Figure

FOR TOBACCO AND SNUFF

Plate

Figure

FOR PATCHES OR BEAUTY SPOTS

Figure

TO CONTAIN HATS, COMBS, AND BONNETS

Plate

Figure

ARTISTS' PENCILS, BRUSHES, AND COLORS

Plate

Figure

FANCY NEEDLEWORK AND PLAIN SEWING

Plate

Figrue

CONVENIENT STORAGE OF SALT

Figure

KEEPING CANDLES AND TINDER DRY

Figure

PANTRY AND HOUSEHOLD NEEDS

Plate

Acknowledgments

Many persons have generously aided me in assembling the material for this book, which could not have been completed without such help from various sources, and sincere gratitude goes to the numerous collectors who have allowed their boxes to be illustrated with the request that their names not be included. When credits are omitted, private ownership is, therefore, understood.

My warm appreciation also to H. Ray Dennis, Shirley S. DeVoe, Catherine Fennelly, Philip M. Isaacson, Mrs. R. A. MacCready, William B. Osgood, Dorothy and Leo Rabkin, Mrs. Edward Reynolds, J. Peter Spang, Donald M. Walters, and William L. Warren for making available information unobtainable elsewhere.

I am greatly indebted to the following institutions, and to their staff members, who have provided me with particular assistance: Abby Aldrich Rockefeller Folk Art Center, Barbara Luck; American Museum in Britain, Shelagh Ford; Essex Institute, Anne Farnam, Huldah S. Payson; Greenfield Village and Henry Ford Museum, Katharine B. Hagler, Kenneth M. Wilson; Maine Historical Preservation Commission, Earle G. Shettleworth; Maine State Museum, Edwin A. Churchill; Museum of Fine Arts, Boston, Jonathan Fairbanks, Karin Peltz; Museum of Art, Rhode Island School of Design, Christopher P. Monkhouse; Old Sturbridge Village, John O. Curtis, Etta Falkner, Henry J. Harlow, Jane C. Nylander, Mark Sipson; Oneida Historical Society, Douglas M. Preston; The Peabody Museum of Salem, Lucy Batchelder; The Society for the Preservation of New England Antiquities, Abbott L. Cummings, Richard C. Nylander; The Henry Francis du Pont Winterthur Museum, Karol A. Schmiegel.

Special thanks to editor Cyril I. Nelson for suggesting that I write this book and for helpfulness in bringing it to completion; to photographer Richard Merrill for his patience and expertise; and to my husband for his careful editing and typing of the final draft of the manuscript.

Introduction

Boxes, of all domestic objects that furnished the early American home, have always been the most useful and exhibited the most interesting variety of materials and forms. Because many of the purposes for which they were made have become obsolete, they help in the understanding and appreciation of life-styles that have now disappeared. Individual boxes were often listed and valued from the seventeenth century on, and although some kinds are still familiar, others are seldom seen today outside of museum collections. In these pages, the types frequently mentioned in early records are related to their original surroundings by connecting them to specific references noted in the wills, inventories, advertisements, and account books of persons who lived in the seventeenth, eighteenth, and nineteenth centuries.

The third revised edition of the *Shorter Oxford English Dictionary* describes a box as "A case or receptacle usually having a lid," and this concise definition has been accepted in the following study. That the word *case* was a recognized synonym for box is confirmed by the 1790 edition of Bailey's *Universal Etymological English Dictionary*, which defines it as "A little box or covering for anything." Spectacles cases, for instance, denoted boxes to hold eyeglasses, and cases of bottles were wooden boxes containing liquor. A *trunk* suggests a large container used for traveling or storage, and this description likewise applied in the eighteenth century. Yet there were various other meanings. Bailey listed a trunk as "A chest or box usually covered with leather." When harness makers or coppersmiths advertised leather or metal "trunks," they were generally referring to small, rectangular boxes.

Old boxes vary greatly in size, shape, material, finish, and design. Some have flat bottoms, a few are raised on four small feet. Many are fitted with sliding covers, others have hinged lids. Interiors may be undivided, or partitioned into several compartments to serve a special purpose. A few are odd in form—long and narrow to accommodate shaving equipment, or slope-lidded to contain salt. Basic materials range from

wood, metals, ceramics, ivory, and horn to tortoise shell, enamel, cardboard, and papier-mâché. Surface decoration exhibits raised carving, chip carving, and simple incising. Plain or fancy painting, stenciling, and graining were popular in the eighteenth and nineteenth centuries, and exteriors finished in natural wood, brightened with gay printed paper, or covered with nail-studded leather, often provided welcome variety.

Boxes may be divided into two major categories—hand-crafted or factory-made, and then subdivided by use, decoration, or form. Many were put together at home, others were supplied by local joiners. Ruth Henshaw Bascom, the crayon portraitist of Fitzwilliam, New Hampshire, wrote in her Diary on May 22, 1841, "I collecting duds to send to Wisconsin & finished some bundles—painted the box green to enclose them —made by Mr. Styles yesterday without money or price—very clever." Utilitarian boxes varied in value according to size and finish. On December 21 of the same year Mrs. Bascom, who was a frugal minister's wife, "concluded to have a box made for 25 cts." Ten years earlier, in 1831, Jonathan Loomis of Whately, Massachusetts, charged 50 cents. His box may have been larger or was, perhaps, better made. By the second quarter of the nineteenth century woodworking establishments were producing in quantity for the American public. At the same time small leather trunks, bandboxes, and cardboard containers for specialized articles were being turned out in local factories and advertised by neighborhood shops through the medium of the press.

A considerable number of boxes and their contents used in American homes were not originally of American manufacture. Both before and after the Revolution numerous commercially produced articles were imported in exchange for domestic goods sent overseas. Household effects were often sent from England on individual order, and boxes were also brought home by travelers returning from abroad. Perusal of newspapers of the period indicates what an astonishing assortment of foreign goods was available in city shops on the Atlantic seaboard. In fact, the majority of small, decorative objects sold in this country until after 1800 originated in London, Birmingham, Sheffield, Liverpool, and to a smaller extent in Hamburg and Dublin.

Among eighteenth-century importations were brass and pewter tobacco boxes, with snuffboxes made of silver, china, ebony, japanned leather, papier-mâché, tortoise shell, and polished tin. Ivory and enamel patch boxes were advertised in the 1760s, and elegant engraved and inlaid tea caddies with plated ladles were available in 1793. All manner of sewing equipment for ladies was imported from England, including steel-tipped thimbles, needle cases, scissors, pincushion hoops, and chains. Gentlemen were also well supplied with shaving soap, steel corkscrews for bottle boxes, and "cases of razors compleat."

Although boxes are always appealing in themselves, the articles they once contained are often of equal interest. In estates, along with other household goods, many boxes were listed, but it was relatively seldom that contents were specified in detail. From a representative survey of New England inventories dating from 1635 to the early nineteenth century, it is apparent that most contents fall into six major classifications: household linens, wearing apparel, sewing materials, food, books, and money.

Household linens consisting, when specifically enumerated, of sheets, "pillowbeers," "bedding," "childbed linen," damask tablecloths, and napkins, were no doubt stored in the capacious carved or painted boxes of the seventeenth and early eighteenth centuries.

Wearing apparel was folded and laid in chests or boxes long before the present mode of hanging personal belongings from hooks or rods in closets. A few of the more interesting articles of clothing individually mentioned included a bonnet, a muff, a black quoife, a silk hood, handkerchiefs, stockings, and beaver gloves. Among the miscellaneous fabrics were such items as "taffity filliton, figured satin, Naples silk, remnants, and wearing linen."

Sewing, weaving, and embroidery needs were often kept together, and one finds woolen yarn, silk, samplers, laces, "broidered works," bugle beads, thread, pins, and papers of needles listed in considerable detail.

Foods of certain kinds were stored in their own containers for convenience and to preserve flavor. Among the old-time comestibles mentioned with accompanying boxes were butter, cheese, salt, spices, and Indian corn.

Books, writing equipment, and valuable papers were frequently stored in desk boxes with flat or sloping lids. In a court case in 1667, it was deposed that one John Wattson had been offered 5 pounds to pilfer a "writing" that had been put "in a little box, with a key in it, which was in a chest that stood at the cellar door." Although his master had been lured outside by the prospect of a barn raising, Wattson swore that he had refused to steal even at an increased offer of 7 pounds.

Money was evidently considered to be safest when kept in a securely locked box, although this did not always prevent thefts. Quarterly court records abound in statements like the following: "I missed out of my box 3 shillings and 10 pence gone (I know not how)"; "Marget told me she took 4 shillings at one time out of father's box having got the key"; and "James Dunaway told them . . . he broke a little box and tooke out the money."

For general convenience, personal use, domestic purposes, and special needs boxes have always proved indispensable, because despite lack of drawer space, dearth of closets, and crowded rooms they enabled those who so desired to keep their household possessions neat and tidy.

1. Boxes for General Convenience

Embellished with Carving

Boxes were among the earliest furnishings used in the American Colonies. Inventories and other records reveal that their chief functions were separating certain articles of household linen; keeping small pieces of wearing apparel; storing miscellaneous books; and safeguarding valuable items such as documents and currency. Some representative seventeenth-century references pertaining to the above are: "Linen in a box reserved for her by her mother"; "1 Box and some small matters in it, as two small black handkerchiefs, 1 black quoife, 1 Bonnet"; "Smalle squar boxe full of mean books"; "Little box with 4 shillings, 2 pence and half a crown." [1]

The word *desk* in the seventeenth and eighteenth centuries conveyed a different meaning from the term as used today. In Essex County, England, home of many early Massachusetts settlers, a desk connoted a portable box fitted with lock and key to hold books and papers. Numerous references to desks also occur in American probate records. A "descke box" at 3 shillings appears in the inventory of one Robert Day of Hartford, Connecticut, in 1648.[2] In Philadelphia a "book desk" worth 26 shillings was enumerated in 1726.[3] In 1689 James Davids of New Haven owned a "writing desk" valued at 12 shillings.[4] This terminology raises the question still unresolved: whether only those boxes having sloping lids to support a book or papers were referred to as desks (fig. 1), or whether flat-top boxes in which books and writing equipment were stored also came under this

1

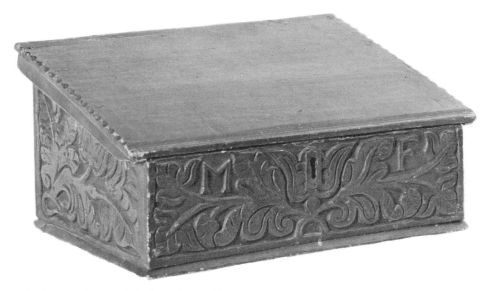

1. Oak and pine desk box. Second half seventeenth century. W. 14¼″. Descended through the Caldwell family of Ipswich, Massachusetts. Identity of the initials *M F* has not been established. (John L. Keiley)

heading.[5] So-called standing desks and scrutoirs were slant-top boxes mounted on frames with legs, and these eventually evolved into the desk as we know it today.

Although both Bibles and boxes were frequently enumerated among seventeenth- and eighteenth-century possessions, they were not necessarily listed in close proximity. In fact, on many occasions, they appeared in quite separate rooms of the house. Moreover, the term *Bible box* is not a recognized one in early records, giving rise to the supposition that it is a relatively recent designation. A rather ambiguous reference may have some bearing on this subject. The inventory of John Coleby of Amesbury, Massachusetts, 1673–1674, contains the following entry: "Box with linen therein and a bible, an old chest, 2 pounds." This statement reveals that linen was stored in the box, but it does not make clear the relationship, if any, between the box and the Bible. If the Bible was kept in the box, it apparently shared space with the linen. Interesting in this connection is an old Scottish maxim handed down to nineteenth-century American descendants: nothing should ever be allowed to rest upon the Bible. Although Bibles were to be found in many different rooms, including parlors, halls, kitchens, and chambers, they were seldom kept in their own specific boxes.

The fine art of furniture carving was well established in England

before the first Pilgrim set foot on Plymouth Rock. Unfortunately few American boxes referred to in the seventeenth-century records are described in any way, albeit occasionally the term *joyned* is used to denote framing with a dovetail joint. In 1646 the inventory of Francis Lightfoot of Lynn, Massachusetts, listed a "Joyne box and littel trunke" valued at 5 shillings, and in 1674 "A chest, and an old Joyned box" were worth 6 shillings. The bottoms and sides of the majority of boxes were rabbeted [6] and secured by large, handmade nails. Hinges consisted of two wooden cleats running the depth of the cover and fastened to either end of the box by wooden pins, or two hand-wrought iron staples linked together, the ends of each staple being clinched into the wood of the cover and back of the box.[7] Oak was preferred in the earliest construction but in the later years of the seventeenth century many boxes were made with bottoms and lids of pine.

Broadly speaking, carved ornamentation divides itself into three main groups, examples of which may be recognized in the accompanying illustrations. These groups consist of cut designs raised above a flat background; carved or paneled surfaces divided by applied split spindles and bosses; and designs created by linear grooving, or incising. Perhaps an "ingraved chest" noted by Dr. Irving W. Lyon referred to this third technique. The majority of seventeenth-century American boxes were carved only on the fronts and but occasionally on the sides. Recurring decorative patterns include notched corners where front and sides join; lunettes incorporating various motifs; scrolls and strapwork combined with rosettes or stylized flowers; and interlaced half circles enclosing incised designs.[8]

Writing in 1891 Dr. Lyon made this noteworthy comment: "Carved chests are seldom mentioned in New England records of the seventeenth century. We have met with but six . . . Carved boxes are found in the records in about the same numbers as carved chests, the first mention being in an inventory made in 1653." [9] Lyon's reference parallels the estate of Thomas Emerson of Ipswich, Massachusetts, whose will in 1653 left to his daughter Elizabeth Fuller "the great carved chest and the carved box with a little trunk with all yt is in it, and a small carved chest with what is in it." In Emerson's inventory the "great carved chest" with a large quantity of household linen was valued at 16 pounds, 10 shillings. The carved box alone was listed at 6 shillings.[10]

One well-known joiner and carver, Thomas Dennis (born in England around 1638), lived and worked in Ipswich, Massachusetts, from 1668 until his death in 1706. A contemporary reference to Dennis appears in *Records and Files of the Quarterly Courts of Essex County, Massachusetts*, in 1682 when Samuel Pearce testified that "while Grace [Stout] lived with him three months as a hired servant, he had 18s 8d taken from a box and desk." At the same hearing Thomas Dennis deposed "that Grace bought

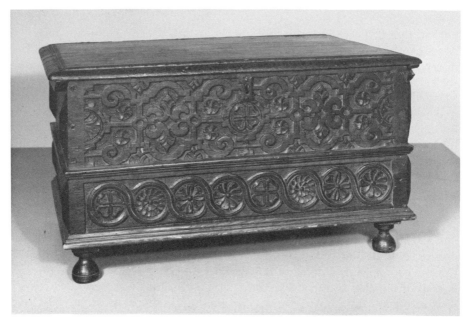

2. Oak deed box with drawer. Owned and made by Thomas Dennis, Ipswich, Massachusetts. c. 1660–1675. W. 25½". Carved in a pattern of strapwork combined with stamping made by an eight-pointed-star punch. Descended to Thomas's son John, to Colonel Thomas Dennis, to John Dennis, who took it to Litchfield, Maine, in 1789, since then it has not left the Dennis family.

a carved box with a drawer in it of him in 1679 and it had two locks for which Grace paid him in money." [11] A small group of seventeenth-century furniture has descended in the Dennis family and includes a carved oak box of the type described above (fig. 2). According to family tradition, this was Thomas Dennis's deed box in which were kept the valuable family papers. It was listed in the inventory of Thomas's son John as "a carved Box upon feet 2/8." [12] Some additional carved boxes, perhaps by Dennis or other Ipswich joiners, are mentioned in *The Probate Records of Essex County, Massachusetts*. In 1672 Mrs. Margaret Lake of Ipswich willed to her granddaughter, Margaret Harris, "my carved box and one Damaske table cloth and six Damaske napkins." [13] The estate inventory of the same year included three carved boxes worth 1 pound, 10 shillings, with damask tablecloth and six napkins at 4 pounds. [14] Also in Ipswich, in the estate of Mrs. Margaret Bishop, "a great chest, a carved box & 3 chairs" were listed in "ye chamber" at 1 pound, 1 shilling, 6 pence. [15]

The handsome box in figure 3 exhibits a type of carving associated with Hartford County, Connecticut, and combines foliated strap decoration with sunflower motifs. It descended in the family of Thomas Bissell who

3. Oak box with strap carving and sunflower motifs. Late seventeenth century. W. 24⅜". Attributed to Thomas Bissell of Hartford County, Connecticut, in whose family it descended. The initials *E B* are believed to have referred to his daughter or granddaughter.

came to Windsor with his father in 1639 and is believed to have been a joiner and the maker of the box. In 1655 he married Abigail Moore and in 1658 was given land in East Windsor where, thereafter, he made his home. Upon his death on July 31, 1689, "tabel frams not finished and chests not finished and turning tools" valued at 1 pound, 14 shillings, were left in his shop.[16] The initials *E B* are skillfully worked into the carved design and are presumed to have designated either Bissell's daughter, Elizabeth (1666–1688), or his granddaughter, Eunice (1686–1773).[17] The piece passed down in direct descent to Mrs. James Erit, by whom it was sold at auction in 1971.

A second box of similar workmanship, found some years ago in Suffield, was rescued from the dump of an old house on the present Ratley Road, which was one of the earliest roads to be settled in the town during the late 1600s. This example still retains its original blue paint as a background for the carving, and it seems probable that the later color, which has been applied to the box in figure 3, was an early effort to reproduce the first blue finish.[18]

The Buell family box in figure 4 is thought to have been owned and

made by the joiner William Buell who was born in England and settled in Dorchester, Massachusetts, in 1630. He removed to Windsor, Connecticut, between 1635 and 1639 and in the late 1650s worked on the interior of the Windsor meetinghouse making pews and casement windows. Buell died in November 1681 and his will stipulated that his tools be divided between his two sons. His "joyntrs tooles betle and wedges" were valued at "£05–07–06." [19] The decoration of interlaced circular scrolls enclosing rosettes is seen in varying forms on other seventeenth-century boxes.[20]

Added embellishment in the form of applied ornaments is a feature of many seventeenth-century chests. These bosses and split spindles were not made of oak but of such woods as birch, beech, or maple. They were often colored black, presumably in imitation of ebony, and were attached to the surface by means of glue, sometimes reinforced by handmade brads. Boxes also were decorated in this manner but are not found as often as cupboards and chests. In figure 5 the ring-turned split spindles are short and stubby in outline, and separate two groups of four small molded panels.

Occasionally one meets a box that differs markedly from the usual rectangular shape, as does the rare example illustrated in figure 6. A half octagon in form, it displays the notched carving and lunettes so popular in seventeenth-century furniture design, combined here with simplified foliated linear patterns. Originally in the collection of Luke Vincent Lockwood, the piece was said by him to have come from Greenfield, Massachusetts.[21] It is dated on the back, *DEM 20 of 12 MO 1671.*

In figure 7 may be seen an unusually large box exhibiting intersecting half circles combined with trefoil motifs, the whole enclosed at the top and bottom with bands of chisel carving. The front of the box and cover of the till are made of oak, the secondary wood is pine, and the sides still retain a thin wash of old red color. The large iron lock has disappeared, as have the two wooden cleats from the underside of the lid, although several holes for the pegs that once secured them are plainly visible in the illustration. Carved on the top of the till is the legend *S 1696 F.* Recent research by Robert B. St. George indicates the provenance as either Marshfield or Scituate, Massachusetts. Two similar examples are: one in the Henry Ford Museum, the other pictured as figure 145 in Nutting's *Furniture of the Pilgrim Century.*

When color appears on seventeenth-century chests, it is usually found in a combination of black and red that is used alternately on stiles and rails. It may also appear on applied ornaments, moldings, or as a background for the carved designs. Many boxes that have been subjected to generations of domestic scouring, or more recently to overzealous restoration, have now lost the remnants of whatever painted finishes they may have once possessed. The box in figure 8 is, therefore, of particular interest. It

4. Oak box believed to have been owned and made by William Buell of Windsor, Connecticut. W. 27″. Notched corners and interlaced circular scrolls were favorite forms of carving during the seventeenth century. (Oneida Historical Society, Utica, New York)

5. Oak and pine box. Second half seventeenth century. W. 14½″. Front ornamented with small molded panels, bosses, and ring-turned split spindles. The cover is cleat-hinged with molding that forms a lip over the top and sides. (Courtesy The Henry Francis du Pont Winterthur Museum, Winterthur, Delaware)

6. Oak and pine half-octagon-shaped box, with incised decoration. W. 26½″. Carved on back, *DEM 20 of 12 MO 1671*. Said to have come from Greenfield, Massachusetts. (Courtesy Greenfield Village and Henry Ford Museum, Dearborn, Michigan)

was found during the 1930s in the ownership of an old Taunton, Massachusetts, family, although Taunton may not have been its place of origin. When discovered, the surface had been obscured by two coats of worn old paint, but when these were removed, the crispness of the carving became immediately apparent. Even more interesting, however, were the painted designs that covered the sides and top, being more decorative in character than the usual surface washes. The lid displays an ornamental cartouche enclosing a circle. The sides are embellished with wavy black lines surrounding two rectangular panels outlined in black. One contains the initials *A H* and the other the date *1698* painted in red.[22]

Heretofore our attention has centered on the capacious, professionally carved desk and storage boxes of seventeenth-century date, a gratifying number of which still survive in public and private collections. Retaining their usefulness long after case furniture had, come into fashion, they were

7. Oak and pine box with gouge and chisel carving. W. 30". The incised inscription *S 1696 F* appears on the cover of the till. Two additional boxes and a table and chest with similar carving indicate a Marshfield or Scituate, Massachusetts, provenance.

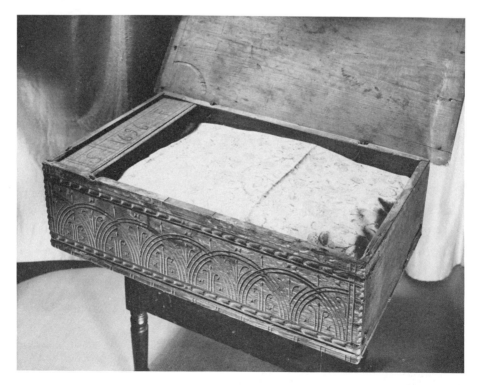

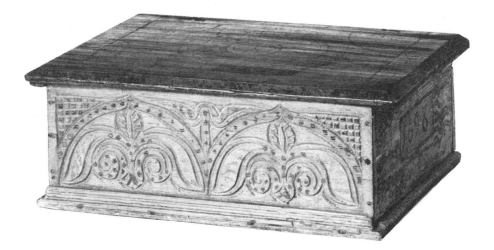

8. Box with incised carving, the top exhibiting a painted geometric design with a carved circle in the center. W. 20″. The sides display two rectangular panels outlined in black. One encloses the initials *A H*, the other the date *1698* in red. (Courtesy The Henry Francis du Pont Winterthur Museum, Winterthur, Delaware)

often filled with papers or memorabilia and then forgotten, to be rediscovered two hundred years later in attics or barns and cherished as family heirlooms. Unhappily this was not often the case with the small, homemade boxes that filled the everyday needs of pioneer living. Subject to hard usage and kept only as long as they served an immediate purpose, they were easily expendable and few datable examples have survived for study. Useful references are usually lacking in contemporary documents as small utilitarian items were only listed, and seldom described because they were not considered to be of sufficient importance to occupy the time and attention of the inventory taker. Spice boxes, however, are an exception as they were often designated by name.

A small black-painted box of unknown origin but of obviously domestic workmanship, is seen in figure 9. Fashioned rather crudely from a single piece of tamarack (American larch), the back and front elevations were grooved to accommodate a now vanished sliding cover. The unidentified carver was quite unskilled. But this did not deter his efforts to decorate his handiwork according to the precepts of the day—with sawtooth borders enclosing the initials *I.B.* and the date *1674*. One surmises that this humble piece may exemplify the type of box designated in the following typical entry: Will of Jaine Lambert of Ipswich, Massachusetts, 1659, "One little box and all that is in it." "A small box and silke" was worth only two pennies in 1671.

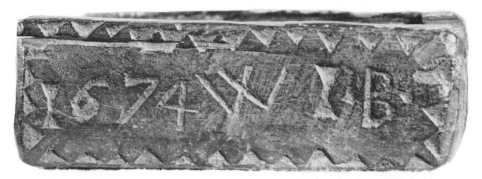

9. Tamarack box dated and initialed *1674 I.B.* W. 6½″. The sliding cover is missing. Small, inexpertly carved boxes of this type have mostly disappeared, but they served many useful purposes in seventeenth-century households.

By the close of the seventeenth century the appearance of carved boxes had begun to change. In the early years of the eighteenth century oak was becoming scarce, at least in some rural areas of New England, and was being replaced by walnut, chestnut, and pine. By 1665 such inroads had been made upon the oaks that the town of Ipswich, Massachusetts, ordered the selectmen to issue a permit before a valuable tree could be cut. "Felling grants" were made in specific cases to enable property owners to improve their outbuildings or fences, but the town was strict in checking up on trees cut without permission. When one unfortunate citizen felled seven white oaks without leave "the Constable was ordered to distrain him of 10 shillings for every tree according to Town order." [23] Traditional styles of carving also took on a different character, or were gradually superseded by painted decoration. New furniture forms emerged, and the increased use of ball feet not only facilitated moving heavy boxes about but also resulted in the added convenience of gaining extra height if used on the floor. The obvious advantages of drawer space soon brought an increasing demand for highboys and chests of drawers, which obviated the inconvenience of the conventional flat storage box.

Figure 10 is a transitional piece with a long Massachusetts history. It still exhibits the low seventeenth-century profile, original double lock, wooden cover cleats, and heavy iron staple hinges. It is, however, constructed entirely of pine and the bold designs are executed by means of a chisel rather than a knife. This technique was the forerunner of much decoration to be found in later years and is often referred to as "Friesland" because of the similarity of the chip-carved patterns to those used by the peasants in Friesland and other areas of northwestern Europe.

Expertly carved hearts, stars, and pinwheel motifs typical of many

found on American boxes of the second half of the eighteenth century, appear in figure 11. But the designs themselves are ancient and almost universal. They occur as ornamentation on numerous objects as widely divergent as eighteenth-century American gravestones and wall carvings above doorways on picturesque vernacular buildings in the Dordogne region of France.

Most of the small boxes used in the eighteenth and nineteenth centuries did not rely entirely on carving for decoration. If they did, they were usually examples of individual workmanship unrelated to a generic group, as their seventeenth-century predecessors had been. The small dome-top piece in figure 12 dates to around 1810. It is painted red and carries the owner's name *SETH WHITM* in phonetic spelling. Borders of sawtooth carving enclose two bands of naïvely shaped palmettes. The scratched designs on the top and sides are set off by corner fans, all suggesting that a local artisan, perhaps Mr. Whitm himself, had at least a nodding acquaintance with the prevailing neoclassic style.

The box in figure 13 exhibits a raised diamond-point pattern enclosing rectangular ribbed reserves, all carefully carved on the outer surface of the substantial pine panels that form the top and sides. This technique was used for embellishing picture frames and other small objects during the first quarter of the nineteenth century and is slightly reminiscent of some of the raised ornamentation to be found on tramp art of a later period. Reserves sometimes consisted of hearts and stars, or provided smooth areas on which to inscribe the owner's name. Contrasting colors were desirable to emphasize the effectiveness of this type of carving. Here

10. Pine box of Massachusetts origin with a cleated lid and the original double lock. W. 27¾". The chisel carving suggests a transitional date of c. 1700.

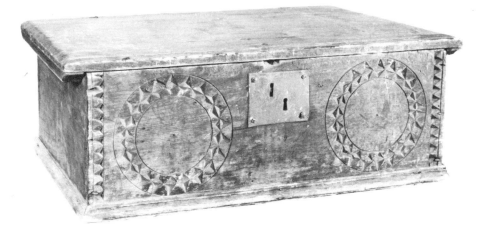

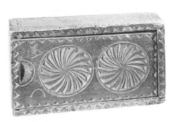
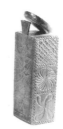
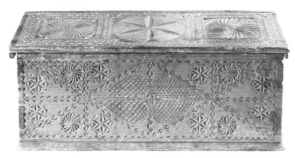

11. Three boxes with chip-carved decoration. Upper left, painted pink. W. 10¼″. Initialed *A C* on the sliding top and *1785* on one end, bottom incised *A W 1795*; upper right, painted green. W. 8″; below, unpainted. W. 15⅜″. Carved on back, *S*D 1765*. Much chip carving with pinwheel, heart, and star motifs, dates to the second half of the eighteenth century.

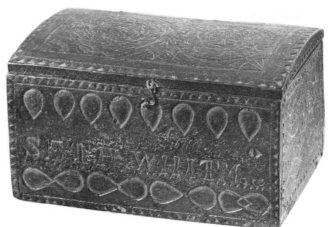

12. Dome-top box, red-painted. c. 1810. W. 5¾″. Scratched decoration with palmettes and fans. Owner's name, *SETH WHITM*, incised on front.

13. Dome-top box. W. 12″. The diamond-point pattern is accentuated by the use of red and mustard yellow, emphasizing the combination of carving and painting popular in the first quarter of the nineteenth century.

the use of vibrant red and mustard yellow results in an eye-catching combination of carved and painted decoration.

NOTES

1. Unless otherwise noted all seventeenth-century Essex County references are found in *The Probate Records of Essex County, Massachusetts* (Salem: Essex Institute, 1916–1920), vols. 1, 2, 3, 1635–1681. *Records and Files of the Quarterly Courts of Essex County, Massachusetts* (Salem: Essex Institute, series beginning 1911), vols. 1, 3, 4, 5, 6, 7, 8, 1636–1683. Archaic spelling and capitalization have in some cases been modernized.

2. Irving Whittal Lyon, M.D., *The Colonial Furniture of New England* (New York: Dutton Paperbacks, 1977), pp. 110–114.

3. Luke Vincent Lockwood, *Colonial Furniture in America* (New York: Charles Scribner's Sons, 1921), vol. 1, p. 210.

4. Patricia E. Kane, *Furniture of the New Haven Colony, The Seventeenth-Century Style* (New Haven: The New Haven Colony Historical Society, 1973), p. 43.

5. The desk box in figure 1 was in the collection of Irving P. Lyon, M.D., of Buffalo, New York, in 1937, and was illustrated and described in his article, "The Oak Furniture of Ipswich, Massachusetts," *Antiques* (December 1937), p. 301. Dr. Lyon's ownership was through purchase from descendants of the seventeenth-century Caldwell family of Ipswich, the box having been an heirloom passed down from a Caldwell grandmother born in 1825. For a thorough discussion of desk boxes see Lyon, *Colonial Furniture,* pp. 109–113.

6. A rabbet is a cut or groove along or near the edge of a piece of wood that allows another piece to fit into it to form a joint.

7. Illustrations of pin and staple hinges may be found in Russell Hawes Kettell, *The Pine Furniture of Early New England* (Garden City, N.Y.: Doubleday, Doran, 1929), drawing no. 4; and in Nancy A. Smith, *Old Furniture, Understanding the Craftsman's Art* (Boston and Toronto: Little, Brown, 1975), p. 80.

8. A large variety of carved boxes is illustrated for comparison in Wallace Nutting, *Furniture of the Pilgrim Century* (Framingham, Mass.: Old America Company, 1924), figs. 125–159.

9. Lyon, *Colonial Furniture,* p. 5.

10. *The Probate Records of Essex County, Massachusetts,* vol. 2, pp. 35, 37.

11. *Quarterly Court Records of Essex County, Massachusetts,* vol. 8, p. 282.

12. Dean A. Fales, Jr., ed., "Essex County Furniture," *Essex Institute Historical Collections* (July 1965), p. 178.

13. *The Probate Records of Essex County, Massachusetts,* vol. 2, p. 290.

14. *Ibid.*

15. *Ibid.*, vol. 3, p. 411.

16. Patricia E. Kane, "The Joiners of Seventeenth Century Hartford County," *Connecticut Historical Society Bulletin* (July 1970), p. 80.

17. Genealogical data courtesy of Amelia F. Miller.

18. This box is illustrated in Charles S. Bissell, *Antique Furniture in Suffield, Connecticut, 1670–1835* (Hartford: The Connecticut Historical Society and the Suffield Historical Society, 1956), plate 8, p. 17.

19. Kane, "The Joiners of Seventeenth Century Hartford County," pp. 78, 79.

20. Compare Nutting, *Furniture of the Pilgrim Century*, figs. 130, 131. See also the Thomas Dennis box, fig. 2 herein.

21. Luke Vincent Lockwood, *Colonial Furniture in America*, 3rd ed. (New York: Charles Scribner's Sons, 1926), vol. 1, p. 378.

22. Chauncey C. Nash, "A Carved and Decorated Box," *The Walpole Society Note Book* (1944), pp. 41, 42.

23. Town Records of Ipswich, Massachusetts, MS vol. 1.

Ornamented with Inlay, Gilding, and Paint

Innumerable boxes are recorded in the ownership of seventeenth-century families, most of them for personal or household storage and kept for convenience in the parlor, chamber, or kitchen. Unfortunately few were described with reference to ornamentation or finish. One "prentice box" costing 10 pounds was recorded in the inventory of Robert Sallows of Salem, Massachusetts, in 1662. At that time an apprentice box was not a rarity. An expertly made box was formerly one of the requirements of apprenticeship to the trade of ship's carpenter, and is still obligatory in many woodworking courses today. What appears to have been an eighteenth-century apprentice piece is illustrated in figure 14. It is fashioned from a solid piece of mahogany in box form, with the obvious purpose of displaying the use of various kinds of inlaid woods.

In 1666 Thomas Wells of Ipswich, Massachusetts, left to his wife Abigail his "best chest and inlayed Box with *T W* upon the lid." A mahogany box with satinwood inlay, possibly of Rhode Island provenance, illustrates

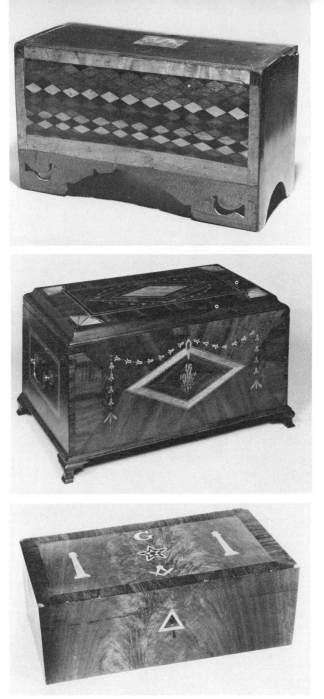

14. Apprentice piece made in the form of a box. W. 11½". Inlaid with different woods to demonstrate the skill of the maker. (America Hurrah Antiques, New York City)

15. Mahogany box with inlaid decoration. c. 1800. W. 21⅛". The fan motifs and graceful garland of bellflowers illustrate the delicate work of the neoclassic period. (Courtesy The Henry Francis du Pont Winterthur Museum, Winterthur, Delaware)

16. Inlaid box of mahogany veneer, dated in pencil 1846. W. 13¼". The six Masonic symbols are indicative of its original ownership.

a fine example of the delicate style of work that became increasingly popular as the eighteenth century progressed (fig. 15). A more unusual piece of later date, exhibiting Masonic symbols inlaid on cleverly matched mahogany veneer, was probably intended to contain the owner's Masonic regalia (fig. 16).

Moses Pearce of Ipswich, Massachusetts, in a court session of 1682, testified that he had received of Grace Stout 3 pence for "one gilt box." Whether this was of English or American make is now impossible to say. Most of the original gilding on small utilitarian objects of seventeenth-century date has pretty well disappeared owing to continued use over the past 300 years. The overlaying of wood with a finish of gold leaf was produced by two techniques known as oil gilding and water gilding. Oil gilding, being partially waterproof, was used chiefly in outdoors work such as weathervanes and signs. Water gilding on furniture, however, was applied on a carefully prepared gesso ground, a material usually composed of gypsum or whiting, linseed oil, and glue. This often cracked or loosened with years of wear, sometimes revealing the wooden surface beneath.[1] Many old pieces whose gilded gesso surfaces became impaired have been scraped and refinished to natural wood thereby destroying all evidence of a once gilded finish.

Much of the early furniture made in the Colonies was painted, either with pigments imported from England or with stains made from locally obtainable vegetable dyes. Tempera colors ground in water with size were also used to some extent but these were transitory if scrubbed by a too fervent housewife. Many surfaces were covered with solid colors, including bluish-green, red, and black, with structural elements such as moldings and spindles picked out in contrasting shades. In other instances decoration in the form of scrolls, vines, and geometric designs were superimposed on plain background colors.

The majority of furniture still retaining original paint applied before 1700 comprises chairs, press cupboards, and chests. Most of the boxes of that period, however, have either been resurfaced (some a great many years ago), or they were originally left with a natural wood finish. One painted box dating between 1680 and 1710 is illustrated in Fales, *American Painted Furniture*.[2] This piece combines tulip-carved decoration with an allover surface in a strong blue-green. Painted boxes described as such appear infrequently in seventeenth-century inventories. "A great and a little painted box" are mentioned in the *Records and Files of the Courts of Essex County, Massachusetts*, as having been taken from Captain Manning and returned to him by Peter Cheevers, Constable, on July 2, 1680.[3]

Eastern Connecticut was especially rich in furniture with patterned finishes, and boxes with feet are among the most interesting to appear

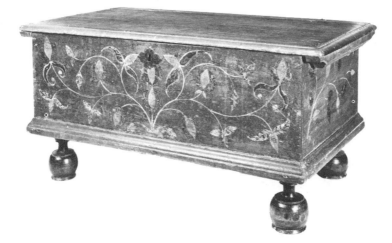

17. Box, having a reddish-brown background, painted with leaf and flower designs in red and green, outlined in white. c. 1725–1730. W. 32¼". One of a small group of Connecticut pieces exhibiting similar decoration. The feet are replacements. (Courtesy The Henry Francis du Pont Winterthur Museum, Winterthur, Delaware)

from 1710 to 1735. A pioneer exhibition of early painted chests opened at The Connecticut Historical Society in Hartford in December 1957, and in January and April 1958, the *Connecticut Historical Society Bulletin* published two articles by William L. Warren dealing with various groups of decorated furniture found in Connecticut. Among the specialized examples discussed by Mr. Warren was a distinctive group of case pieces exhibiting a flowering vine motif springing from a small, central mound. Two chests of drawers were cited in the article, and other similar pieces are known to include two storage boxes with bun feet. Figure 17 illustrates an example in The Henry Francis du Pont Winterthur Museum that is constructed of maple, red oak, and tulip wood. The background is reddish-brown, the front decorated with scrolled vines bearing elliptical blossoms and veined leaves outlined in white. A second similar box appears in plate 1, employing the same designs and painting technique. Like other pieces of this type, the colors used in various parts of the decoration are yellow, dark green, and red. The name of the decorator, however, is as yet unknown.

Another group of early pieces, unmistakable because of their bird and vine decoration, originated in Taunton, Massachusetts, during the second quarter of the eighteenth century. They are attributed to the furniture and drum maker Robert Crosman (1707–1799) whose work was first revealed by Esther Stevens Fraser in *Antiques*, April 1933.[4] Distinctive features of Taunton chests are the spread-winged birds and the unusual

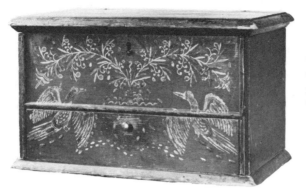

18. Box with a lift cover and drawer. c. 1727. W. 17″. Made and decorated by Robert Crosman of Taunton, Massachusetts, in white with touches of vermilion on a dark, reddish-brown ground.

delicacy and grace of the floral sprays, some of which cover the entire facades of the pieces ignoring the divisions of drawers. Backgrounds are a dark reddish-brown with designs traced chiefly in white, and with accents in vermilion as on the box with lift cover and drawer illustrated in figure 18.

A less sophisticated group of early eighteenth-century painted furniture from the vicinity of Hampton, New Hampshire, was illustrated and discussed by Esther Stevens (Fraser) Brazer in the April 1930 issue of *Antiques*.[5] The key piece was a pine blanket chest signed by the house carpenter and joiner *Sam Lane* of Hampton Falls and dated *1719* when he was twenty-one years old. Lane is also believed to have executed the unusual floral decoration. To this chest with its curving scrolls, black wavy lines, and stylized trees, Mrs. Brazer linked a closely related country-style press cupboard that is now in the Yale University Art Gallery: Mabel Brady Garvan Collection. A second chest, then unknown to the author, has since been found, undoubtedly also ornamented by the same ingenuous hand.

Two further examples comprising another press cupboard and a so-called Bible box formed a second very similar group that was also illustrated in the *Antiques* article. In these pieces the style of decoration resembled, yet did not duplicate, motifs found on the Lane furniture. Mrs. Brazer, however, confidently assigned the second group on structural and stylistic grounds to Hampton or Hampton Falls, either to Lane himself in his maturer years, or to another decorator, perhaps Lane's instructor, who was living in the same locality.

Figure 19 shows the box illustrated by Mrs. Brazer in 1930, which was then in her collection. Made of walnut, the ground was originally covered with a thin, black stain that served as a base for the naïve decoration painted in white and red. Standing birds, and crescent motifs centered on the four points of a cross, are combined with single and double circles surrounding

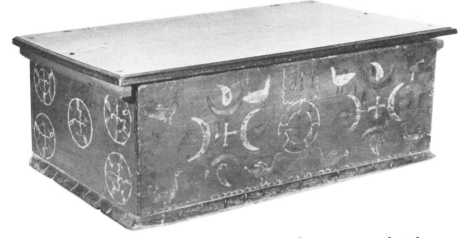

19. Walnut box initialed *J M*. c. 1730. W. 21″. Birds, crescents, and circles enclosing wavy lines are painted in red and white on a dark ground. Attributed to a decorator in Hampton, New Hampshire. The top is a replacement. (Formerly collection of Esther Stevens Fraser Brazer)

distinctive wavy lines. Along the lower edge of the front is a painted border composed of small half circles that form a scalloped band. In the upper center of the front the letters *J M* are enclosed in the curving brush-strokes that are a distinguishing characteristic of this craftman's style. Mrs. Brazer's research revealed that these initials might have belonged to one John Moulton (1669–1740) of Hampton, New Hampshire, who, like Sam Lane, was a house carpenter. A generation older than Lane, Moulton could well have been the master from whom the younger man learned his trade.

In 1963 another box came to light, this one with original feet and decoration in white by the same naïve hand (fig. 20). Constructed of pine with maple feet, the ground coat is worn red paint used as a background for the familiar birds, circles, and conjoined half-circle bands. This piece differs from that in figure 19 in having been a bridal box with a heart as the central motif, surmounted by the initials *A P* enclosed within the afore-mentioned wavy lines. It was owned in the second quarter of the nineteenth century by Daniel Poor of Danvers, Massachusetts, whose name and place of residence appear on an old printed slip still glued to the inside. Daniel was born in Danvers in 1822 and died on the island of Batavia in 1847 when only twenty-five years of age. If, as seems probable, he inherited this piece from a Poor ancestor, one must look for the initials *A P* in a previous generation of the Poor family. Daniel's great-grandfather, Thomas

Poor of Andover, Massachusetts, was born in 1703. He married Mary Adams, daughter of Captain Abraham and Ann (Longfellow) Adams who lived at Highfields, the ancient house in Byfield, Massachusetts, where the bottle box illustrated in figure 163 was found. The marriage took place on September 30, 1728, "at Newbury," which then included a portion of Byfield parish. Newbury is scarcely more than ten miles south of Hampton, New Hampshire, where the decorator of this piece is believed to have worked. Moreover, the marriage year is just the date that one would ascribe to such a box. It was an occasional eighteenth-century practice to combine the surnames of a bride and groom on needlework coats of arms, but it was not the custom so to mark wedding furniture of the time. Although it is tempting to speculate that the letters A P surmounting the heart denoted the Adams-Poor marriage of 1728, it is more likely that they signify the ownership of a hitherto unidentified member of the Poor family.

During the second half of the eighteenth century the role of the ornamental painter assumed increasing importance in connection with home decoration, as his magic brush could transform the bleakest interior into a place of warmth and beauty. Old fashioned sheathing might be painted to resemble up-to-date paneling, or pine chimney breasts grained and marbleized to imitate imported mahogany or cedar wood surfaces.

20. Marriage box initialed A P above a heart. c. 1728–1730. W. 21¾″. Descended to Daniel Poor of Danvers, Massachusetts, before 1847. Painted in white on a red ground, the decoration is attributed, as in figure 19, to a decorator in Hampton, New Hampshire.

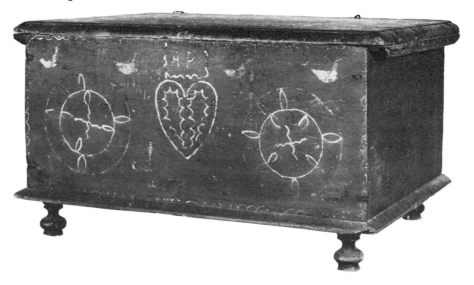

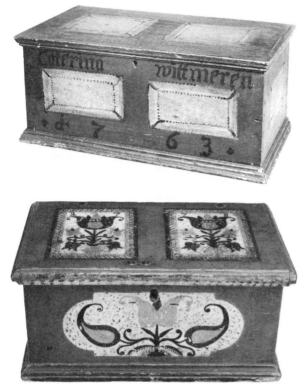

21. Pennsylvania box, inscribed *Caterina Wittmeren 1763*. W. 16⅝". The painted reserves simulate raised fielded panels superimposed on a background of olive green, black, and tan. (Courtesy The Henry Francis du Pont Winterthur Museum, Winterthur, Delaware)

22. Pennsylvania box dated *1778*. W. 16". Three white reserves enclose tulip motifs, the date appears at the tops of the two panels on the lid. (Courtesy The Henry Francis du Pont Winterthur Museum, Winterthur, Delaware)

Country furniture and accessories were also glorified by the decorator's hand. Blanket chests, worktables, and boxes were among the pieces receiving painted bands of inlay so expertly applied that they still defy detection. Fronts of highboys and tall chests of drawers were grained to convey the pattern and texture of curled maple, and dainty sewing boxes were frequently shaded to resemble satinwood.

The box in figure 21 presents an unusual illustration of naïve deception painting. The four reserves cleverly simulate raised fielded panels superimposed upon a variegated background of olive green, black, and tan. As with much other Pennsylvania work the name of the owner, *Caterina Wittmeren*, and the date, *1763*, are boldly inscribed on the front.

A second example more typical of Pennsylvania German workmanship is seen in figure 22, the colorful black and red designs featuring tulips are laid on three white-grounded reserves. It exhibits no personal identification, but the date *1778* is enclosed at the top of the two panels on the lid. Stylized flowers, with the name *Margaret Miller* and date *1796*, are seen

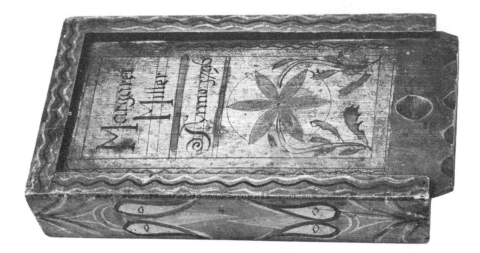

23. Pennsylvania box, with stylized flowers. W. 8⅝″. The name *Margaret Miller* and the date *Anno: 1796* are painted on the sliding cover in black on a white ground. (Courtesy The Henry Francis du Pont Winterthur Museum, Winterthur, Delaware)

on the shallow box illustrated in figure 23. Sliding covers were so convenient that they were used over a long period of time.

Painted boxes originating in Pennsylvania exhibit conventionalized motifs derived from a combination of designs familiar to successive generations of settlers emigrating from Germany and Central Europe. Plate 2 illustrates a representative example with white reserves that enclose tall, handled vases from which spring stylized blossoms of tulip and pinwheel shapes. Plate 3 pictures a box that relates to certain Pennsylvania German chests of the late eighteenth century. This piece is dated *1785* across the top of the front panels and bears on each end a figure on horseback carrying a sword and flanked by tall, flowering plants.

In decided contrast to the flamboyant stylized patterns of the Middle Atlantic states, many New England pieces exhibit soft colors and freely rendered designs. What appears to be a unique homemade example is seen in figure 24. The wooden back and sides were first given a protective paper covering. This served as a background for the restrained yet graceful pen-and-ink drawing executed in circular and meandering lines enclosing

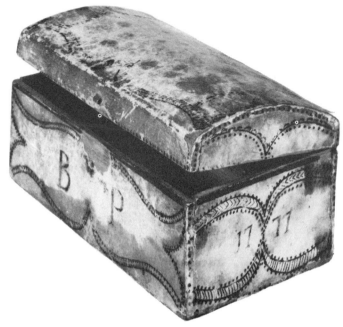

24. New England box with paper covering. W. 5¼". The pen-and-ink-drawing was probably done by Bridget Powers whose initials, *B P*, and date, *1777*, appear on the front and one end.

the date *1777*. *B P* signifies the initials of Bridget Powers, its owner, who was also likely to have been the decorator.

During the opening years of the nineteenth century the number of boxes with painted decoration greatly increased, and over the next forty years colorful finishes reached the peak of their popularity. Employing motifs used in other aspects of the decorative arts, swags, tassels, and quarter fans appeared as embellishments on fronts and lids, echoing the cornice and mantel carving of the Federal period. An attractive style of drapery decoration may be seen in plate 4. Painted a warm orange-red, the striping is executed in white and green and the swags in a faded mustard yellow. Probably of Vermont origin, the initials *M C* appear in script on the top. One might easily believe that this essentially simple box was a one-of-a-kind piece, but this is not so, another almost identical one bears other initials.

Boxes featuring prim buildings are occasionally found and convey a pleasingly personal touch often lacking in more formal decoration. Plates

5 and 6 illustrate a Pennsylvania and a New England example, the former being inscribed *Catharine Landes* and dated *1849*. Although one could assume that the houses portrayed the homes of the owners, this was probably seldom the case. More likely these structures derived from engravings or from illustrations contained in drawing instruction books.

In the first quarter of the nineteenth century American patriotic symbols proliferated in paintings, carvings, fabrics, chinaware, and other useful objects. A box with decoration typical of this era of self-conscious nationalism appears in figure 25. The ground is black and provides an excellent foil for the painting in vibrant yellow. Two spiky trees adorn the front upon which the initials *L B* are formed in brass-headed upholstery tacks. Neoclassical fans, crudely rendered, fill the corners of the lid, and a fine spread-winged eagle is only slightly obscured by the oval escutcheons of the brass handle. Lettered with a brush across the upper edge of the front is the legend: *Chester Vermont December 19th 1810*.

After 1820 variegated patterns were applied to boxes in a riot of colors and designs. Such finishes were not intended to imitate the grain but to beautify or "enrich the wood," and startling effects were gained by several different methods. *Sponging* required careful application of a coarse sponge or other absorbent material. Swirls were accomplished by the dexterous rotating of a crumpled pad of cloth called a "pounce," or by twisting the thumb or heel of the hand. Small, bristled brushes and different sizes of metal-tooth combs produced veining and evenly spaced grained patterns. Marbling or clouded effects could be achieved by allowing candle smoke to play across a tacky varnished surface.

Plate 7 illustrates a handsome box having stylized motifs in white and two shades of green on a brown background. The brushstroke technique suggests the probability that the unknown decorator also painted tinware. Quite different is the decoration on the storage box seen in plate 8 where some of the freely rendered swirls are reminiscent of large seashells.

Certain fancy-painted boxes and small low chests look so typically American that it comes as a surprise to learn that some fine old examples could well have been imported from China. Furniture in the western style was shipped into Providence, Rhode Island, as early as 1801,[6] and chairs, tables, and sofas of early nineteenth-century taste are found in a rare drawing of a Chinese cabinetmaker's shop (pl. 9). Of particular interest are the boxes, all so similar in form and decoration to American pieces of the 1820s.

Other kinds of boxes that display animals, human figures, and nautical motifs were painted by amateurs. Most country towns were also visited from time to time by itinerant drawing instructors or by "house, sign and fancy painters," all of whom contributed to the needs of a rural clientele.

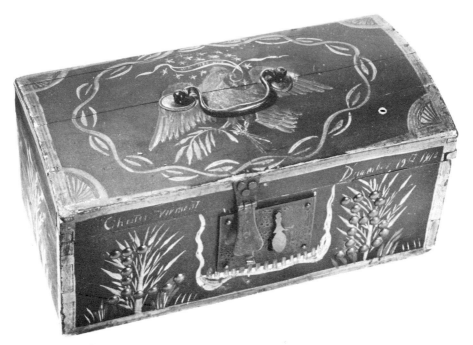

25. Dome-top box with a patriotic flavor. W. 12″. Decorated in yellow on a black ground, the legend *Chester Vermont December 19th 1810* is lettered across the lower edge of the cover. Brass upholstery tacks form the initials *L B*.

NOTES

1. Nancy A. Smith, *Old Furniture, Understanding the Craftsman's Art* (Boston: Little, Brown, 1975), p. 100.
2. Dean A. Fales, Jr., *American Painted Furniture, 1660–1880* (New York: E.P. Dutton, 1972), p. 16.
3. *Records and Files of the Quarterly Courts of Essex County, Massachusetts,* vol. 7, p. 404.
4. Esther Stevens Fraser, "The Tantalizing Chests of Taunton," *Antiques* (April 1933), pp. 135–138.
5. Esther Stevens Fraser, "Pioneer Furniture from Hampton, New Hampshire," *Antiques* (April 1930), pp. 312–316.
6. Carl L. Crossman, *The China Trade* (Princeton: The Pyne Press, 1972), p. 143.

Decorated in Fancy Painters' Techniques

A small but colorful group of boxes has gradually come to light bearing decoration that relates to the designs used by ornamental painters during the first thirty-five years of the nineteenth century. Many traveling artists

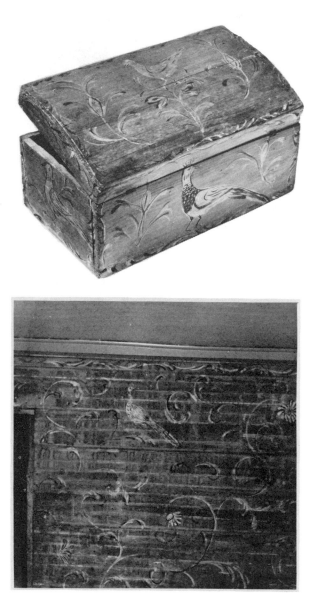

26. Back of a box decorated by an unidentified itinerant wall painter. 1800–1810. W. 12″. Ochre ground, designs in gray and black with touches of red. A number of houses in New England and eastern New York State were painted freehand by this man.

27. Sheathed wall from the Williams Tavern, Sunderland, Massachusetts. Early nineteenth century. By the same hand as the box in figure 26. Horizontal lines are marks left by later laths. (The Society for the Preservation of New England Antiquities, Boston)

were jacks-of-all trades and in addition to scenic murals and stenciled repeat-patterns with which they decorated their clients' homes, they occasionally embellished furniture and accessories using corresponding methods.

The box shown in figure 26 was ornamented by the same hand that painted a recognized group of freehand walls found in old houses in Con-

necticut, Massachusetts, Vermont, and over the border in eastern New York State. Featuring flowers, graceful scrolls, and stylized birds—rendered in black and white with traces of vermilion on gray or yellow plaster grounds—this anonymous itinerant was responsible for some of the most striking murals of the early 1800s.[1] The newspaper lining includes a probate notice dated *Windham* [Vermont] *1806*, a year that falls within the period that his comparable wall paintings were apparently executed. Figure 27 illustrates for comparison one section of a wood-sheathed room that formed part of the now-demolished Williams Inn in Sunderland, Massachusetts. The similarity of wall and box designs is immediately noticeable, and the box adds a new dimension to the decorator's repertoire.

One of the best-known Yankee craftsmen of the first half of the **nine**-teenth century was Rufus Porter (1792–1884) who, among his many achievements, painted gay scenic frescoes in countless houses throughout northern New England. "Spongy" foliage and foreground "shrubbery" are

28. Box with decoration of the Rufus Porter type. Second quarter nineteenth century. W. 13¼″. Inscribed on cover *P. Porter*. Dark ochre background with foliage in brown, green, and red.

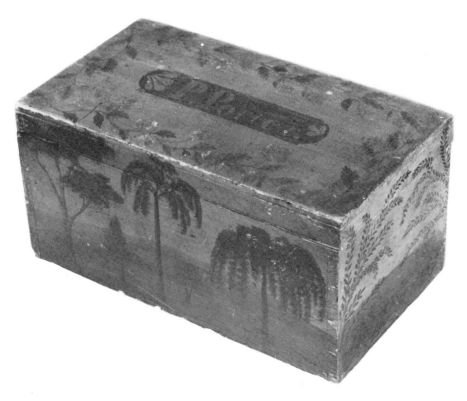

features typical of Porter murals. The front of the box presented in figure 28 exhibits Porter-like trees. On the end is a group of his characteristic ferns to which he referred as follows: "A tall fern, is always convenient to fill a vacancy, or conceal any defect in the painting . . ."[2] Because Porter's style has never lost its popular appeal, various well-preserved pieces of furniture have recently appeared on the market decorated in his picturesque manner. This box, however, is in untouched condition and carries the name *P. Porter* lettered in red on the lid. It may have been intended for Pauline (King) Porter, his cousin's wife, after whose brother Rufus King, the artist, named his second son.

A chest and dome-top box are seen in plate 10, both decorated with typical wall stencilers' patterns that were usually cut larger in size than those intended for use on furniture. Traveling decorators often painted floors and fireboards to complement their repeat-patterned walls and also on rare occasions used the same geometric wall stencils for furnishings that were designed to be used in the same room. This chest was found many years ago, standing forlornly for sale on a back country road adjacent to the old farmhouse where a stenciler had once paused to ply his trade. Because homeowners occasionally were able to do their own walls, some pieces decorated with wall stencils are undoubtedly the work of amateurs.

The box in figure 29 is one of a group that is easily recognizable because of the same red and yellow patterns stenciled against a black ground. The decorator, seemingly a professional, appears to have worked in central Massachusetts, possibly in the vicinity of Worcester County. These boxes have been found in a variety of sizes, one having been lined with a newspaper, *The Liberator,* dated 1840.

The hand of an unknown fancy painter can be easily discerned in the motifs shown in plate 11. This unusual box is a rare survival pertaining to the clandestine activities of the once powerful Washington Benevolent Society. Offshoots of the organization constituted active fraternal clubs that operated secretly to gain political influence for the Federalists. The first Benevolent Society was formed in New York City in 1808, soon to be followed by others in Rhode Island, New Hampshire, and Vermont, with Massachusetts added in 1812. Branches then sprang up in many small New England cities and towns. This resulted in considerable social ill feeling emanating from the spread of the society, although it ceased to attract much attention after the close of the War of 1812. Each applicant took an oath to support the Constitution and received a textbook containing Washington's Farewell Address and the Constitution of the United States, with a certificate of membership printed on the flyleaf. In the remaining examples of these little books, the frontispiece presents a little-known bust

29. Dome-top box with stenciled designs in yellow and red on a black ground. 1825–1840. W. 20″. Numerous similar pieces of varying sizes have been found in Massachusetts, all attributable to the same unidentified hand.

of Washington inscribed *A. Todd Sculpt.* One engraved portrait may be seen framed under glass in the center of the cover in plate 11.

This particular box was probably made to be used by the secretary of one of the Massachusetts Benevolent Societies, a position often held in secret by a locally prominent man such as Harrison Gray Otis, an active Federalist, who was secretary of the Boston society. Fitted with drawers and pigeonholes for writing material and papers, the cover when closed down forms one of the sides of the box so the top does not open upward, making access to the interior not readily apparent to prying eyes.

Anson Clark of West Stockbridge, Massachusetts, has been called "one of the most amazing characters in the history of the Berkshires." Born in Connecticut in 1783, he began his career as a stonecutter in the marble quarries and went on to become a musician, musical instrument maker, and daguerreotypist.[3] He also invented such novel mechanisms as a hand-operated dynamo, a revolving-brush street-sweeper, and an improved drilling machine. For the drilling machine he received an award from the Mechanics Institute of New York City in 1839.[4] Among his diverse activities, Clark at some time must have practiced the art of stenciling, for a fine group of picture frames and a nicely decorated box are identified by family tradition as his handiwork (fig. 30). Each frame carries a different set of motifs, all cut with clarity and applied with precision and a satisfying sense of good design. The sliding lid of the black box is ornamented with a subtle combination of stencil and freehand techniques.

Stenciled decoration was not always of the country type. Ornamental painting had long served as an acceptable substitute for marble, carved

30. Picture frame and box stenciled by Anson Clark, West Stockbridge, Massachusetts. c. 1830. W. of box 5¼". Clark was a craftsman and inventor and advertised daguerreotype landscapes and portraits in 1841. The watercolor, not original to the frame, depicts Mount Holyoke, central Massachusetts, by Elizabeth Goodridge.

work, and inlay. Richly grained woods such as mahogany, walnut, and cedar were cleverly imitated by brushwork in the eighteenth century, and during the Empire period fashionable furniture made of rosewood received lavish decoration that included stenciled patterns and painted simulations of gilt ormolu mounts. Plate 12 illustrates a high-quality box with stenciled top and border designs on a simulated rosewood ground. The front ornament, however, is expertly painted freehand in imitation of a metal mount.

NOTES

1. Further illustrations of this artist's work appear in Nina Fletcher Little, *American Decorative Wall Painting, 1700–1850* (New York: E.P. Dutton, 1972), pp. 93–96, 143, 144.

2. Rufus Porter's instructions for "Landscape Painting on Walls" appeared in the March 26, 1846, issue of volume I of the *Scientific American*. The original drawings for ferns that accompanied Porter's instructions are reproduced in Jean Lipman, *Rufus Porter* (New York: Clarkson N. Potter, 1968), p. 96.

3. A broadside dated June 12, 1841, advertising "Daguerreotype Portraits taken by A. and E. H. Clark" is owned by the Albany Institute of History and Art.

4. Edna Bailey Garnett, *West Stockbridge, Massachusetts, 1774–1974* (West Stockbridge, Mass.: Bicentennial Committee and Friends of the Library, 1976), p. 107. I am grateful to Ruth Piwonka, Director, Columbia County Historical Society, Kinderhook, New York, for calling this account of Anson Clark to my attention.

Fashioned of Leather and Hide

Micah Richmond, tanner, came to Plymouth, Massachusetts, from Weymouth, England, in 1630, and thereafter the tanning of hides was to become one of New England's most important basic industries.[1] Skins were kept in the garrets of many homes like that of Henry Short of Newbury, Massachusetts, in 1673, and leather trunks with either hair or smoothly dressed surfaces were made in all sizes from the seventeenth to the nineteenth century.

It should be emphasized that in the seventeenth century the word *trunk* included both large chests and small boxes. This is indicated in the entry "2 boxes, or little red trunks" valued at 3 shillings, 2 pence that appeared in *The Records and Files of the Quarterly Courts of Essex County, Massachusetts*, in 1678. Other typical references to what we today

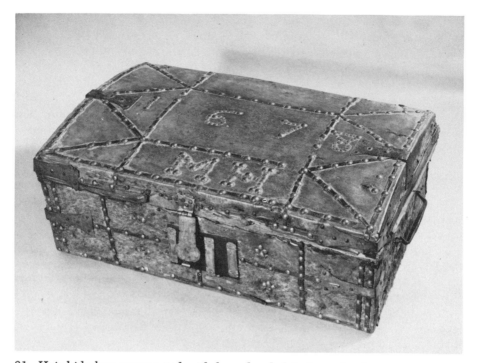

31. Hair-hide box ornamented with brass-headed tacks on leather strips. W. 22". Elaborate iron lock and reinforcing corner pieces. Initials *M H* and date *1678* on the cover. (Courtesy Essex Institute, Salem, Massachusetts)

consider as boxes include, "A small red trunk, half a crown," and "One small very old blacke truncke (calve skin)," that was listed in a Henrico County, Virginia, inventory of 1678.[2] Small children's trunks of box size were also prevalent during the eighteenth century.

A rare leather box surviving from the seventeenth century, initialed *M H* and dated *1678*, appears in figure 31. Made of hair hide, it is lined with block-printed paper overlaid with geometric designs. The leather industry supplied hides for many utilitarian purposes beyond that of trunks and boxes, including the making of shoes, coverings for chairs, bindings for books, and leather for fire buckets, saddles, harnesses, and countless other items.

Pioneer families often did their own tanning and currying, seasonal activities that processed the hides of farm cattle slaughtered for food. Eventually tanning was done by men who worked for the farmers on shares, and many little tanneries were to be found scattered throughout the countryside. Even on a small, local basis tanning was complicated, and variations in preparation were numerous, depending on the choice of each

individual. It was not until 1800 that the principles were entirely understood, when large plants with mechanical improvements gradually began to supply the commercial market on a wide scale.

The primary objective of tanning was to render the skins into a substance that would not decay and could be moistened or dried without becoming hard. The use of tanning pits was only one step in the long process required to convert hides into leather. Great vats were filled with an infusion of bark (usually of oak, but on occasion derived from other trees and plants) that was ground in water. Sometimes it took as long as a year before the hides could be stretched preparatory to currying. Currying involved additional soaking, scraping, paring, beating, and coloring to produce the finished product, and many different methods were used. Skins of domestic livestock such as lambs, sheep, goats, horses, and cattle were commonly utilized, together with seal, beaver, and other small animals. After processing was completed, the leather passed through the hands of the cutters and was finally sold to the manufacturers of commercial goods. Hides that retained their hair surfaces did not go through the entire tanning process.[3]

During the first half of the nineteenth century, ventures in hides constituted an important element in overseas trade, particularly with Africa, the West Indies, and South America. Spanish hides from Curaçao and Puerto Cabello were offered for sale in Perth Amboy, New Jersey, in 1806–1807, and from the cargo of the schooner *Rover* hides from Port-au-Prince were auctioned in 1823. Salted cowhides were arriving from Calcutta in 1825, and 1837 witnessed large importations from La Plata, Argentina, Chile, and Rio Grande and Pernambuco, Brazil. Into New England harbors sailed vessels returning from Buenos Aires, Argentina, Montevideo, Uruguay, and Martinique, whose cargoes included molasses, hides, horn, and beef. From the African coast came ivory, hides, and gum.

The Spanish tradition of boxes that combined hide with decoratively patterned leather lacing came to the American Southwest by way of Mexico in the late seventeenth century. Since that time hair trunks and boxes of all sizes, fitted with hand-forged latches of home manufacture, have continued to be made in virtually the same form for various domestic purposes. Once to be found in many old curiosity shops in southern Colorado and New Mexico, early specimens of this work are now seldom seen (fig. 32).

Sealskin trunks, both large and small, appear in American inventories from the seventeenth through the nineteenth century, early valuations ranging from 1 pound to 6 shillings. They were often cylindrical in form, and were used to carry personal belongings on long journeys. In the 1808 inventory of Solomon Ingraham of Norwich, Connecticut, "1 small seal

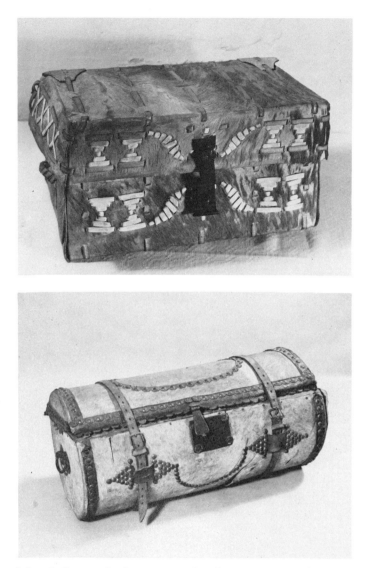

32. Box of deer hide stretched over a wooden frame. Nineteenth century. W. 15″. Leather lacings and hand-forged iron hasp. Deriving from Mexican prototypes, boxes of this kind have been made in the American Southwest for many generations.

33. Cylindrical hair-hide box originally owned by Richard Wheatland of Salem, Massachusetts. Early nineteenth century. W. 21″. Lined with newspaper dated 1818. This type of trunk was used for stagecoach travel. (Courtesy Essex Institute, Salem, Massachusetts)

skin Traveling Trunk" was listed at $1.50.[4] The trunk or box in figure 33 is embellished with brass tacks in a well-planned design and is fitted with iron bail handles. It was originally owned by Richard Wheatland of Salem and is lined with a newspaper dated *Boston, April 4, 1818.* A very rare miniature trunk, only 2 3/4 inches wide, is almost a counterpart of the above (fig. 34). This tiny receptacle (perhaps intended for snuff) is delicately ornamented with a silver key escutcheon and an oval plate bearing the engraved name *M. Dixon.*

Throughout the first fifty years of the 1800s, small rectangular leather trunks (or boxes) were manufactured in quantity, and although similar in shape, no two appear to be exactly alike. They are traditionally said to have been transported on the tops of coaches when the more perishable paper bandboxes were carried inside to rest on the owners' laps.

The majority of leather boxes were made of wood covered with dressed calfskin, and virtually all were decorated with multiple brass-headed tacks. An 1830 entry in the account book of Jonathan Loomis of Whately, Massachusetts, reads, "To a trunk trimmed—$1.34." [5] The most interesting features are the pictorial makers' labels that are fixed to the under-side of the covers as shown in figure 35. This particular card bears the name of John Smart, Sadler, Cap and Harness Maker, No. 162 Water Street, New York, who was only in business at that address during 1797 and 1798. Labels like this are historical documents in themselves, advertising not only numerous products of the leather industry but also illustrating actual samples of dealers' contemporary stocks in trade. Printed in

34. Miniature hair-hide box in cylindrical form. c. 1800. W. 2¾". Edged with bone. Silver escutcheon and plate engraved *M. Dixon.* The thimble is included to indicate relative size.

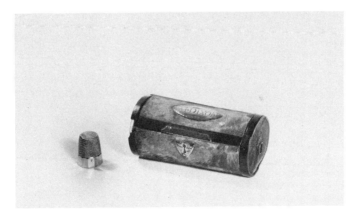

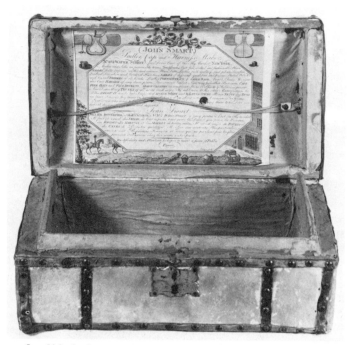

35. Untanned calf-hide box, with calf and sheepskin strips. New York City. Late eighteenth century. W. 13". John Smart, "Sadler, Cap and Harness Maker," kept shop at 162 Water Street only during 1797–1798.

both English and French, Smart's comprehensive label enumerates saddles, saddlebags, bridles, portmanteaus, harness of every description, leather caps, fire hats, fire buckets, horsewhips, walking sticks, and "trunks of all sorts and sizes." Saddles, whips, caps, a bucket, and four styles of leather trunks or boxes are pictured on the label, together with the shop doorway and display window (fig. 36).

Among the scores of harness makers in Boston, all of whom offered much the same type of goods, the name of James Boyd stands out as one of the most prominent dealers in the city. His shop was listed from 1830 to 1836 at 27 Merchants Row. Figure 37 illustrates two of his leather boxes. Shown on the left is a particularly handsome specimen decorated with tacks and brass plates, and bearing the label in figure 38 printed by the Pendleton firm, now considered to be the real founder of lithography in America. On the left in the label stands the old Quincy market with a harmonious granite warehouse on the right, the gable end of which carries a large signboard identifying the premises as "J. Boyd's Hose Factory." In 1825 Mayor Quincy instituted a progressive piece of city planning that provided Boston's Faneuil Hall with a fine new approach from the harbor. This important project, designed by the well-known architect Alexander

36. Label inside the cover of the box in figure 35. Printed in both French and English, it pictures John Smart's shop with saddles, whips, a fire bucket, and four styles of leather boxes.

37. Two leather boxes sold by James Boyd, Boston. W. left, 16¼"; right, 16". Typical of many boxes offered by numerous saddlers in the first half of the nineteenth century. Boyd's shop was at 27 Merchants Row, 1830–1836.

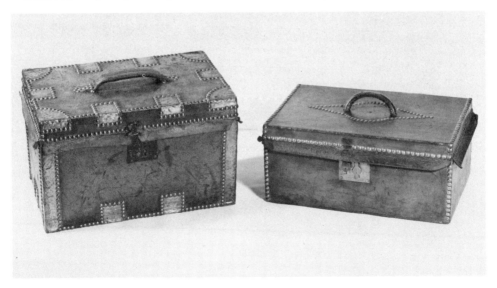

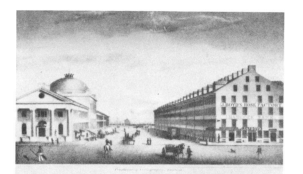

JAMES BOYD,

SADDLER,

NO. 27 MERCHANTS ROW, BOSTON.

Manufacturer of **ENGINE HOSE, FIRE CAPS** and **BUCKETS,**
MOLASSES & **OIL HOSE** for Ships use. NAVAL GUNNERY
and **MILITARY EQUIPMENTS,** Travelling and Common **TRUNKS,**
VALISES, Carpet Bags, Hat Cases, Truck, Cart and Waggon
HARNESSES.

Merchants who ship Saddlery and those who purchase for the Western
Market, can have their orders executed promptly & at the lowest prices.

38. Label of box at left in figure 37, picturing Boston's old Quincy Market on the left. A signboard lettered *J. Boyd's Hose Factory* is affixed to the gable of the warehouse at right. In this label Boyd advertised engine hose, military equipment, hat cases, and carpetbags!

39. Calfskin box by James Boyd & Sons, who continued at 27 Merchants Row until 1862. Late 1840s. W. 10″. This later example lacks the brass-tack trimming seen on earlier pieces. (Collection of Richard Merrill)

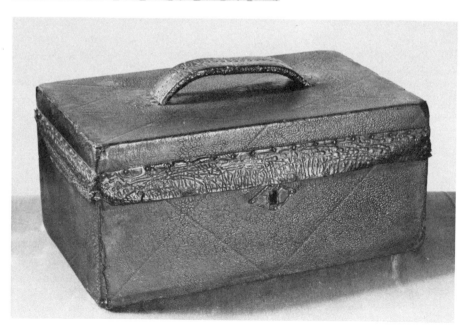

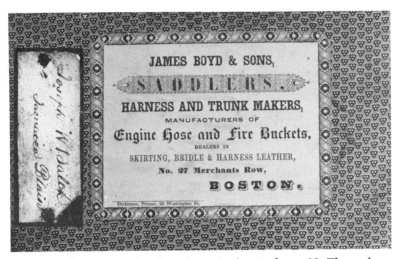

40. Later label of James Boyd & Sons from the box in figure 39. The early owner's name, Joseph W. Balch of Jamaica Plain, is seen at left. (Collection of Richard Merrill)

Parris, involved the filling of old land on the waterfront, and the creation of the domed granite market house and flanking warehouses on North and South Market streets. Fortunately, the handsome buildings shown on the early Boyd label still remain and have now been restored to commercial and special community uses.

By 1839 James Boyd had taken his two sons Francis and James P. into the business, which continued at the same address until 1862. The box in figure 39 was made by them, probably in the late 1840s, and bears yet another style of printed label (fig. 40). Joseph W. Balch, the owner, whose handwritten name is seen at left, was in the insurance business and lived in Jamaica Plain, a suburb of Boston.

NOTES

1. Seth Bryant, *Shoe and Leather Trade of the Last Hundred Years* (Boston, 1891).

2. Esther Singleton, *Furniture of Our Forefathers* (New York: Doubleday, Page, 1900), vol. 1, p. 54.

3. Harry B. Weiss and Grace M. Weiss, *Early Tanning and Currying in New Jersey* (Trenton: New Jersey Agricultural Society, 1951).

4. Phyllis Kihn, "Captain Solomon Ingraham," *Connecticut Historical Society Bulletin* (January 1964), p. 26.

5. Account book of Jonathan G. Loomis, joiner—painter, of Whately, Massachusetts, 1821–1839 (unpublished MS).

Crafted by American Indians

To what degree individual seventeenth-century English settlers fraternized with the Indians still remains a matter of conjecture. Also uncertain is the extent to which they used Indian-made domestic utensils. But at least one pertinent reference to this practice has survived, contained in the inventory of Mrs. Phebe Eaton of Haverhill, Massachusetts. Recorded in her estate in 1673 was an "Indyan boxe, 2 earthen pots, 2 shillings." [1] What was the appearance of the "boxe"? It is interesting to speculate that it might have resembled in form and workmanship the illustration in figure 41, as family tradition places this example in 1676, just three years later than the taking of the Eaton inventory.

Here we see a large, oval container of elm bark with split-root lacing and "bent wood" top. The shape and construction are traditional forms used by the Indians of New England and eastern Canada from very early times

41. Elm-bark box with split-root binding. W. 15⅞". An old handwritten label states that it was left behind by the Indians after the raid on Medfield, Massachusetts, in 1676. The incised patterns are accentuated by the use of a black pigment. The shape and construction are traditional features of Indian workmanship in eastern Maine and the Maritime Provinces of Canada.

42. Box of bark. Possibly mid-eighteenth century. W. 14½". An incised design of flowering vines is painted in light colors on a black background. (Courtesy Essex Institute, Salem, Massachusetts)

until the nineteenth century. Decorative patterns of a similar type were accomplished by scraping through the outer surface to a layer of bark below, thereby obtaining designs in two contrasting colors. This piece, however, exhibits two unusual features: black pigment was used to accentuate the major elements of the pattern and, contrary to custom, the cover was left undecorated. Well-documented examples of Indian boxes dating before 1800 are extremely rare, making comparisons inconclusive, but there is nothing in the decoration or construction of this box that is inconsistent with a seventeenth-century date.[2] Moreover, documentation in the form of written tradition strengthens this exciting possibility.

A small slip of paper, of mid-nineteenth-century vintage, is pasted on the cover, bearing in writing, now almost illegible with age, the following: "This birch bark box was left behind by the Indians when they burnt the town of Medfield Mass Feb 21 1675. But one house left standing." The date 1675 is an inadvertent error, as this well-known raid in King Philip's War actually took place in 1676. An 1839 account describes the incident graphically in part as follows: "The destruction commenced at the east part of the town. Most of the houses and barns were consumed between the meeting house and the bridge leading to Medway. Nearly 50 buildings and two mills were destroyed."[3]

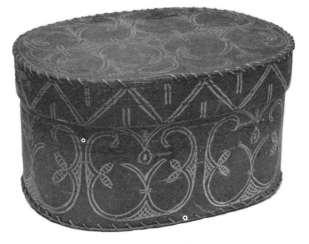

43. Birchbark box, Passamaquoddy. Nineteenth century. W. 11¼". Pale brick-red forms the background for carefully planned designs scratched through to a layer of bark beneath. (Courtesy The Peabody Museum of Salem, Massachusetts)

Belts of wampum woven with significant symbolic figures and signs were often used to record important happenings and to convey vital messages between the early Indian tribes. These revered tribal records were zealously preserved by succeeding generations and kept together in a traditional container such as a bag, basket, or birchbark box. The receptacle in figure 41 may well have held valuable inherited wampum pieces that would probably have been quickly dispersed if the box was left behind after the raid.[4]

Another interesting box (fig. 42) is owned by the Essex Institute in Salem and could date to pre-Revolutionary times when Dutch-type motifs spread through colonization up the Hudson River. The running heart-shaped flowers are incised and painted in light colors on a black-stained ground, but the provenance is unfortunately not known. Figure 43 presents a later example, probably nineteenth century in date. This is a product of the old Passamaquoddy tribe who still inhabit an area adjacent to Eastport, Maine. The pale brick-colored exterior derives from the use of the underside of the bark, the designs having been created by scratching through to a second layer beneath.

A further handcraft employed by the Indians was embroidery done with moose hair or porcupine quills. The use of moose hair as a substitute for silk thread seems to have been perfected by French Ursuline nuns in Quebec during the middle of the seventeenth century. The nuns learned Indian methods of preparing and dyeing the hair, but the needlework techniques and floral patterns later taught to the Indians in the eighteenth-century Canadian convents were European rather than Indian in origin.

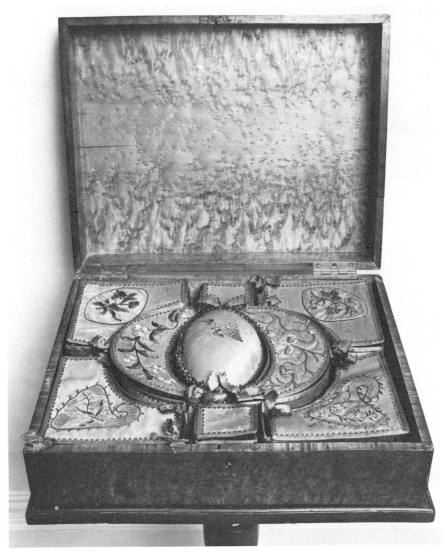

44. Bird's-eye maple sewing box with birchbark fittings. c. 1791. W. 17½″. Said to have been given to Mrs. Benedict Arnold by Elasaba of the Micmac tribe. The front and center covers are embroidered in silks. (Reproduced by permission of the American Museum in Britain, Bath)

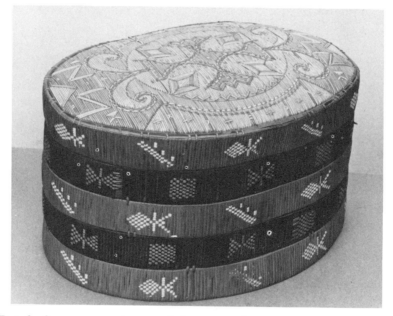

45. Detail of rear compartments of the sewing box in figure 44. The birchbark covers are embroidered in moose hair. (Reproduced by permission of the American Museum in Britain, Bath)

46. Box with a wooden bottom, and sides and top of bark. New England or Nova Scotia. Nineteenth century. W. 12⅜". The exterior is ornamented with horizontal bands of porcupine quills in light, medium, and dark brown and white. (Courtesy The Henry Francis du Pont Winterthur Museum, Winterthur, Delaware)

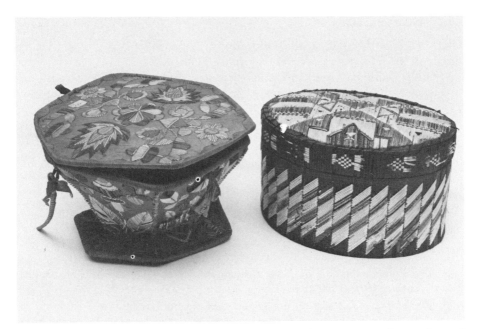

47. At right, birchbark box. Nineteenth century. W. 7½". Micmac tribe, traditional quillwork in blue, red, and cream. At left, hexagonal birchbark box on base with quillwork designs. W. 8". An example of Chippewa Indian work taught by New England missionaries near Lake Superior in 1831. (Courtesy The Peabody Museum of Salem, Massachusetts)

The piece in figure 44 is a good example of Indian stitchery applied to a sewing box of European form. Made of bird's-eye maple fitted with birchbark compartments, it is said to have been given to Mrs. Benedict Arnold in 1791 by Elasaba of the Micmac Indian tribe. Four of the covers and the center pincushion are embroidered in silks, but the floral sprays in the rear are worked in moose hair (fig. 45).[5]

The art of porcupine-quill ornamentation on garments and household objects was practiced throughout the woodland areas of the North American continent before the advent of the first European explorers. Dyes were obtained from natural sources such as local trees and plants, and abstract units arranged in geometrical sequence constitute many of the traditional patterns. The box in figure 46 is decorated in solid quillwork. It has a wooden bottom with bark top and sides, and the quills are colored in white with contrasting shades of brown.

A Micmac box of conventional Indian design appears at the right of figure 47, patterned in red, blue, and cream, it may date to the middle of the nineteenth century. When bark was used as a foundation, the quills

were applied through small perforations made by an awl, a procedure intended to hold them securely in place.[6]

Quills were also used to embellish boxes that were far less traditional in character. Floral patterns were first drawn on the background, then filled in with short sections of quills. This method left ample sections of the bark background visible, in the manner of contemporary needlework. The hexagonal box on the left of figure 47 is raised on its own base and betrays the influence of the white man. A long inscription in ink, affixed to the underside of the lid, gives its history, and affirms that it was completed under the tutelage of the Misses Boutwell and Hale, missionaries to the Chippewa Indians near Lake Huron, on August 5, 1831.

NOTES

1. *The Probate Records of Essex County, Massachusetts,* 1635–1681 (Salem: Essex Institute, 1916–1920), vol. 2, p. 343.

2. For opinions relating to the period and decoration of this box, I am indebted to Peter L. Corey, Director-Curator, Sheldon Jackson Museum, Sitka, Alaska; Ernest S. Dodge, Director, The Peabody Museum of Salem; William C. Sturtevant, Department of Anthropology, National Museum of Natural History, Washington, D.C.; and U. Vincent Wilcox, Curator, Museum of the American Indian, New York.

3. John Warner Barber, *Historical Collections Relating to the History and Antiquities of Every Town in Massachusetts* (Worcester: Dorr, Howland, 1839), p. 473.

4. For information on the early uses of wampum, I am indebted to Anne Molloy, author of *Wampum* (New York: Hastings House, 1977).

5. Margaret Swain, "Moose-Hair Embroidery on Birch Bark," *Antiques* (April 1975), pp. 726–729.

6. An informative section on quillwork is contained in Georgiana Brown Harbeson, *American Needlework* (New York: Bonanza Books, 1938), pp. 3–9.

For the Safekeeping of Money

Before the days of safe deposit boxes, money and valuables were kept at home and stored in special containers, some of which were hopefully secured by locks from tampering and theft. A Salem, Massachusetts, will of 1644 lists "A littell boxe with lock and key" worth 6 shillings. Currency when specified in wills was designated for the most part as "silver," "money," and half crowns, shillings, and pence. One John Harman was

fined in 1653 for stealing from a "round turned box of wood" the tidy sum of "ten pounds sterling in pieces of eight." There was another instance of pilfering in 1668 when a summons was issued by the Essex County Quarterly Courts for the stealing of 1 shilling from "a little box in which were kept four shillings, and two-pence and half a crown."

The box in figure 48 was obviously intended for a very special purpose and on the bottom is the scratched inscription: *W C 1765*. The sides are dovetailed, the outer surface is covered with the original coat of red paint, and the ends of the partitions are expertly shaped to fit into slots in the sides. No nails were used in the construction. A sum calcu-

48. Box traditionally said to have been used as a cashbox. W. 8". Inscription in ink reads in part *of Oakham, Massachusetts*. Two covers, one not shown, are held closed by wire hooks. *W C 1765* is carved on the bottom.

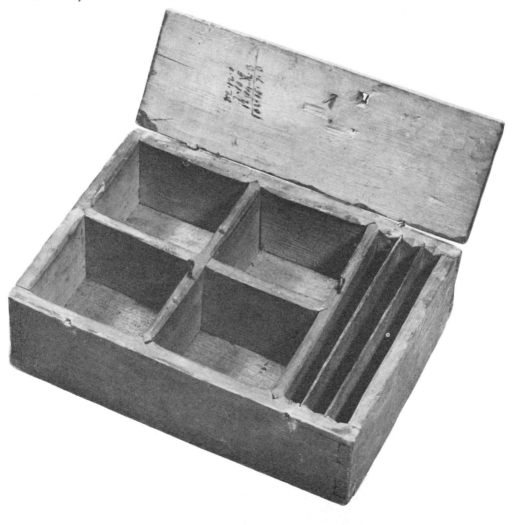

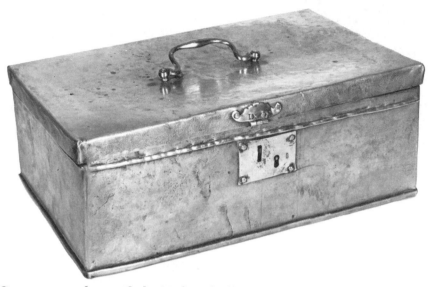

49. Copper money box made by Nathaniel Alley for Ebenezer Clough of Boston in 1819. W. 15⅛″. Clough was a well-known wallpaper manufacturer in the early nineteenth century, and after 1818 became a custom house officer.

lated in pounds, shillings, and pence is written in ink on the underside of one of the hinged covers because traditionally this was a cashbox with compartments for currency and slots for folded notes. On the underside of the second cover (not shown in fig. 48) an old inscription once contained further information but the ink has faded and is now unreadable except for the words ". . . of Oakham, Massachusetts." Whatever its history, the little box never moved far from home, for it remained in Oakham until the early 1940s.

Very different in character is the handsome copper box with brass handle and decorative lock (now broken) that is illustrated in figure 49. The original owner was Ebenezer Clough of Boston, and attached to the underside of the cover is a large card that reveals in his hand much pertinent information about his business ventures in the year 1819. In 1795 Clough had founded the Boston Paper Staining Manufactory, situated near the Charles River Bridge. His rare billhead, engraved by Samuel Hill, pictures three chronological steps in the making of early wallpapers —the mixing of the colors, the sizing of the paper, and the printing with hand blocks (fig. 50). Clough is well known because in 1800 he issued

50. Original bill of Ebenezer Clough dated 1808, showing various processes in the making of early wallpapers. (Courtesy American Antiquarian Society, Worcester, Massachusetts)

51. Document written by Ebenezer Clough attached to the inside cover of the box in figure 49, enumerating sums of money totaling $415 that were kept in the box in 1820.

one of the most important designs in the history of American paper hangings, which depicted the figures of Liberty and Justice standing beside an urn topped by an eagle, and inscribed on the base "Sacred to Washington." Among the few remaining fragments of this paper, one is illustrated in Nancy McClelland's *Historic Wall-Papers*.

As time went on, Clough's wallpaper business declined and he embraced other pursuits. In 1813, and for many years thereafter, the Boston street directories listed his vocation as "Custom House Officer." It was during this prosperous period that he evidently felt the need for a secure receptacle in which to keep what he had "saved, received and collected." From the document still remaining in the box (fig. 51), we learn the following facts concerning Clough's mercantile transactions: "Boston Jan^y 1^st 1820 This day I got Mr. Nath^l Alley the coppersmith to make me this Trunk gave him $8.25 for it." The fact that Clough's father, John, had followed the craft of brazier in Boston may suggest a reason for the son's choice of a heavy metal container in which to keep his valuables. In the "trunk," on January 8, Clough placed American Eagle coins and Spanish milled dollars in the amount of $415. This sum had accumulated in 1819 from various unusual sources that included "prize Money" for "Rum Seized at Spear Wharfe and at the South End"; for earnings as "Measurer of Salt and Coal"; "as a Witness for Attending the Circit Court"; and "as premium for Exchanging Boston Money into Foreign Money." By adding the sum of $5.00 saved from each month's wages, Clough was able to write at the bottom of the accounting: "Very Good Doings for this Year May I do as well the next."

Wealthy merchants were not the only persons who had need of special containers in which to keep their cash. To encourage juvenile thrift, parents often cut convenient slots in the lids of pantry boxes. Larger coin boxes, cleverly disguised as models of English Regency houses, were brought back from foreign travel in the mid-nineteenth century. All these money-saving devices were forerunners of the cast-iron mechanical banks that were to proliferate during the last quarter of the nineteenth century.

Occasionally a young lady would fabricate her own bank, lavishing on it the time and attention usually expended on the embellishment of more traditional household items. The refreshingly original concept pictured in plate 13 is titled *MARY F. KELLEY SAVING'S BANK*, leaving no doubt as to its intended purpose. Fashioned of pine with wallpaper lining, it dates to around 1830. The cover has a slot for coins and the exterior surface is divided into ten sections formed by narrow molded wooden strips. Each section encloses a paper panel painted with gay watercolor

52. Shelf of boxes in the form of books. Nineteenth century. The stone book-shaped piece is third from the right on the bottom shelf. The smaller box on the center shelf bears the carved title *PSALMODY*.

designs and covered with thin old glass that has served to protect the brightness of the colors. A perky young couple is depicted on the front and the ends. Do the figures represent Mary Kelley and her future husband?

Made in the Form of Books

Various objects simulating the appearance of bound books have for many

53. Book made of Barre, Vermont, marble by George Boardman Merrill. c. 1860. H. 3½″. Merrill was apprenticed to his brother in the monument business and made this piece as an apprentice exercise. (Collection of Richard Merrill)

years provided a fascinating element in American decorative arts. Pieces in this form were fashioned of various materials, including wood, stone, and pottery. During the early twentieth century sections of genuine book pages were hollowed out inside their bindings to create decorative receptacles for cigarettes and other accessories placed on a library table.

A bill of sale headed "Fenton's Patent Flint Enamel Ware Manufactured in Bennington, Vermont . . . " lists *book bottles* among the factory's output in July of 1853. The design is attributed to the English potter Daniel Greatbach who came to Bennington as a modeler in 1852.[1] These cleverly simulated ceramic volumes bore such humorous titles as *Ladies' Companion* and *Departed Spirits*. Although strictly speaking they were not boxes, they emphasize the popular appeal of the book form in nineteenth-century domestic arts.

Seventy-five years earlier, on a Sunday in July 1775, the home of one Richard Cornish of New York City was broken into and sundry valuable articles were stolen, such as silver shoe and knee buckles, a silver punch ladle, and several initialed teaspoons. The most unusual item, however, was "a stone box in the form of a prayer book."[2] Seemingly an

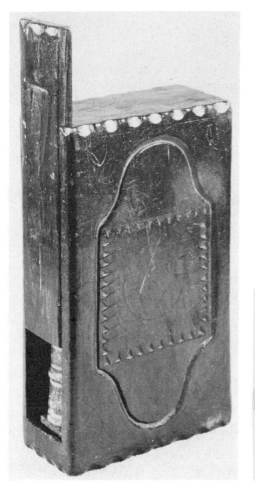

54. Walnut box containing an early prayer book. H. 7⅜". The shape of the carved design suggests mirror frames of the eighteenth century.

55. Chip-carved box, unpainted. Dated 1809. W. 3½". An early example, perhaps European in origin.

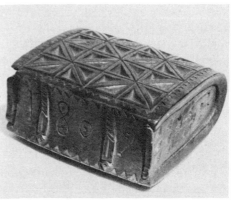

unlikely substance from which to fashion a box, stone was actually used for various household objects made in the shape of books. In figure 52 an old soapstone "book" stands third from right on the lower shelf. It is heavy, and may have been used as a doorstop.

The stylish example in figure 53 (perhaps a paperweight) was made by George Boardman Merrill who was born in 1848 in Laconia, New Hampshire. When a young boy in the late 1850s, Merrill was apprenticed to his brother in the marble and monument business and is said to have made this book as an apprentice exercise. He is reputed to have been embarrassed in later years because he had unwittingly placed his initial on the back rather than on the front of the cover!

Book boxes made of wood are the type most frequently found today

and the previously quoted 1775 description, "Box in the form of a prayer book," not only described the shape of the box but also hints at the special function of some eighteenth- and nineteenth-century examples. The sliding cover of figure 54 reveals the backstrip of a small prayer book that still remains within. The wood is walnut, and the notch carving and double-crested rectangle are reminiscent of eighteenth-century workmanship and design.

The smaller box on the center shelf of figure 52 bears the pertinent designation *PSALMODY* with the owner's name, *S.A. Jones*. Recently a small group of mid-eighteenth-century Dutch colonial antiques was dispersed in London, among them a "small Bible box made in the shape of a book" that was auctioned for 380 pounds. American examples, somewhat later in date, are also occasionally found bearing the word *Bible* on the backstrip, and it seems probable that at least some book-form boxes were intended to hold a religious volume.

Figure 55 illustrates a good book box inscribed *1809*. As chip carving of comparable style was almost universal in origin, this box could be either an American or a Continental piece, but the date emphasizes the fact that the book-shaped box has been made over a long period of time.

In New England today, however, all book boxes whatever their age, origin, or original purpose are categorized as containers for spruce gum that date to the late nineteenth or early twentieth century. This substance, as its name implies, was the pitch that exuded from a bruise or cut in the bark of the spruce tree. During cold weather it became hard and dry but softened to a pink chewing-gum consistency when in contact with the warmth of the tongue. Within recent memory it was successfully used in dental practice to protect abrasions of the mouth, and commercially prepared spruce gum may still be had at local shops in Maine.

Perpetuating a long stylistic tradition, spruce-gum boxes comprise a specialized group. Created as a leisure time activity by loggers in the large lumber camps of northern Vermont, New Hampshire, Maine, and New Brunswick, most were made during the fifty years between about 1870 and the 1920s. Originally intended as containers for spruce gum collected by the woodsmen, some were eventually sold for trifling sums or, more frequently, given to sweethearts and wives for domestic use or as keepsakes of sentimental value. Two characteristics are commonly found: the boxes were almost invariably hollowed out of a single piece of soft wood, usually spruce or pine, and the narrow sliding covers were formed by either the ends or the spines of the simulated volumes. This typical construction must have rendered access to the contents particularly inconvenient.

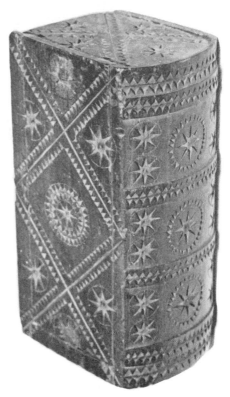

57. Book box with raised ribs on the spine. Nineteenth century. W. 7⁷⁄₁₆″. Red background with decoration in black and cream. The simulated page ends are marbled in red and cream. (Courtesy The Henry Francis du Pont Winterthur Museum, Winterthur, Delaware)

56. Spruce-gum box, unpainted. Nineteenth century. H. 5″. The intricate chip-carved designs betray the hand of an experienced carver.

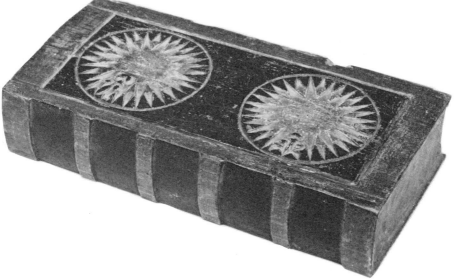

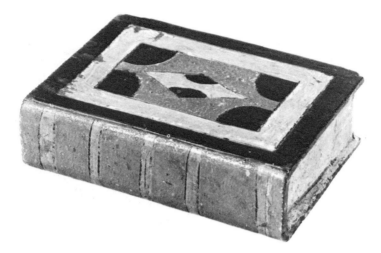

58. Spruce-gum box. Nineteenth century. W. 4½". Painted in shades of black and cream on a deep rose ground.

Because they were personal expressions of craftsmanship, no two spruce-gum boxes are exactly alike, and their ornamentation attests to the varying degrees of skill and ingenuity displayed by the individual maker. A small group of representative examples, several previously referred to, appears in figure 52. Among those on the lower shelf are three wooden boxes, either painted or in natural finish, whose ribbed backstrips simulate leather bindings. A great variety were intricately chip-carved with stars and serrated circles, as shown on the unpainted specimen in figure 56. Other pieces exhibit carved surfaces enhanced by means of contrasting paints. Figure 57 exhibits a red background, a black spine and panels, with radiants picked out in cream color. The edges of the simulated pages are curiously marbled in red and cream, and the interior is painted a bright red-pink. Less practiced carving is also seen, together with inlaid and painted designs that include diamonds, hearts, and initials, each expressing the personal taste of the maker. Figure 58 shows a naïve example colorfully decorated in mellow tones of deep rose, cream, and black.

NOTES

1. Lura Woodside Watkins, *Early New England Potters and Their Wares* (Cambridge: Harvard University Press, 1950), pp. 214–218.

2. *The New York Journal or General Advertiser*, August 3, 1775, as quoted in Rita Susswein Gottesman, comp., *The Arts and Crafts in New York, 1726–1776* (New York: The New-York Historical Society, 1938), pp. 82, 83.

59. Page from an English pattern book, watermarked 1824. Five sizes of straw splitters are pictured at the upper right. (Courtesy Essex Institute, Salem, Massachusetts)

With Designs and Pictures in Straw

Boxes decorated with straw marquetry have long been known in America, but having been considered foreign in origin, they have never been of particular interest to students of American decorative arts. It now appears, however, that items embellished with straw were made for various purposes, and imported for use in this country as early as the third quarter of the eighteenth century.

In 1764 "straw dressing boxes with private drawers" were to be found in New York City.[1] On November 8 of the same year Edmond Milne, goldsmith and jeweler of Philadelphia, advertised in the *Pennsylvania Journal* a very large and elegant assortment of articles imported from London that included enameled snuff and patch boxes, velvet and silk needle books, and paper, ivory, and straw toothpick cases.[2]

Preparing the material for this type of decoration was a tedious and painstaking process. Wheat or rye straw of the whitest, longest, and thinnest quality had to be gathered, split, bleached, and tested. Special implements for these purposes were made in Birmingham, England, from 1750 to 1850 and illustrated in priced pattern books used by salesmen to show to prospective customers. Several English pattern books, undated but containing paper watermarked 1824, are in the collection of the Essex Institute,

60. Sewing box owned by S. M. Goddard, born in 1811. W. 6½". The cupid with musical trophies was a favorite artistic device. The two homemade boxes of cardboard covered with straw fit inside the larger box. W. 2⅛". One is marked *needles*.

Salem, Massachusetts, and include a page illustrating, among other tools, the "best straw splitters," which were available in five sizes, priced from 16 shillings, 6 pence, to 10 shillings, 6 pence, per dozen (fig. 59).

Various workshops specializing in elegant strawwork advertised in Paris from the 1750s on. French prisoners confined in England during the Napoleonic Wars were responsible for many of the less sophisticated examples that, with other small items, they were allowed to make and sell for their own benefit at neighborhood fairs.[3] During the first half of the nineteenth century young ladies in England fashioned straw pictures as a pleasant pastime, some of which exhibit the naïve quality of American folk art. In professional work the varicolored strips were glued to small sheets of paper backing. These were then cut up in desired lengths according to color and pasted, following a prearranged pattern, to the body of the article to be decorated. In amateur items the straw was glued directly to a wood, papier-mâché, or cardboard surface. Victorian times witnessed the springing up of a brisk commercial market dealing in straw-decorated souvenirs.

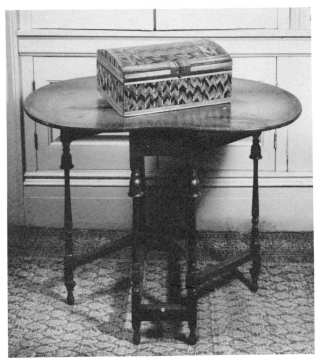

61. Wooden box covered with straw, flame-stitch design in black and brown. c. 1830. W. 12¼″. Used to hold painting equipment by Mary Nettleton who moved from Connecticut to Ohio in 1839.

European straw-veneered pieces were elaborately patterned and included writing, dressing, and bon-bon boxes, some with decoration imitating Chinese flowers and ornaments. Examples used in America, however, were less sophisticated in design. Two small homemade boxes, one marked *needles*, were found in the early nineteenth-century sewing box shown in figure 60.

The wooden, dome-top box in figure 61 is decorated in black and two shades of brown to simulate flame stitching. It was used to hold the pigments, brushes, and theorem patterns of Mary Nettleton who was born in Bethany, Connecticut, in 1818 and studied art at Wesleyan Academy at Wilbraham, Massachusetts, in 1834. Mary married and moved West in 1839, and there, stored in her farm home in Portage County, Ohio, the box and its contents remained undisturbed for almost one hundred and twenty-five years.[4] Two other straw boxes used by Mary descended with the Nettleton box, the larger of which is dated 1816.

Another box, also decorated in flame stitching in shades of green, red, and brown, is illustrated in figure 62. Made of papier-mâché, the interior

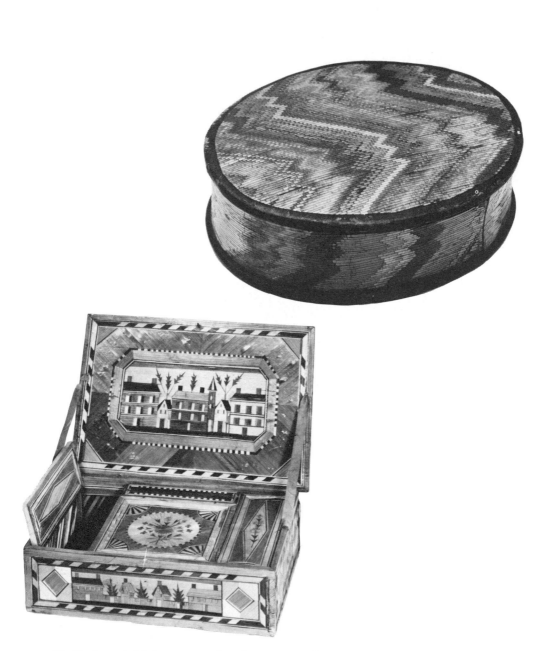

62. Papier-mâché box covered with straw. Eighteenth century. W. 3¼″. Flame-stitch pattern in red, brown, and green. (Courtesy The Henry Francis du Pont Winterthur Museum, Winterthur, Delaware)

63. Workbox of wood covered with straw. c. 1800. W. 10″. Probably imported from England or France. The cleverly executed scenes add variety and interest.

is lined with an early block-stamped paper with a floral design in red, green, and yellow printed on a white background. This piece is believed to be eighteenth-century in date and may be of English workmanship.

Considering the limitations of the material, it is amazing what a delightful variety of borders, patterns, and scenes were featured on boxes and other accessories. The workbox in figure 63 is an excellent example that combines fan and flower motifs in the Adam style with groups of prim little houses set off by stylized trees. Straw boxes presented very delicate surfaces that were particularly susceptible to dust and wear, so relatively few have survived in pristine condition.

NOTES

1. Esther Singleton, *The Furniture of Our Forefathers* (New York: Double-day, Page, 1900), vol. 1, p. 301.

2. Quoted in Alfred Coxe Prime, *The Arts and Crafts in Philadelphia, Maryland, and South Carolina, 1721–1785* (Topsfield, Mass.: The Wayside Press for the Walpole Society, 1929), p. 81.

3. Two informative articles on strawwork have appeared in *Antiques* (November 1923), p. 213; and (September 1933), p. 109.

4. The contents of this box are discussed and illustrated in the section "Artists' Pencils, Brushes, and Colors."

2. Boxes for Personal Use

For Toilet Articles and Trinkets

Dressing boxes (or toilet cases as they were sometimes called) were very much a part of the seventeenth- and early eighteenth-century domestic scene. They were owned by both men and women and contained, as the name implies, objects of a personal nature, either toilet articles or small accessories connected with the wardrobe. The third edition of *The Shorter Oxford English Dictionary* defines the uses of the word *toilet* as: "The articles required or used in dressing; the furniture of the toilet-table; a case containing these, 1662."

In 1742 the estate of Peter Faneuil of Boston (for whom Faneuil Hall was named) contained a useful list enumerating the late owner's toilet case and its contents. This comprised six razors, strop and hone, a pair of scissors, penknife, two bottles, and a looking glass, all silver-mounted.[1]

Dressing boxes appear most frequently in the inventories of wealthy citizens such as William Cox, prominent New York merchant, whose box was listed in 1689 in his widow's chamber, indicating its use by her. The famous Captain Kidd, who died in 1692, acquired two dressing boxes through marriage with Sarah, widow of John Ort. John Mico and Mrs. Mary Blair, both citizens of Boston, owned dressing boxes at the time of their deaths in 1718 and 1728 respectively. These pieces as one would expect, were listed in the best chambers. Sometimes, as in the case of Sir William Phipps, governor of Massachusetts in 1696, dressing boxes were to be found in "my lady's chamber."

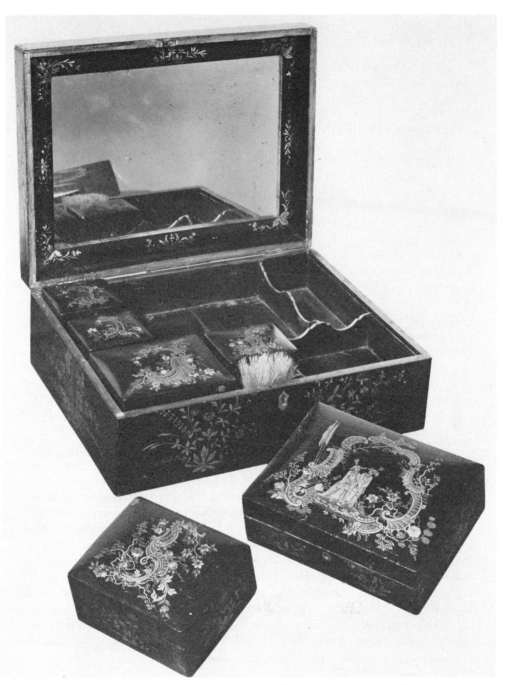

64. English dressing box. c. 1735. W. 14". Gold japanning on a black ground. A "Gilt" box was recorded in a Massachusetts estate in 1682. (Collection of Benjamin Ginsburg)

Rural, as contrasted with urban, inventories reveal few dressing boxes, suggesting that they were primarily furnishings of sophisticated households that were influenced by contemporary English fashion. However, John Bowles, [Gent.] late of Roxbury, Massachusetts, owned a dressing box in 1691 valued at the goodly sum for the period of 2 pounds 10 shillings.[2]

As early as the 1680s boxes from the Orient brought by way of England were arriving in the Colonies. "India dressing boxes" could still be purchased in New York in 1759 and "straw dressing boxes with private drawers" were also available to the well-to-do in 1764.

Few seventeenth-century dressing boxes used in America have been identified, but "one gilt box" owned by Moses Pearce of Ipswich, Massachusetts, and referred to in 1682, may have borne some resemblance to the English example of around 1735 illustrated in figure 64. Gilt boxes when mentioned in estates could have referred to those japanned in gold on a black or colored ground, a decorative finish popular in both England and America from the late seventeenth to the mid-eighteenth century. Japanning was an Occidental imitation of Asian lacquer work. In England the wood was first treated with a mixture of whiting and size, then covered with numerous coats of varnish, to be finally ornamented with raised gesso decoration, usually in Oriental designs. In America this process was often simplified by eliminating the gessolike base and applying instead clear varnish over the coats of base paint.[3] The japanned piece in figure 64 has compartments fitted with separate boxes for toilet articles, and exemplifies the type of toilet cases that were admired and used in America.

The early eighteenth-century American box in figure 65 (and similar ones of small size) may well have served as informal dressing boxes accommodating toiletries or "gewgaws." Although not fitted with compartments, this piece is hardly large enough for the storage of books or linen, and the absence of a lock minimizes the likelihood of valuable contents. Yet it would have rested conveniently on the top of a chest or table. The inventory of Isaac Fitch, master joiner of Lebanon, Connecticut, taken in 1791, lists "a small oak Box, 1/0."[4] Although this may have been made by the joiner himself, the minimal price combined with the mention of oak wood tempt one to wonder if it was an inherited item that might once have served as a country dressing box.

During the second quarter of the eighteenth century outdated dressing boxes began to disappear from high-style households to be gradually supplanted by ornamental "dressing glasses" fitted with small drawers below.

By the late eighteenth century "toilet" or "trinket" boxes made their appearance in less formal homes. Many attractive examples were used on

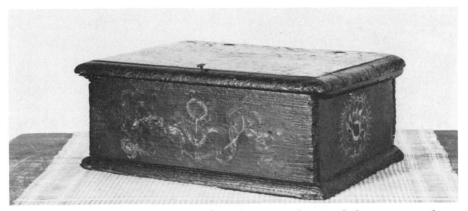

65. Pine and chestnut box with a cleated cover and painted decoration on front and ends. First half eighteenth century. W. 13¼″. The small size suggests it was used as a toilet or trinket box.

dressing tables or Federal-style chests of drawers, and their popularity continued well into the Victorian era. The word *trinket* is still in everyday use, connoting as it did two hundred years ago "a small ornament, usually an article of jewelry for personal adornment." In the nineteenth century a young lady's trinkets might have included chains, beads, buckles, ribbons, and other small oddments of everyday attire. The charm bracelet is a good twentieth-century example.

Countless newspaper advertisements from 1765 onward prove that in the eighteenth century trinkets were small, decorative pendants made of metal—either pinchbeck, silver, or gold. Pinchbeck was a cheap imitation of gold, commonly referred to as "gilt," that was invented by Christopher Pinchbeck, an English watchmaker who died in 1732.

On July 23, 1770, one Isaac Heron inserted a notice in the *New York Gazette and the Weekly Mercury* that gives a good idea of typical merchandise being advertised prior to the Revolutionary War. He offered for sale clocks, watches, seals, chains, keys, and trinkets, also earrings, lockets, buttons, and plated buckles. Seals, watch keys, and trinkets appear together in many advertisements, sometimes designated as pendants for gentlemen's watch chains. One merchant offered ladies' gilt trinkets to be sold on cards. A large amount of inexpensive jewelry and other metal goods were noted as importations from Birmingham, Liverpool, Sheffield, and London, as well as from Paris and Hamburg.

Trinket boxes were very special items. Silas Ball, of Townshend, Vermont, entered in his account book in 1806, "To making a trinket box, 8 shillings." For a full-size coffin with glass in the lid, he charged but 2 shillings more.[5] A fine example, perhaps professionally made, may be seen

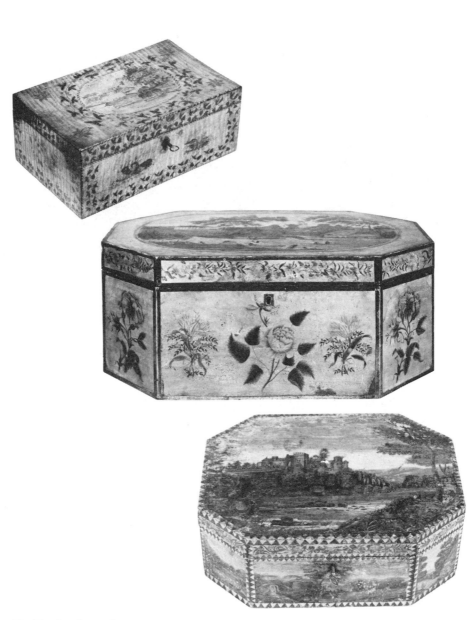

66. Trinket box of satinwood with painted decoration. c. 1810. W. 13″. A handsome piece, probably professionally made. Lined with blue-painted paper.

67. Octagonal box of wood covered with paper. c. 1820. W. 16¾″. Panels of flower sprays are edged with applied gilt strips. The interior is lined with orange-painted paper. (Abby Aldrich Rockefeller Folk Art Center, Williamsburg, Virginia)

68. Trinket box, with scenic decoration painted directly on the wood. 1815–1820. W. 11″.

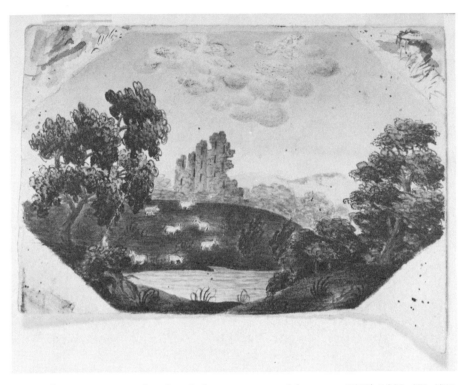

69. Preliminary watercolor sketch for an octagonal box top. 1815–1820. W. 5½″. One of a number of designs for furniture decoration from Newburyport, Massachusetts.

in figure 66. Skillfully embellished with landscape and flower designs on satinwood, it is tastefully lined with paper of a bright robin's-egg blue. The majority of nineteenth-century trinket boxes, however, were decorated by young ladies for their own use, and many were shaped in octagonal form. The surfaces of some, such as that in figure 67 and plate 14, were first covered with good-quality paper and then painted with naïve landscapes and floral sprays. Others (fig. 68) were painted directly on the wood, their picturesque scenic designs deriving in large part from drawing instruction books, many of the illustrations originally coming from various English publications. Certain academies taught their pupils how to draw practice compositions of landscapes, flowers, fruits, and shells, eventually to be copied and applied as decoration on household furnishings. A preliminary sketch drawn by a young lady from Newburyport, Massachusetts, appears in figure 69. Octagonal in outline, this bucolic composition with

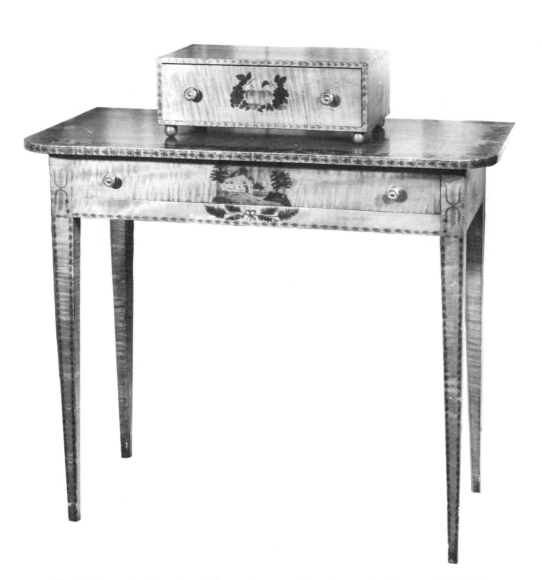

70. Curly-maple dressing table and a matching box with drawer. 1800–1820.
W. of box 14⅞". Decorated by Sarah Bass Foster of Littleton, Massachusetts. Fruit
motif with a band of painted inlay.

sheep and a ruined castle was evidently painted as a sketch for the top
of an intended box.

At times dressing tables were accompanied by matching boxes, al-
though many of these combinations have become separated over the years.
Figure 70 illustrates companion pieces decorated by Miss Sarah Bass

Foster of Littleton, Massachusetts, between 1810 and 1820. House and fruit designs typical of the period are enhanced by painted bands of simulated inlay.

A very unusual group of toilet boxes dating to the second quarter of the nineteenth century has come to attention within the last three years, although two have been owned by the Abby Aldrich Rockefeller Folk Art Center and Old Sturbridge Village since the 1950s. Comprising six closely related examples, they also include several other boxes with quite similar characteristics. All of the first group are made of wood covered with paper, which serves as a background for watercolor drawings of various stylized buildings that do not resemble actual scenes but give the appearance of architectural renderings. Each is enclosed by a border of colored blocks or squares (pl. 15).

Written in flowing script within rectangles on the backs of five boxes are inscriptions that name recipients and identify the presenter, who appears also to have been the artist. One typical inscription begins with a stanza credited to Alexander Goldsmith, titled "Friendship," and closes with the words "To Miss Emma J. Shurtleff. By Dan^l Evans/Augusta Me. 1839." Other names found in similar context include Clarissa Buckman, Climena Hallett, Joseph Grant, and Harriet Gray, all of whom were members of Augusta families.

Daniel Evans, Sr., was one of the early settlers of Hallowell, Maine, in 1793. His son, Daniel Evans II, appears in the Hallowell section of the federal censuses of 1820 and 1830, but by 1840 his name had disappeared from these records.

71. Paper-covered wooden box from Augusta, Maine. 1838–1840. W. 15½". Inscribed on back: *YOUNG LADY'S TOILET BOX*. The paper label on the bottom reads: "Made and painted for Mr./ Winslow of the Mansion/ House which is on the cover./ By Dan^l Evans, Jr." Unfortunately the cover is now missing. (Abby Aldrich Rockefeller Folk Art Center, Williamsburg, Virginia)

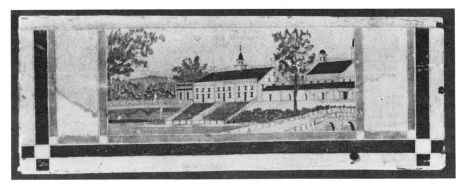

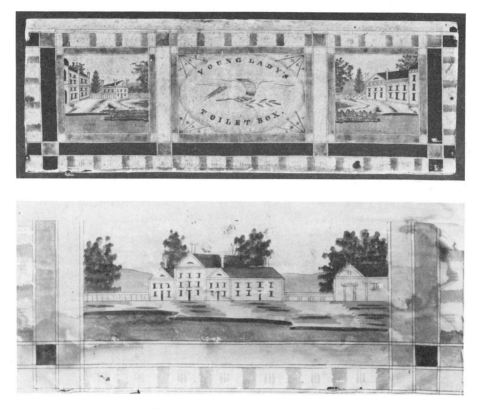

72. Back of the box in figure 71, showing Greek Revival buildings and the in-
scription as quoted. By Daniel Evans, Jr., Augusta, Maine. (Abby Aldrich Rocke-
feller Folk Art Center, Williamsburg, Virginia)

73. Toilet box with a view of a large house. W. 10⅜". The style of drawing is
typical of this artist's work. A stanza titled "Friendship" is written in ink on the
back and inscribed "To Miss Emma J. Shurtleff. By Danˡ Evans/ Augusta Me.
1839."

Whether Evans was an art instructor at one of the several private
academies in nearby Hallowell, an independent writing or drawing master,
or just a self-taught amateur is not now known, but his work exhibits a
considerable degree of proficiency. Some of the structures, such as that in
figure 71, suggest public buildings. This particular composition is repeated
on several occasions, among them on a box inscribed to Miss Climena Hallett
(married in Augusta in 1841) that is signed "Augusta Me. 15th Janʸ 1838.
By D. Evans." Most of the views, however, present country houses and
outbuildings, with architectural features typical of the Greek Revival styles

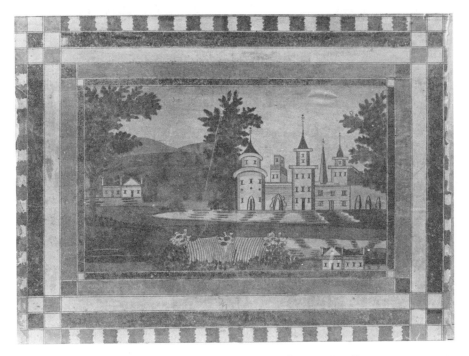

74. Cover of "Harriet Gray's Cap and Ruffle Box." W. 13¾". Written in script inside the cover is a stanza titled "Christ's Crucifixion," inscribed: "To Miss Harriet Gray, 1841/ by Isaac Shurtleff." The castle and waterfall suggest a drawing book source. (Old Sturbridge Village, Sturbridge, Massachusetts)

of the 1830s, as illustrated in figure 72. The structure with wings in figure 73 is pictured on the Emma Shurtleff box dated 1839.

The sources of the designs are of unusual interest but none is definitely identified at the present time, except the church building in plate 15 that presents the facade of St. John's Chapel built in 1807 on Varick Street, New York.[6] Subjects of the other scenes suggest derivation from printed prototypes, which might have been found in an architectural manual, a drawing instruction book, a volume of miscellaneous views, or other compendiums available in Augusta during the period in question. One picture alone, with turreted castle and waterfall (fig. 74), betrays the romantic theme of the English drawing books, the illustrations of which were intended to serve as models for aspiring amateurs.

The decorations on several other boxes closely connected with this group suggest that persons other than Daniel Evans may have been working in an almost identical manner. One is inscribed inside the cover to "Joseph Grant 1837 by H. D., Enfield," a town in Maine some forty miles northeast

of Augusta. Another is identified as a "Cap and Ruffle Box" and was presented to Miss Harriet Gray by Isaac Shurtleff in 1841. Shurtleff was an Augusta cabinetmaker, born in 1780, which raises the question whether he made the boxes that Evans decorated.[7] Two other known examples are painted directly on the wood, one of which exhibits two naïve small portraits on the inside of the cover within a characteristic border.

NOTES

1. Esther Singleton, *Furniture of Our Forefathers* (New York: Doubleday, Page, 1900), vol. 2, p. 383.

2. Abbott Lowell Cummings, *Rural Household Inventories* (Boston: The Society for the Preservation of New England Antiquities, 1964), p. 55.

3. Nancy A. Smith, *Old Furniture, Understanding the Craftsman's Art* (Boston: Little, Brown, 1975), p. 103.

4. William Lamson Warren, "Isaac Fitch of Lebanon, Master Joiner, 1734–1791," *The Connecticut Antiquarian* (December 1976), p. 24.

5. Account book of Silas Ball, Joiner, Townshend, Vermont, 1797–1808 (unpublished MS).

6. I am grateful to Earle G. Shettleworth, Jr., Director, Maine Historic Preservation Commission, for bringing the identity of St. John's Chapel to my attention.

7. For assistance in providing information on Daniel Evans II and Isaac Shurtleff, I am indebted to Edwin A. Churchill, Research Historian, Maine State Museum, Augusta.

Gentlemen's Shaving Equipment

Shaving equipment consisting of various combinations of toilet articles was usually part of the domestic furnishings of an eighteenth-century household. Shagreen cases complete with razors, hones, scissors, penknives, combs, bottles for oil, brushes, and soap were to be found in the homes of the well-to-do,[1] when more modest families owned shaving boxes that contained only one or two razors and a brush. A "Shaving Box & Raisors" was inventoried at 6 shillings in 1763 and curiously enough was located in the front parlor. By the early 1820s, according to an account book kept by one Philip Deland of West Brookfield, Massachusetts, "first rate shaving brushes" had risen in price to 50 cents for two, and shaving boxes to $1.35.[2]

In 1787 several brands of shaving soap, which included Naples, Windsor, and Bailey's, were being imported from England. Toilet articles were obviously valuable to their owners, as witness a notice of theft inserted in a New York City newspaper in 1777: "Stolen out of a room, a small red

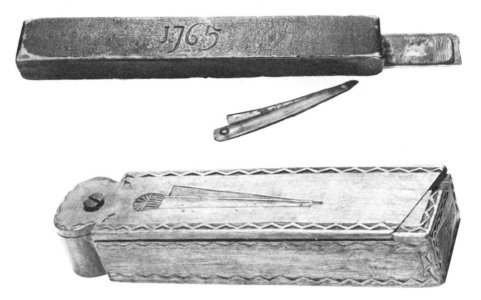

75. Razor box and folding razor, the box dated *1765*. W. 14″. Fashioned from one piece of pine with a sliding cover, the interior is shaped to accommodate two razors and perhaps a shaving brush.

76. Razor box with swivel cover. Early nineteenth century? W. 8¼″. Unusual features are the carved representations of a folding razor and a shaving brush. (Courtesy Essex Institute, Salem, Massachusetts)

leather trunk with several articles in it, particularly two razors, one marked Palmer, A pewter shaving box with soap. . . ." [3]

Of all shaving appurtenances razors seem to have been the most highly valued. Many were imported and bear the names of various well-known Sheffield firms. The earlier examples had long bone handles with a short, folding blade and carried the name of the maker stamped on the shank between blade and handle. Cases were made of shagreen or "fish skin" from the middle of the eighteenth century on, and cases of razors were appraised as high as 50 shillings in the inventory of one Dorchester, Massachusetts, merchant as early as 1732.

Wooden boxes with compartments especially made to accommodate one or more razors are occasionally to be found. "Razors very convenient

for travelling" were featured in Philadelphia in 1775 and a box fourteen inches wide and dated *1765* was intended for this purpose (fig. 75). Fashioned from a solid piece of pine, it contains one section shaped to hold two folding razors with a separate space at the other end, perhaps for a shaving brush. Two very worn strips of leather used as hones are attached inside the cover and along one side, and are secured by large rose-headed nails.

An important box in the collection of the Essex Institute, Salem, exhibits a cover that swivels on an early screw (fig. 76). The piece is nicely decorated with an incised border, and an interesting carved representation of a razor with folding blade adorns the top of the lid. The razor within appears to be original to the box and has a long bone handle, short steel blade, and the stamped mark of *Roberts Warranted*. An added feature is the picture of a shaving brush neatly carved on the end of the box.

NOTES

1. Abbott Lowell Cummings, ed., *Rural Household Inventories, 1675–1775* (Boston: The Society for the Preservation of New England Antiquities, 1964), p. 194.

2. Account book of Philip Deland, turner, carpenter, cabinetmaker of West Brookfield, Massachusetts, 1812–1846. MS, Old Sturbridge Village Research Library, Sturbridge, Massachusetts.

3. *New York Gazette and Weekly Mercury*, March 3, 1777, as quoted in Rita Susswein Gottesman, comp., *The Arts and Crafts in New York, 1777–1799* (New York: The New-York Historical Society, 1954), p. 108.

To Hold Spectacles

Visual aids in the form of spectacles were well known in Europe by the thirteenth century and have been a necessity in America since the arrival of the first settlers. Early lenses were not individually ground as they are today but were intended primarily for simple magnification. Farsighted persons, however, were helped by those of convex shape and others with myopic vision used concave.[1]

The boxes, or cases, in which spectacles were kept are frequently referred to in contemporary records and could have been purchased for the sum of 1 shilling in the shop of Captain Joseph Weld of Roxbury, Massachusetts, in 1646. Spectacle cases "guilt or unguilt" were included in a list of taxable articles established by the House of Parliament on June 24, 1660.[2]

In the eighteenth century many steel-rimmed eyeglasses were imported

77. Polished-steel spectacles case from Guilford, Connecticut. W. 5¼". Engraved on the cover: *Hannah Bond / 1799.*

from London and advertised for sale in the local press. Both "nose" and "temple" spectacles (the latter fitted with springs) were to be had in city shops, and were rated as either "common or best."

Silver rims, however, were valuable, as one may gather from the following notice that appeared in the *Boston Gazette* on November 6, 1758: "Lost on the 3d Instant, on the Road from Boston to Roxbury, a Pair of spectacles set in Silver, and Temple Springs, the maker's Name *Ribright,* engrav'd on them, the Case polish'd, and tip't with Silver. Whoever hath taken them up, and will bring them to the Printers hereof, shall be well rewarded." [3]

A polished-steel spectacles box is illustrated in figure 77. Engraved with the name of the owner, *Hannah Bond,* and the date *1799,* it was originally owned in Guilford, Connecticut, and is typical of the late eighteenth-century style. A similar example containing a pair of old-fashioned glasses may be seen in figure 78. Original linings of coarsely woven fabric are often found still intact, having evidently been intended as protective padding.

Handmade boxes were produced either locally or at home. Fashioned from a single piece of wood, the interiors were hollowed out to fit the exact size and shape of the spectacles to be accommodated. The cover of the box in figure 79 is embellished by a small incised border picked out in red that encloses the initials *S.J. 1792.* The front reads *S.J. August, 13, 1792.* The back is incised *M.* [ade]*By E. F. J.* The price was 3 shillings.

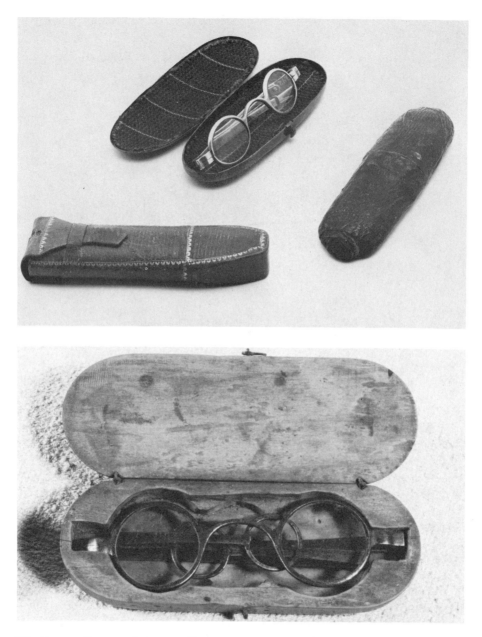

78. Group of spectacles cases. First quarter nineteenth century. Center, polished steel. W. 5"; left, red morocco labeled: "John Peirce Optician Gold & Silver spectacle manufr. No. 21 Marlboro St. Boston."; right, case is papier-mâché. (Old Sturbridge Village, Sturbridge, Massachusetts)

79. Wooden box made to fit the spectacles it contains. W. 5". Painted in red on

front: *S.J. August 13 1792*; on back: *M.[ade] BY E. F. J.*; on end: *PRICE* $\frac{s}{3}$.

By the end of the eighteenth century spectacles were being mounted in gold, silver, and tortoise shell in several different patterns and could be sent on order to "all parts of the continent." [4] More attention was also being paid to individual needs. "Achromatic" spectacles that gave images practically free from extraneous colors were advertised, and John Benson in New York announced in *The Daily Advertiser* for July 26, 1779: "The utility and blessing of spectacles are too well known to need any comment, and circumstance of person using glasses not adopted [*sic*] to the sight is one great reason why so many are afflicted with bad eyes." [5]

The nineteenth century saw a great profusion of eyeglass containers, which were made in many varieties of leather and papier-mâché (see fig. 78). The red morocco case at lower left carries an interesting label of around 1823 that reads: "John Peirce Optician Gold & Silver spectacle manuf[r]. No. 21 Marlboro St. Boston."

NOTES

1. *Encyclopaedia: or a Dictionary of Arts, Sciences, and Miscellaneous Literature* (Philadelphia: Thomas Dobson, 1798), vol. 17, p. 677, and vol. 13, p. 265.

2. George Francis Dow, *Every Day Life in the Massachusetts Bay Colony* (Boston: The Society for the Preservation of New England Antiquities, 1935), p. 247.

3. George Francis Dow, *The Arts & Crafts in New England, 1704–1775* (Topsfield, Mass.: The Wayside Press, 1927), p. 64.

4. Rita Susswein Gottesman, comp., *The Arts and Crafts in New York, 1777–1799* (New York: The New-York Historical Society, 1954), p. 80.

5. *Ibid.*, p. 79.

For Tobacco and Snuff

Tobacco was the earliest product to be raised in the Colonies and shipped to England with commercial success, having been first introduced into England from North America in the sixteenth century. Although initially acclaimed in Europe for its supposed medicinal qualities, smoking was strongly opposed by King James I in 1604, who considered it to be both dangerous and harmful. At one time the Great and General Court of Massachusetts also banned tobacco smoking at home or in public under penalty of a fine of 2 shillings and 6 pence.[1] Its popularity persisted, however, and is proved by the number and variety of smoking accessories that were produced and used in both Europe and America during the seventeenth and eighteenth centuries.

80. Brass tobacco box. Holland. D. 3½″. Engraved with emblem, mottoes, and the maker's name: *Balthasar Sierkost. fecit.* $\frac{5}{4}$ *1684.*

John Rolfe, the husband of Pocahontas, began to experiment with the cultivation of tobacco around 1612 and it soon became an important money crop. Fifty thousand pounds were shipped from Virginia in 1618, and this trade eventually brought a flourishing economy to the southern Colonies. Connecticut, later known for its production of fine wrapper leaf, was the only northern Colony to raise tobacco successfully on a large commercial scale. It was grown in East Windsor, Connecticut, as early as the second quarter of the seventeenth century. Early importers were glad to handle all of the crop that Americans were able to raise, but the peak of prosperity was reached about the middle of the eighteenth century because tobacco quickly depletes the soil, and by the time of the Revolution many growers were in debt to their British customers.[2]

Containers for tobacco fall into two groups, those of a size to be carried in the pocket and large receptacles intended to rest upon a table. Many boxes were made of metals such as pewter, brass, and copper, the majority of which were importations from England.

Odd combinations of household articles are sometimes found listed

together in inventories. In the estate of John Symonds of Salem, Massachusetts, in 1671, one finds a "dressed calf skin and 2 tobacco boxes 2 shillings for all." The example in figure 80 relates to this period. Made of brass with emblematic decoration, the cover is engraved in Dutch: "One will avoid ungrateful people." On the bottom appears the phrase: "A sweet

81. Group of smoking accessories. Eighteenth-century pipe tongs from Byfield, Massachusetts, and a late eighteenth-century long iron pipe. The grain-painted wooden tobacco box dates 1825–1840. Diam. 6¾".

82. Copper tobacco box, top and bottom of brass, with inscriptions in Dutch. W. 6″. Battle scene depicting a Prussian victory over the French, dated *Nov 1757.*

83. Bottom of the box in figure 82, picturing a naval victory of the English Admiral Osbourne over the French squadron of Monsieur Duquesne.

appearance a sweet deception" and the legend, *Balthasar Sierkost. fecit.* $\frac{5}{4}$ *1684.* Many receptacles for tobacco, such as this one, originated in Holland.

A tobacco box and tongs worth about 2 shillings were to be found in the lower room of one Daniel Howard in 1675. Howard was a blacksmith in the country town of Hingham, Massachusetts, and it is probable that he made the tongs himself for the purpose of extracting coals from the fire to light a long clay pipe. Figure 81 exhibits a pair of eighteenth-century iron

pipe tongs that descended in the Adams family of Byfield, Massachusetts. On the table rests a wooden grain-painted tobacco box dating to the first half of the nineteenth century. Leaning across it is an iron pipe of a type popular in the 1790s when they were made in the form of traditional clay pipes.

By the middle of the eighteenth century rectangular tobacco boxes, which carried inscriptions in Latin and Dutch, exhibited portraits of prominent personages and battle scenes. Typical examples were made of copper with tops and bottoms of brass. The piece in figure 82 descended in a Salem, Massachusetts, family and bears relief profiles titled King Frederick and Prince Henry of Prussia. Between them a vignette of a spirited battle scene represents the victory of the Prussians over the French at Rossbach and Merseburg, November 1757. The picture on the bottom of the box (fig. 83) is identified as a naval victory of the English Admiral Osbourne over the French squadron of Monsieur Dusquesne.[3]

Pinchbeck, an inexpensive alloy composed of copper and zinc, simulated the appearance of gold and was widely used in the eighteenth century for reasonably-priced jewelry and small ornamental objects. A gold-colored tobacco box, probably of brass or pinchbeck, appears in the 1789 portrait of James Reynolds of West Haven, Connecticut, and is seemingly typical of many to be found in America during the Revolutionary period (pl. 16). A rare example in gold by Charles Le Roux, New York, 1735, is in the collection of the Historical Society of Pennsylvania.[4] Silver tobacco boxes were also owned by the affluent and were often valued by weight. One of these weighing 1.3 ounces belonged to Colonel Robert Oliver of Dorchester, Massachusetts, and was in 1763 enumerated among sundry other valuable pieces of plate.

Particularly interesting are the boxes exhibiting "secret" combination locks controlled by four dials on the outer surface of the lid (fig. 84). When the two pointers and the rising sun at the top are all correctly set, the mechanism inside the cover interlocks and allows the crescent moon at bottom to slide upward, thereby releasing the catch that holds the cover closed (fig. 85). It comes as no surprise that this and other boxes with ingenious keyless locks were the work of expert watchmakers in Prescot, Lancashire, England. When deprived of their livelihood in the early 1820s by the introduction of machine-made tools for cutting watch parts, these craftsmen discovered a lucrative market by designing snuff- and tobacco boxes with lock controls reminiscent of the motifs painted on the dials of clocks.

Tobacco had other uses beyond that of smoking. One of the most popular was the manufacture of snuff, which derived from tobacco that

84. Brass tobacco box with a combination lock controlled by dials and the sun. c. 1820. Diam. 3½″. Boxes of this type were made by watchmakers in Lancashire, England.

85. Inside cover of the box in figure 84. When the exterior dials are correctly set, the center lever drops into slots in the three disks, as shown here, and the inner catch is thereby released. Descended in a family of which the members in each generation must discover the combination for themselves.

had been dried, grated, and sometimes perfumed. Snuffing was more fashionable than smoking, the accessories pertaining to it were more elegant and varied, and were made both here and abroad by the most skilled craftsmen of the period. A gold box dating 1730 to 1740 by Jacob Hurd, and engraved with the arms and crest of Lieutenant Governor William Dummer, is owned by the Museum of Fine Arts, Boston.

Early advertisements for the sale of snuffboxes are legion, the majority of sophisticated examples having been imported prior to 1800. One newspaper entry representative of many in the Revolutionary period advertised "Curious snuff boxes just arrived from London."

Snuffboxes were cherished by their owners, and in 1766 a distraught citizen inserted the following notice in the *New-York Mercury* of March 3: "Lost, or left on one of the Pews in the Presbyterian Meeting House, an oval Silver Snuff-Box, with a Mother-o'-pearl Top, marked with the Letters T.ᴳ· C." Five shillings reward was offered for the return of this precious possession.[5] Four years later the Hon. Andrew Belcher, Governor of the Massachusetts Bay Colony, owned two silver snuffboxes and a silver "Medell," valued together at 15 shillings.[6] Figure 86 illustrates an oval silver snuffbox, the lid engraved with a border of overlapping leaves that encloses scrolls and a bird with outspread wings. The maker is unknown, but inscribed on the bottom is the name *John Machett Januʳʸ, [sic] 23ʳᵈ,/ 1748/9.*[7]

86. Silver snuffbox. Boston. W. 3¹⁄₁₆″ Engraved on bottom: *John Machett Januʳʸ 23ʳᵈ,/ 1748/9.* (Courtesy Museum of Fine Arts, Boston; Mary L. Smith Fund)

87. Imported enamel snuffboxes. Second half eighteenth century. W. 2½"–3". Top center is probably French, with a stylishly dressed lady inside the cover; left, English with a fluted body and metal screw top; bottom center, Continental, with detailed plans of a battle between the Prussians and Austrians, October 1, 1756; right, dark blue background with an English village scene surrounded by raised gold ornamentation.

Prices of snuffboxes, in every conceivable material, were available to suit any purse. Noted among many eighteenth-century references were boxes of silver, gold, pewter, polished tin, enamel, ebony, leather, tortoise shell, ivory, horn, whalebone, and papier-mâché. Goldsmiths and jewelers stocked a mouthwatering array of personal accessories for both gentlemen and ladies during the years just prior to the Revolution. Advertised as "in the best and newest taste," many of the most elegant items came to the Colonies by way of London. In Philadelphia alone enameled snuffboxes were offered by several jewelers between 1764 and 1771. Rectangular, or occasionally oviform, in shape, they were decorated with charming painted designs and originated both on the Continent and in England at Battersea, Bilston, and other Staffordshire factories (fig. 87).

Tortoise-shell containers were particularly popular judging from the

shopkeepers' advertisements in the daily press, and the "reasonable rewards" posted for their return when lost. For persons in more modest circumstances, "Neat tortoise-shell snuff boxes" were imported from London and "sold cheap" in New York City in 1767.

Some boxes fashioned of tortoise shell (and others of gold, ivory, and papier-mâché) carried pictures on the lids that depicted ladies, children, or other subjects of special interest to the owner. A pair of such boxes, one with a silver rim, is illustrated in figure 88. They are decorated with named views of places in New York State. The one on the right presents a striking overlook on an *Indian Camp. Mohawk Country.* That on the left portrays Johnson Hall, once the home of Sir William Johnson. Johnson was a well-known pre-Revolutionary figure who was very prominent in Indian affairs, having been adopted by, and made sachem of, the Mohawk tribe. In 1744 he was named by Governor Clinton Superintendent of the affairs of the Six Nations (Iroquois), and later was influential in equipping the Indians for participation in the English warfare with French Canada. Johnson built

88. Pair of snuffboxes. Diam. 3¼". Left, mounted in silver and titled *1773 Sir William Johnson's House.* Johnson was prominent in Indian affairs in New York State. During the Revolution his Johnstown estate was confiscated and sold to an Albany merchant in 1785; right, view titled *1774 Indian Camp . Mohawk Country.*

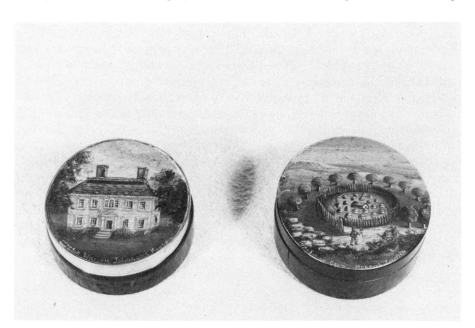

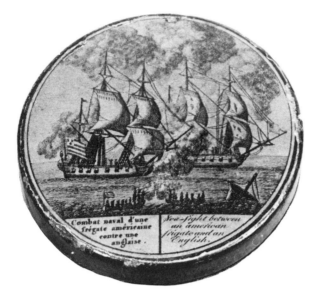

89. Papier-mâché snuffbox. First quarter nineteenth century. Diam. 3⅜". Typical of many pieces depicting naval engagements between the Americans and the English during the War of 1812.

this Georgian mansion on 100,000 acres of land granted him by the Crown. It still stands in Johnstown about thirty miles northwest of Schenectady and is now a historic site open to the public.

Papier-mâché, material made from paper pulp mixed with paste or glue and shaped by molding when wet, enjoyed a great vogue over a long period of time. It seldom suffered from serious cracking and was credited with keeping the contents cool and moist. A large group of papier-mâché snuffboxes calculated to appeal to the domestic market carried engraved scenes of American naval heroes and battles pertaining to the War of 1812. A typical example (fig. 89) is captioned "Sea-fight between an american [*sic*] frigate and an English" and is titled in both English and French.

During the later eighteenth century the thrilling sport of ballooning engendered much interest in America, France, and England following the pioneering ascent by the Montgolfier brothers in France in 1783. Other flights followed in rapid succession, and representations of balloon ascensions soon appeared in various types of decorative arts, many of them produced in England and France but shortly to be seen in the young Republic. Among other currently fashionable items were topical prints, souvenir plates, scenic mirror knobs, and pictorial snuffboxes.

Figure 90 illustrates a small selection of eighteenth-century balloon pieces. The papier-mâché snuffbox at lower left is probably of French manufacture, its cover gaily painted with a group of stylishly garbed white-

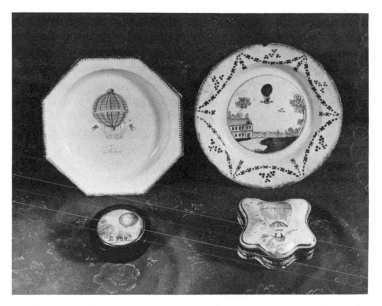

90. Group of imported pieces with balloon decoration. Late eighteenth century. The plates are of French creamware inscribed *adieu*, and English Lambeth delft. Lower left, French papier-mâché snuffbox, gentlemen with large balloon. Diam. 3½"; lower right, snuffbox inscribed *Blanchard 1784*. W. 4¼". Balloon souvenirs relating to Jean-Pierre Blanchard were especially popular in America because of his Philadelphia ascent in 1793.

wigged gentlemen clustered around the gondola of a large, circular balloon. Beside it is an enamel snuffbox that carries the name of *Blanchard* and the date *1784*. This design was intended to memorialize the first crossing of the English Channel by the Frenchman Jean-Pierre Blanchard, which did not actually take place until January 7, 1785. Blanchard's exploits were of particular interest to Americans because in 1793 he made the first aerial journey in America, lasting for forty-six minutes, from the yard of the old Washington Prison in Philadelphia, then the nation's capital. The earliest true aerial voyage in England had been accomplished by the Italian Vincenzo Lunardi in 1784, and because the second ascent took place near the Lambeth potteries in London, it is not surprising to find a floating balloon used as a decorative device on a few rare Lambeth delft plates and bowls (upper right, fig. 90). There was, unfortunately, another and less happy side to this exciting sport, which was thrust into the foreground by the first fatal air crash in France near Boulogne in 1785. The French creamware plate at top left perhaps commemorates this sad event with its wistful sentiment: *adieu*.

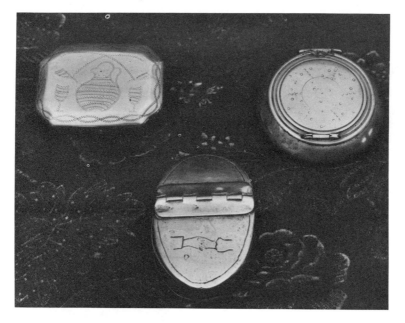

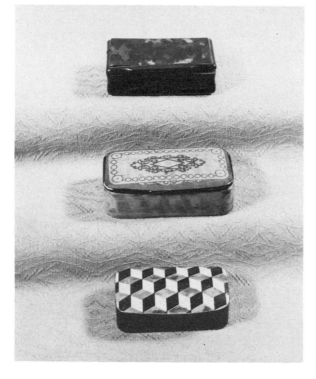

91. Three brass and copper snuffboxes. Eighteenth century. W. 2¾″–3″. At left, the wine jug, pipes, and glasses suggest conviviality; right, has two compartments for a miniature and snuff, date *1752* incised on the underside of the cover; center, clasped hands—the symbol of brotherhood.

92. Three papier-mâché snuffboxes. Early nineteenth century. W. 2½″–3″. Showing the variety of decoration found in this medium.

Figures 91 to 93 illustrate a few examples of the large variety of small boxes that are commonly believed to have been used for snuff. Little pocket receptacles that measured between two and three inches were equipped with tightly fitting covers to prevent the contents from sifting out when carried on the person. Figure 91 presents three metal containers of differing forms. The lid of the brass box at top left is appropriately engraved with convivial symbols consisting of pipes, glasses, and a jug. It snaps shut by means of a tiny, inner iron clasp released by pressure on an exterior button. The circular box at top right (also brass) has a double cover, each section of which is fitted with a separate hinge. Upon first opening, the upper space provides a flat surface for the insertion of a miniature. Beneath is a deeper compartment that held the snuff. The date *1752* is incised on the underside of the lid. The copper box below is engraved with a pair of clasped hands, the ubiquitous symbol of brotherhood.

Three nineteenth-century papier-mâché examples suggest the variety of decoration to be found in conjunction with this medium (fig. 92). One

93. Three snuffboxes of horn and wood. W. 2"½–3". The wooden base of the center box is carved *Thomas Cummons 1777*; bottom of left-hand piece is initialed *H A E 1819*; right, box of thinly shaved polished wood still retains remnants of snuff.

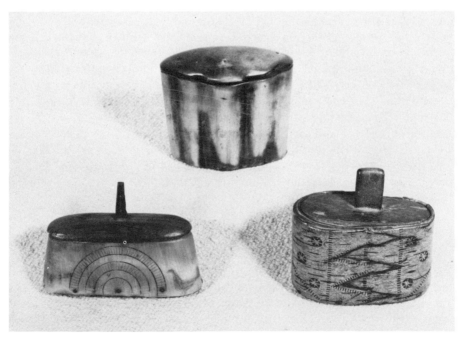

is embellished by a translucent piece of tortoise shell incorporated in the cover. The background of the second is delicately mottled in a rich shade of yellow, obviously to simulate the appearance of tiger maple, and the lid of the third is a clever imitation of raised blocks painted in brown, black, and cream.

Yet a third group of snuffboxes comprises examples of wood and horn, substances that served many useful purposes in the American home (fig. 93). This type was often fitted with inset tops and bottoms that provided excellent opportunities for personal identification. The wooden cover of the center box is neatly matched to the horn sides. The fitted base bears the carved inscription: *Thomas Cummons 1777.* The bottom of the left-hand piece is initialed *H A E 1819.* A box of similar style on the right is made of thinly shaved polished wood and still retains remnants of snuff.

NOTES

1. George Francis Dow, *Every Day Life in the Massachusetts Bay Colony* (Boston: The Society for the Preservation of New England Antiquities, 1935), p. 63.

2. Ruth Davidson, "Tobacco, the Crop That Saved a Colony," *Antiques* (January 1957), pp. 55–57. Wendell D. Garrett, "Paraphernalia of Smokers and Snuffers," *Antiques* (January 1968), pp. 104–108.

3. I am indebted to Karin Peltz, Museum of Fine Arts, Boston, for her kindness in translating the inscriptions on the two Dutch tobacco boxes and for informing me that the designs on the round one were associated with proverbs and relate directly to engravings by van de Venne, a seventeenth-century Dutch artist.

4. This box is illustrated in Martha Gandy Fales, *Early American Silver for the Cautious Collector* (New York: Funk & Wagnalls, 1970), p. 180.

5. Rita Susswein Gottesman, comp., *The Arts and Crafts in New York, 1726–1776* (New York: The New-York Historical Society, 1938), p. 78.

6. Abbott Lowell Cummings, *Rural Household Inventories, 1675–1755* (Boston: The Society for the Preservation of New England Antiquities, 1964), p. 242.

7. Kathryn C. Buhler, *American Silver 1655–1825 in the Museum of Fine Arts, Boston* (Boston: Museum of Fine Arts, 1972), p. 200.

For Patches or Beauty Spots

"Face patching" was a prerogative of the aristocracy in France and England during the seventeenth and eighteenth centuries, and patches of all sizes and shapes were carried in small boxes of silver, gold, ivory, enamel, and other costly materials. That the Colonial gentry quickly followed suit is

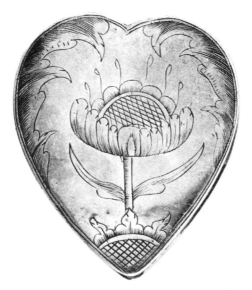

94. Silver patch box. American. 1720–1750. H. 1⅜". Cover with engraved flower springing from a cross-hatched mound. (Courtesy Museum of Fine Arts, Boston)

proved by the existence of a number of silver patch boxes produced by American silversmiths. One early example, owned by the Yale University Art Gallery, is the work of William Rouse of Boston, made for Lydia Foster who died in 1681.[1] Two other silver boxes by unknown makers are in the collection of the Museum of Fine Arts, Boston. Figure 94 illustrates a dainty heart-shaped piece with an engraved flower and leaf design that dates to the second quarter of the eighteenth century. Many silver patch boxes were imported for those who preferred the cachet of a European provenance.

A handsome Sheffield box (fig. 95) bears a portrait of Washington in bold relief; the use of the title *General* suggests a date prior to his presidency in 1789. The exportation of Sheffield plate to America constituted a brisk trade, and old record books of the Sheffield firm of T. Bradbury & Son indicate that large amounts were shipped to their agent in Philadelphia to be sold by local merchants.[2]

Enamel patch boxes from London were advertised here in the 1760s and continued in fashion until the early years of the nineteenth century. Round or oval in shape, many of the lids were fitted with mirrors and were embellished with sentiments such as "Remember the Giver," or with representations of English views of topical interest.

Historical subjects that found their way onto the box covers are particularly appealing today. At the top in figure 96 is shown a transfer-printed portrait of Admiral Horatio Nelson with the words *Nelson & Victory*. This was one of various mementos honoring Nelson's death at the Battle of

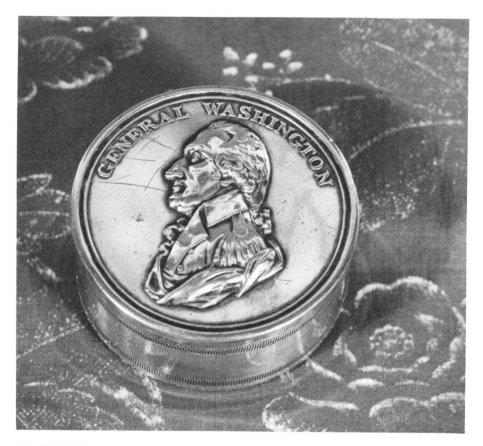

95. Sheffield patch box. Late eighteenth century. Diam. 2⅛″. Made for the American market with *General Washington* on the cover. Large shipments of Sheffield plate were received and sold by American merchants.

Trafalgar, which took place on October 21, 1805.

Another motif that appeared frequently on ceramics commemorated the opening of the Iron Bridge over the River Weare in the County of Durham, England. This famous cast-iron structure, consisting of a single arch span of 236 feet, was opened in 1796, and immediately captured public attention.

The little box at the left in figure 96 presents a romantic version of a fishing lady with net, seated in a rowboat tied to the shore. It is now almost impossible to identify the original uses of many individual boxes of small size. They could have held pills, pins, or other dressing table items, even snuff. But tiny examples in enamel or precious metals were probably at least intended to serve as receptacles for beauty spots.

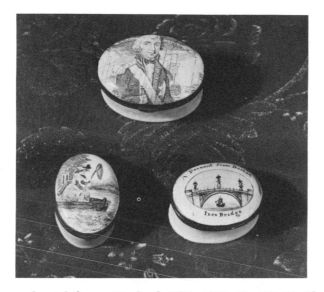

96. Three enamel patch boxes. England. 1790–1810. W. 1½"–2". The box in the center is captioned *Nelson & Victory*, and no doubt commemorated his death on October 21, 1805; at left, a picturesque scene featuring a fishing lady; at right, the famous Iron Bridge, opened in 1796. Souvenirs of this type were made for eighteenth-century vacationers, this one designated *A Present from Boston* [England]. All these boxes have mirrors fitted within the covers.

NOTES

1. This box is illustrated in Martha Gandy Fales, *Early American Silver for the Cautious Collector* (New York: Funk & Wagnalls, 1970), p. 8.

2. Samuel W. Woodhouse, Jr., "Old Sheffield Plate," *Antiques* (December 1927), p. 477.

To Contain Hats, Combs, and Bonnets

Until recent years hats have always been an important adjunct to a gentleman's wardrobe. In the seventeenth and eighteenth centuries beaver hats were the most fashionable and costly headgear because large quantities of beaver pelts were shipped from the Colonies to England and Holland, thus drastically reducing the supply available for home consumption.[1] Because of their value men's hats were carefully protected when not in use and even during the seventeenth century references to hat cases occur in contemporary records. In 1666 John Brocklebank of Lynn, Massa-

chusetts, owned a hat case that, with various trunks and boxes, was valued at 10 shillings. This particular piece was shipped by sea from Newbury, Massachusetts, to an undisclosed point in New Jersey but it was never delivered, an unfortunate circumstance that resulted in a lawsuit being brought by the prospective purchaser against William Hacket, the owner of the vessel.

In 1686 in New Amsterdam (from where it is said that between four and seven thousand beaver pelts were exported between 1624 and 1632),[2] Cornelys Van Dyke kept a leather hat case in his "Fore Room" together with such handsome furnishings as two bedsteads, a painted chest of drawers, and an eight-sided table.

Fashions in seventeenth-century Colonial dress followed English styles, often with surprising rapidity, as vessels sailing between the two countries provided constant communication. One may surmise the appearance of early hat cases by considering the prevailing hat styles, although these differed somewhat according to locality and the personal preference of the wearer. Many conservatives favored a high crown with rolled brim and small silver buckle. The form of the crown varied, but by the 1690s headgear with the brim cocked three ways was coming into vogue—a type that was to be worn for the next one hundred years.

The eighteenth century witnessed general use of the tricorn hat with a low crown and wide brim turned up at the back and on either side and coming to a point just above the forehead (fig. 97). Beaver continued to be a popular fur and beaver hats were often included in substantial estates. A "beaver hat and box" or "beaver hatt and case" are typical references, usually priced between 12 and 20 shillings in the 1760s. Felt was also used for hats, felt then being a mixture of wool and fur, or hair fulled into a compact substance by rolling and pressure. The inventory of Benjamin Curtis, feltmaker of Roxbury, Massachusetts, listed in his shop a "Stamper and Hat Blocks, 5 dozn & ½ of Felt Hatts, 1 Beaver Hat, 2 Castor ditto."[3] The term *castor* referred to the European species of beaver from which hats were made in the Low Countries prior to the exportation of American pelts to England and Holland.[4]

Military men were proud of their tricorns and often had them included in their portraits either carried under arm, hanging on an adjacent wall, or prominently displayed on a nearby table. The hat in figure 98 with its edging of gold lace was part of the uniform of Captain Samuel Chandler of Woodstock, Connecticut, who served during the Revolution with the Eleventh Company of the Eleventh Regiment of Connecticut Militia. A hat of this type was valued highly enough to cause its owner to insert the following notice in *The New-York Mercury* on December 5,

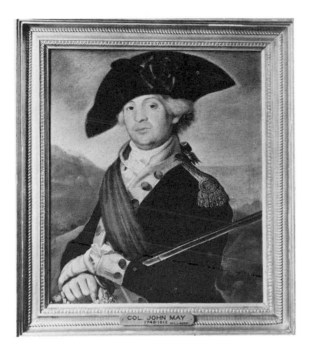

97. Colonel John May of Boston by Christian Gullager. 30″ x 25⅛″. Signed at lower right: *C Gullager. / pinx / 1789.* Colonel May's tricorn hat with a black rosette was a type worn throughout the eighteenth century. (Courtesy American Antiquarian Society, Worcester, Massachusetts)

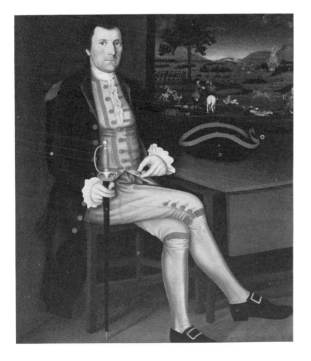

98. Captain Samuel Chandler of Woodstock, Connecticut, by Winthrop Chandler. c. 1781. 54⅞″ x 47⅞″. His tricorn hat edged with gold lace lies on the table beside him. (National Gallery of Art, Washington, D.C.; Gift of Edgar William and Bernice Chrysler Garbisch)

99. Triangular pine hatbox with accompanying tricorn hat. Newport, Rhode Island. c. 1790. W. 22¾". Lined in part with a 1792 Newport Theatre playbill and with a newspaper printed and sold by Benjamin Russell, State Street, Boston, dated June 10, 1795.

1757: "Lost on Sunday . . . a New Gold-Laced Hat. Whoever has found the same, and will bring it to the Printer hereof, shall be handsomely rewarded for his trouble." [5]

Wigs were a part of both seventeenth- and eighteenth-century dress and, like hats, were stored in their own boxes. On March 23, 1732, an important vendue of household goods was held at the Sign of the Heart and Crown in Boston's Cornhill. In company with a dressing glass, a chamber grate, and a group of cane and leather chairs, "Wiggs and Boxes" were offered for sale. As an added incentive to prospective customers the newspaper announced, "N.B. The Buyers may depend upon having fair Play, good Liquor, and if they are Wise, good Bargains." [6]

A triangular box typical of its eighteenth-century date is shown in figure 99. The accompanying hat is made of felt and trimmed with an ornamental black cockade. Hand-planing is visible on the unpainted pine surface and a substantial brass ring fixed to the lower edge of the point was used to hang it against a wall. Found in Newport, Rhode Island, and said to have been the property of a local citizen, it is lined in part with a playbill of the Newport Theatre dated July 15, 1792. A second tricorn box appears in figure 100. Although also constructed of wood it is covered with an eighteenth-century English-made paper that is block-printed in black on a blue-gray ground and features a lion rampant surmounted by a crown. This box, like many others, is lined with a section of newsprint, in this case the *Massachusetts Centinel* [Boston] of November 1, 1798.

100. Wooden hatbox. Late eighteenth century. W. 20″. Covered with block-printed paper, black on a blue-gray ground with a crowned lion rampant. (Courtesy Essex Institute, Salem, Massachusetts)

101. Bandbox of ash and pine. Second half eighteenth century. Diam. 15¼″. Gray background with crest and mantling in white and red, probably by a professional coach painter. Above is a wooden bandbox covered in blue paper with a floral decoration of white, pink, and green. Second quarter nineteenth century. W. 10″. The label pasted inside the cover reads "Warranted nailed/ BAND BOXES/ manufactured by HANNAH DAVIS/ East Jaffrey, N.H."

102. Wooden bandbox painted red with black decoration. W. 18⅝". The weeping willow tree on the lid was a favorite motif in the 1820s. (Abby Aldrich Rockefeller Folk Art Center, Williamsburg, Virginia)

The word *bandbox* was used in New England as early as 1636 when one was recorded in the estate of Sarah Dillingham of Ipswich, Massachusetts. It was listed in her parlor, but an amusing note on the margin of the inventory reads "the child hath it." During the eighteenth century bandboxes were used by both men and women to store or carry articles of wearing apparel. In 1785 James Adam Fleming, upholsterer and trunkmaker of New York City, advertised "hat and cap cases, fur caps, and band boxes." A bandbox made of ash and pine, the laps secured with large rose-headed nails, illustrates an eighteenth-century example (fig. 101). The decorative mantling is executed in red and white on a gray background and indicates the hand of a professional coach or ornamental painter. Another box of later date, with bottom and top of tulip wood, is painted red with black decoration (fig. 102). The lap joints of the cover and sides are held by cut nails, and the weeping willow tree suggests a second-quarter nineteenth-century date.

Boxes were made for many personal uses from the mid-eighteenth century on. A muff and case worth 4 shillings was kept in the bedchamber of the wealthy widow Elizabeth Ruggles of Roxbury, Massachusetts, in 1741. In Pennsylvania oval boxes, often referred to as brideboxes, were traditional marriage gifts to hold delicate finery or trinkets. Of light,

wooden-splint construction, the decoration with mottoes and human figures was of European origin but the early examples were brought over and then used here by the German settlers. A typical Pennsylvania box of either basswood or linden and pine is illustrated in figure 103. The characteristic finish forms a colorful foil for the stylized floral sprays executed in black and white on a red-painted ground.

Evidence suggests that the establishment set up by Enoch Noyes (1743–1808) in his farmhouse at Old Newbury, Massachusetts, marked the beginning of the comb-making industry in America. In the 1760s his first trials were fashioned from local cattle horns and cut by simple homemade tools. Most of the early examples were straight combs for dressing the hair, fitted with coarse and fine teeth on opposite ends, and it was not until around 1800 that fancy side and back combs became really fashionable. Horn, ivory, and tortoise shell were for sale in local shops, but when tortoise shell was scarce, a paste composed of lime, saleratus (baking soda), and litharge (a lead oxide) could be concocted. When skillfully applied to a horn comb with a feather or a brush, the substitution was surprisingly successful.[7]

103. Bandbox, pine with the bottom of basswood or linden. Pennsylvania. c. 1800. W. 11¼". Painted a characteristic red with stylized flowers in black and white. (Abby Aldrich Rockefeller Folk Art Center, Williamsburg, Virginia)

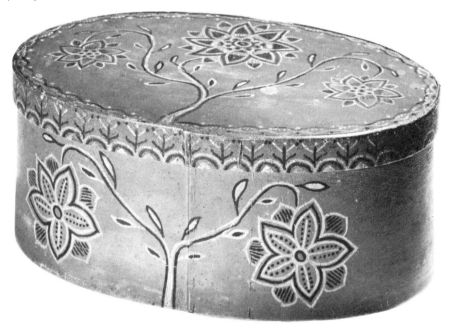

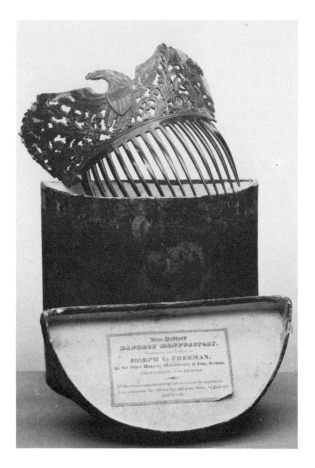

104. Labeled comb box made and sold by Joseph L. Freeman of New Bedford, Massachusetts. 1836–1839. W. 8″. Large carved combs were especially fashionable in the 1830s, and boxes to fit them were supplied by various makers. Freeman also sold bandboxes "put up in nests for exportation." (Courtesy The Henry Francis du Pont Winterthur Museum, Winterthur, Delaware)

Neat cardboard boxes were made in half-round shapes to accommodate the high, carved combs of the 1830s. Figure 104 shows a fine tortoiseshell example and the accompanying box covered in dark-green paper patterned with roses and green leaves. A label inside the lid identifies the maker and retailer as Joseph L. Freeman who worked at the Paper Hanging Manufactory of John Perkins, Union Street, New Bedford, from 1836 through 1839. Another similar box (fig. 105) carries the label of Alfred Willard of Boston, located at 149 Washington Street from 1831 through 1836. On May 13, 1829, Willard advertised in the *Columbian Centinel* that he "has constantly on hand SHELL, HORN and IVORY COMBS of every description. . . ."[8]

As married women seldom went bareheaded either at home or abroad, hat and bonnet boxes for ladies were advertised as early as 1770, and from this time on they were mentioned with increasing frequency. During

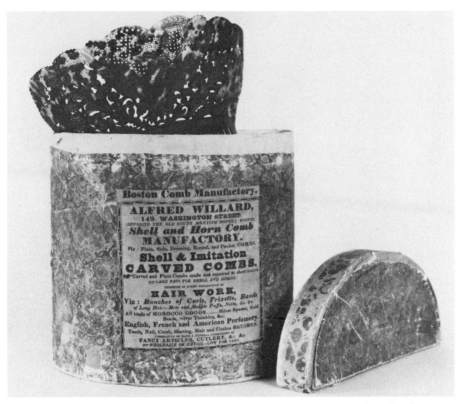

105. Comb box covered with marbleized paper. W. 8⅝″. Alfred Willard manufactured shell and horn combs at 149 Washington Street, Boston, from 1831 through 1836. (Old Sturbridge Village, Sturbridge, Massachusetts)

the first half of the nineteenth century they were used to store and transport the voluminous wired calashes, quilted silk hoods, and braided straw bonnets that were the fashion of the day (figs. 106, 107). It is not surprising, therefore, that country carpenters' account books—those kept by Nathan Cleaveland, Justus Dunn, and Silas Ball, for example—list numerous wooden hat and bonnet boxes priced between 50 and 75 cents.[9] Some were paid for by Cleaveland's customers through the barter of household goods, candles, shoes, shovels, tea, brandy, and rum. He also carried on a brisk business in mending "old hat cases."

After 1800 the appearance of men's hats changed again and the tricorns went out of fashion, to be gradually superseded by felts and beavers with high crowns and narrow brims (fig. 108). The height of crown and shape of brim (either flat or down-turned) varied from year to year according to the prevailing style. Little boys even wore this formal headgear

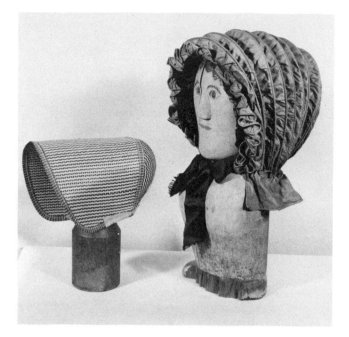

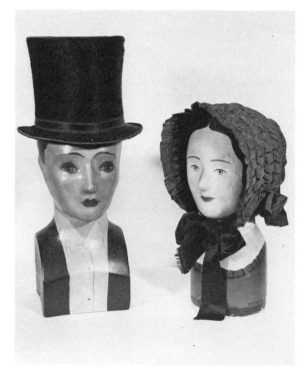

106. A straw bonnet and wired silk calash, two types of headgear that were stored or transported in the large paper bandboxes. Calashes folded flat for convenient storage.

107. Two papier-mâché milliner's models exhibiting a tall hat and a quilted silk hood. They are dressed as they might have been displayed in a nineteenth-century shopwindow.

to school. Young George Richardson is seen hat in hand (fig. 109), painted around 1820, as he presumably approached Lawrence Academy in Groton, Massachusetts. Various kinds of pasteboard boxes were made to hold top hats during the first half of the nineteenth century, one of the most interesting carried on the outside a block-printed representation of the hat it contained (fig. 110). Several similar prints have been found on boxes sold by different hatmakers. Covered with blue paper of varying shades, the designs themselves came in brown and black, sometimes with touches of red and white. The identification on the lid of figure 110 is not the usual applied label, having been especially printed for Peter Higgins directly on the cover paper itself. Higgins appeared as a hatter in the Boston Directories for many years during the 1830s and 1840s.

In the second quarter of the nineteenth century the use of bandboxes reached its height. The majority were made of pasteboard covered with colorful printed or stenciled papers, some of which were pieces of actual wallpaper, although others were individually designed for bandbox decoration. Boxes were advertised in nests of progressive sizes for convenience in storing and transporting light articles of ladies' apparel.[10] The bigger

108. Watercolor portrait of Captain Alexander Robinson. c. 1815. 12½″ x 10¼″. Captain Robinson is wearing the high-crowned beaver hat fashionable at this period.

109. Portrait of George Richardson on his way to school. c. 1820. 21″ x 17″. Even young boys wore ruffled shirts and beaver hats to the local academy.

containers served for dresses and to carry the large, frilled caps (fig. 111).
Medium sizes were used for gloves, laces, ribbons, beads, or other odd-
ments of feminine attire, and the small sizes for workboxes or children's
treasures. For ease of transportation, strong cotton bags were frequently
made to fit exactly around the bandbox. When pulled up and securely tied
the cord served as a useful handle [11] (fig. 112).

The majority of paper box makers are known only through the labels
that were pasted to the undersides of the lids. The boxes were usually
produced commercially by box or wallpaper manufacturers, or were sold

110. Man's hatbox sold by Peter Higgins, Boston. c. 1835. W. 14″. Blue back-
ground with a printed design in black. Several different hat patterns appear on
boxes of this type.

to accompany the merchandise (such as combs and hats) that they were designed to contain. An exception to this rule was Miss Hannah Davis (1784–1863), a large, strong woman with a limp, the daughter of a Jaffrey, New Hampshire, clockmaker. Her sturdy wooden boxes covered with block-printed papers have outlasted many of the more perishable receptacles of her generation. Thin slices of spruce logs were cut off by means of a foot-powered machine invented by herself, bent for the oval sides and lids, and nailed while still green. Thicker pieces of pine were used for tops and bottoms. In return for their choice of her mer-

111. Portrait of Achsah Fisk Farrar by Asahel Powers. c. 1834–1835. 34½″ x 25½″. The large frilled caps popular in the 1830s required careful protection in bandboxes when the owners traveled from home.

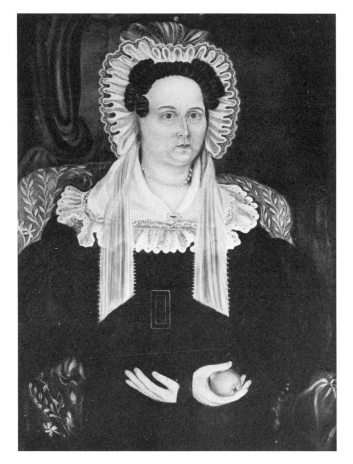

112. Bandbox with an accompanying bag. Diam. 8½". Country girls on their way to work in the large cotton mills of the 1840s carried all their worldly goods in bandboxes with separate cotton bags secured at the top by a drawstring. (America Hurrah Antiques, New York City)

113. Nest of three bandboxes. Second quarter nineteenth century. W., left to right: 8", 10", 12½". Wood covered with blue flowered paper. Each bears a label of Hannah Davis, Jaffrey, New Hampshire. Newspaper linings are dated, left to right: 1839, 1845, 1831. The old doll was found in the smallest box.

114. Three cardboard boxes covered with geometric and floral patterns. From bottom: W. 11½", 8½"; Diam. 3¾". The lowest box is labeled *Henry Cushing & Co., Providence*; center: *Joseph L. Freeman, New Bedford*.

115. Labels inside the covers of the boxes in figure 114. Henry Cushing & Co. was at 68 Westminster Street, Providence, 1832 through 1844. Joseph L. Freeman was located at 97 Union Street, New Bedford, from 1836 through 1839. A comb box labeled by Freeman is illustrated in figure 104.

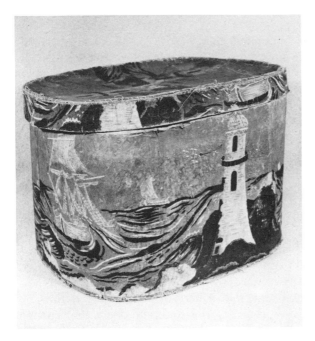

116. Bandbox with a view of the lighthouse at Sandy Hook. 1830–1835. W. 14¾". Rose, green, and white on a blue ground. This famous light was completed in 1764.

chandise, Hannah's friends donated sheets of hand-blocked wallpapers, often blue with floral repeat-patterns (figs. 101, 113). Neighbors also saved their newspapers for her and with these she neatly lined her boxes. The dates of the papers range from 1825 to 1855, the period of her greatest productivity. Small labels, or trade cards, were affixed to the undersides of the lids, and these have been found in at least ten different variations.[12] Hannah first disposed of her boxes through barter or sale to local people, but later she sold directly and in quantity to the young women working in the large textile mills of Nashua, Manchester, and Lowell. She drove a loaded wagon in summer, a sleigh in winter, and her prices varied from 12 to 50 cents according to size.[13]

Box papers came in every conceivable color and design (pl. 17). Many exhibited animals, birds, and floral patterns such as the three examples in figure 114, two of which bear the labels shown in figure 115. More important are the views of public buildings prominent during the 1820s and 1830s. Included in this group were *Castle Garden, Merchants Exchange, New York Deaf and Dumb Asylum,* and the *New York City Hall.* One colorful example displays a spirited marine subject titled *Sandy Hook* (fig. 116). The funds to build this well-known old landmark, situated at the entrance to New York harbor, were raised through two lotteries and a shipping tax. The rubble-stone beacon was first illuminated on

June 11, 1764, and the deed stipulated that "no selling of strong liquors" could ever be allowed on the premises. Despite several nineteenth-century renovations the structure still retains more of its original material than any other American light. Although historically important, it is now rated by the government as only of harbor, rather than seacoast, importance.[14]

Perhaps the most popular bandbox subjects depicted nineteenth-century events that in their time were of particular public interest. Among them was the long-awaited opening of the Grand (or Erie) Canal on October 26, 1825. This important waterway linked Lake Erie at Buffalo with Albany on the Hudson River, thereby establishing direct communication by water from the Great Lakes to New York City, and thence to the Atlantic Ocean. Enthusiastic celebrations were held at Rochester, Little Falls, Albany, and other towns along the way, as Governor Clinton, General Lafayette (on his second American visit), and other notables passed through on canalboats of the latest design. Scenes memorializing the opening of the canal were printed for the American market on dark blue Staffordshire pottery, and a view showing the stone aqueduct that carried the waters of the canal over the Mohawk River at Little Falls, near Utica, appeared on both Staffordshire tableware and large bandboxes (fig. 117).

Manufacturers either mixed or matched their bandboxes, sometimes assembling them with assorted covers whose patterns did not correspond with the main theme of the accompanying box. For this reason two different designs may be found paired together. As the construction of the Erie Canal heralded increased expansion of American trade (until its usefulness was minimized by the coming of the railroads), it seems fitting that a sailing ship personifying the slogan *PROSPERITY TO OUR COMMERCE* should appear on the lid of this Grand Canal box.

Although the science of aerial flight had come to the fore in France during the late eighteenth century, ballooning did not gain wide favor in the United States until the second quarter of the nineteenth century. In 1834 a young Englishman, Richard Clayton, settled in Cincinnati, where until 1856 he practiced his joint occupations of watchmaker and aeronaut. His spectacular flight of 350 miles on April 8, 1835, followed by many subsequent daring ascents, brought him universal fame.[15] Popular interest engendered by his flights was accentuated by the timely appearance of the picturesque *Clayton's Ascent* bandboxes that depicted his balloon preparing to soar over the surrounding rooftops (fig. 117). The cover exhibits quite a different design showing a hen and cock in a rural setting.

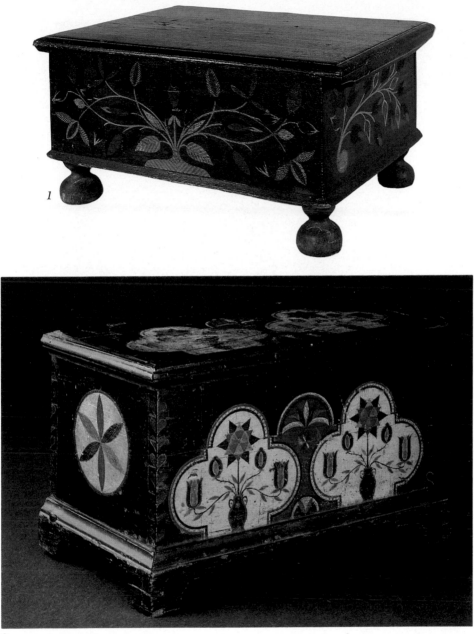

Plate 1. Connecticut box with painted decoration similar to figure 17. c. 1725–1730. W. 24″. One of several known pieces by this unidentified decorator. The feet are old but not original to the box.

Plate 2. Painted box of Pennsylvania origin. 1770–1800. W. 15¹¹⁄₁₆″. The vases of stylized flowers placed within white reserves are painted on a black ground and employ the colors commonly found in Pennsylvania folk decoration. (Courtesy The Henry Francis du Pont Winterthur Museum, Winterthur, Delaware)

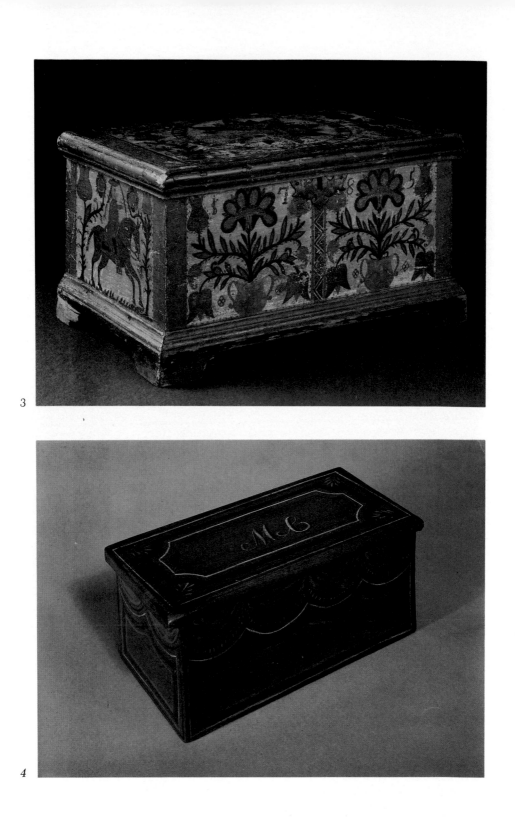

3

4

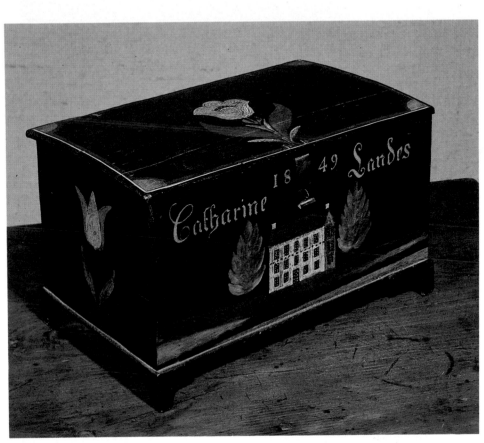

5

Plate 3. Box similar in form to late eighteenth-century Pennsylvania dower chests. Dated at top of front panels *1785*. W. 16¾″. The mounted horseman on the end closely resembles one found on a chest from Berks County. (Courtesy The Henry Francis du Pont Winterthur Museum, Winterthur, Delaware)

Plate 4. Box painted orange-red with initials *MC*. Early nineteenth century. W. 12¼″. The green and white striping outlining mustard-yellow swags results in a particularly pleasing pattern.

Plate 5. Pennsylvania box with house and tulip designs. W. 10″. Inscribed *Catharine Landes* and dated *1849*. This is one of several similar boxes attributed to John Webber of Lancaster County. Photograph courtesy George E. Schoellkopf Gallery, New York.

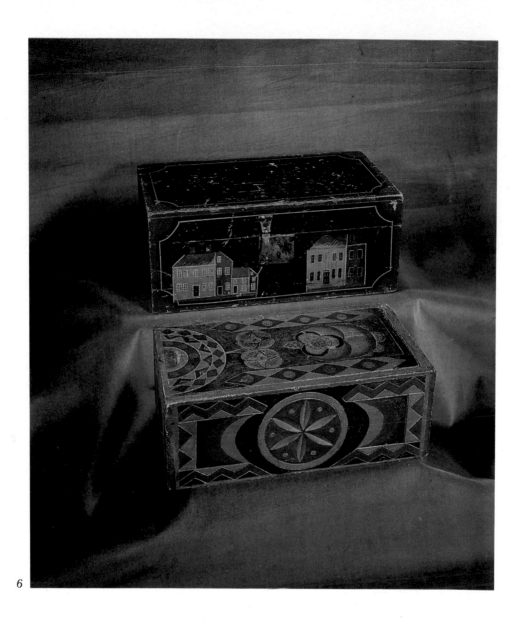

6

Plate 6. The upper box is of New England provenance. W. 14⅛". The prim yellow houses contrast pleasantly with the dark green background and red edging. The candle box below is carved and painted in geometric patterns and has a sliding cover. W. 14". Both date 1825–1840.

Plate 7. Document box probably from New England. 1825–1840. W. 11". The brown background effectively sets off the stylized foliage designs in oyster-white, blue-green, and yellow-green. Photograph courtesy America Hurrah Antiques, N.Y.C.

Plate 8. Storage box with brown graining resembling seashells on a yellow ground. 1825–1840. W. 24".

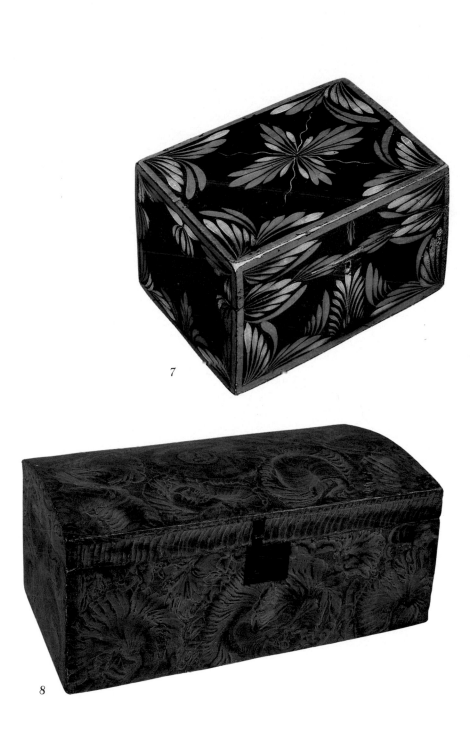

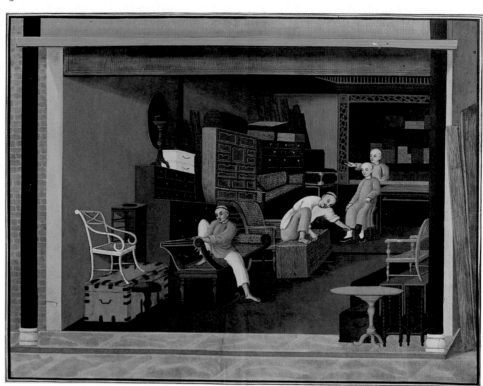

Plate 9. Interior of a Chinese cabinetmaker's shop. c. 1830. Gouache on paper, 11"x14". Several painted boxes decorated in the Western style are shown. All could easily be mistaken for American-made pieces. (Collection of Benjamin Ginsburg)

Plate 10. Chest and box decorated with wall-stencilers' patterns. 1825–1835. W. of chest 35½", W. of box 23¼". The chest displays swags, borders, and pots of flowers, with eagles on the ends. The box exhibits smaller versions of borders found on stenciled walls.

Plate 11. Box used by one branch of the Washington Benevolent Society, a clandestine fraternal organization that worked secretly to gain political influence for the Federalists. c. 1812. W. 21¾". Also shown is one of the textbooks that accompanied each box, with a frontispiece bust of General Washington signed *A. Todd Sculpt*.

10

11

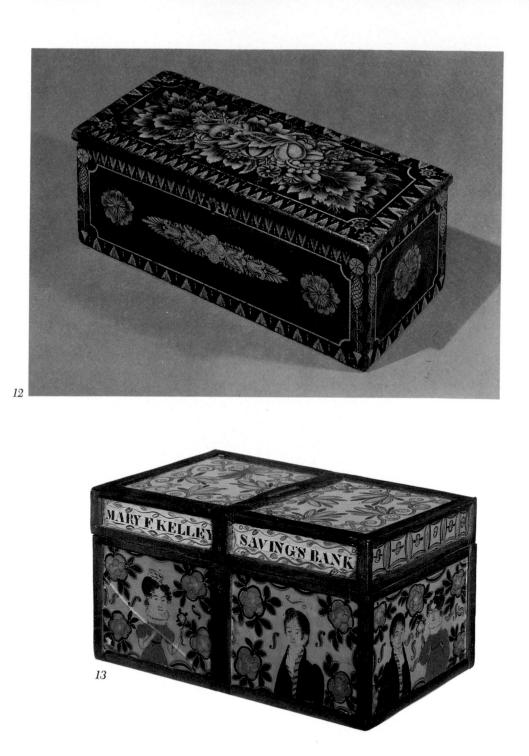

12

13

Plate 12. High-style Empire document box with elaborate stenciled designs on a ground of fine red and black graining in simulation of rosewood. First quarter nineteenth century. W. 18½". The oval ornament on the front is painted freehand in imitation of a gilt-metal mount.

Plate 13. *MARY F. KELLEY SAVING'S BANK*. c. 1830. W. 10¼". Floral motifs framing a young lady and gentleman are painted on glass-covered paper panels. The cover has a slot for depositing coins. (Mr. and Mrs. Stephen Score)

Plate 14. Detail from the cover of a trinket box. 1820–1830. W. 16¾". The watercolor painting on paper pictures an English pastoral scene of the type illustrated in drawing-instruction books. The painting is a particularly fine example of academy art of the early nineteenth century. (Abby Aldrich Rockefeller Folk Art Center, Williamsburg, Virginia)

14

15

Plate 15. *Clarissa Buckman's Toilet Box*, with cover depicting St. John's Chapel, New York City. W. 10¾″. Wood covered with paper. Several similar boxes were painted and signed by Daniel Evans, Augusta, Maine, 1838–1840.

16

Plate 16. Portrait of James Blakeslee Reynolds of West Haven, Connecticut. 1789. 45″ x 36″. A brass tobacco box with hinged lid rests on the book beside him.

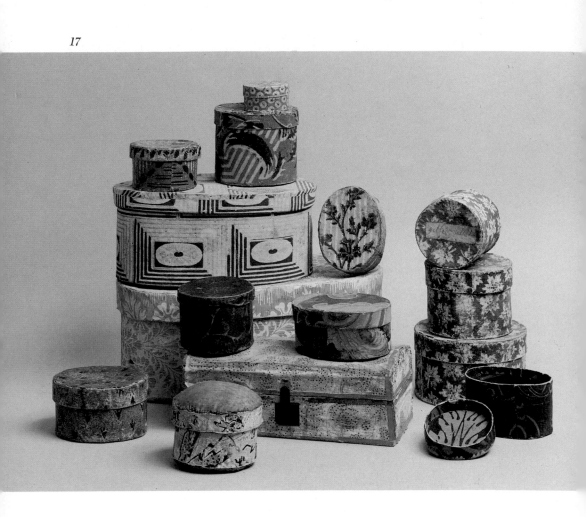

Plate 17. Group of paper-covered boxes. 1825–1840. Some of the many sizes, shapes, and patterns that were available during this period. (America Hurrah Antiques, N.Y.C.)

Plate 18. Watercolor drawing of a late eighteenth-century paint box with the label of William Reeves of London. 10″ x 8″. The cake paints are stamped with the distinctive Reeves shield.

Plate 19. Watercolor drawing by Edwin Whitefield, signed and dated on knife handle *Whitefield. Feb. 1840.* 8″ x 9¼″. Included with the vase of flowers and landscape sketch are the artist's tools: his paint box, brushes, palette knife, mixing saucer, and inkwell.

18

19

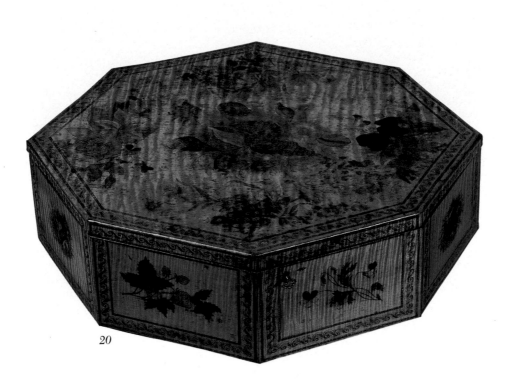

20

Plate 20. Octagonal workbox with flower sprays painted on a curly-maple ground. c. 1825. W. 20½". The lock is located at upper corner of right front panel.

Plate 21. Group of pantry boxes. First half nineteenth century. The firkin at center is labeled *Buckweat*. Shaped, tapered laps identify many of these as Shaker products. At lower right is a Shaker "spit box."

Plate 22. Two household boxes. c. 1830. Yellow with naïve flower spray is of New England origin. W. 15¼". Green with flower basket is probably from Pennsylvania. W. 16¾".

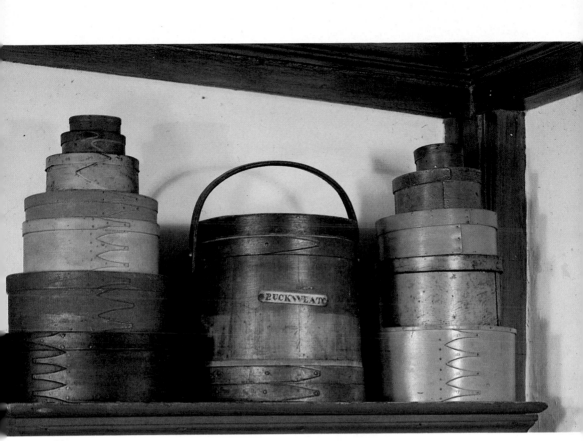

21

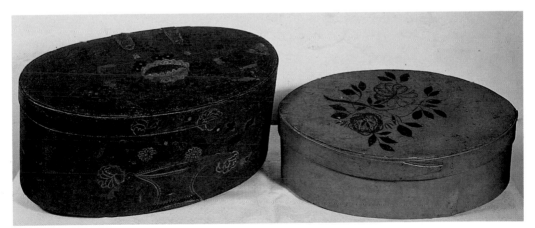

22

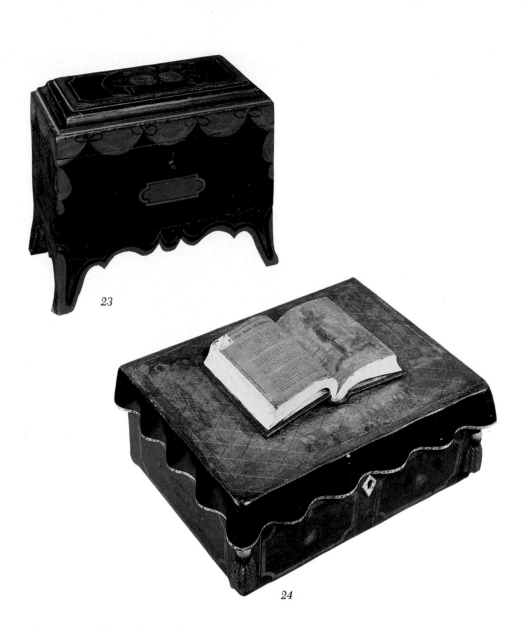

23

24

Plate 23. Wooden tea box with two compartments. 1810–1820. W. 9½". Pine with small brass hinges. Red swags with black bowknots and tassels enliven this stylish caddy from New York State. The French bracket feet and crisply carved skirt are unusual on a country piece.

Plate 24. Carved and painted wooden box in the form of a lectern. 1880–1890. W. 13½". A page of the carved book is inscribed with a three-stanza poem titled "The Rock of Liberty."

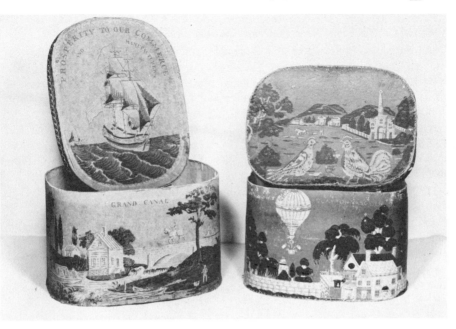

117. Two bandboxes: Left, *Grand Canal.* c. 1830. W. 17¾". White, brown, and olive green on yellow ground. The Grand (Erie) Cànal connecting Buffalo with Albany was opened in October 1825. The cover shows an American sailing ship with title *PROSPERITY TO OUR COMMERCE*; right, *Clayton's Ascent.* c. 1835. W. 16¾". Pink, brown, and white on blue ground. Honoring the ascent of Richard Clayton in Cincinnati, 1835. The cover shows a hen and a cock in a country scene.

NOTES

1. R. Turner Wilcox, *The Mode in Hats and Headdress* (New York: Charles Scribner's Sons, 1948), p. 113.

2. *Ibid.*

3. Abbott Lowell Cummings, ed., *Rural Household Inventories, 1675–1775* (Boston: The Society for the Preservation of New England Antiquities, 1964), p. 254.

4. Wilcox, *Mode in Hats,* p. 113.

5. Rita Susswein Gottesman, comp., *The Arts and Crafts in New York, 1726–1776* (New York: The New-York Historical Society, 1938), p. 327.

6. *Boston News-Letter,* March 23/30, 1732, as quoted in George Francis Dow, *The Arts and Crafts in New England, 1704–1775* (Topsfield, Mass.: The Wayside Press, 1927), pp. 109, 110.

7. Mary Musser, "Massachusetts Horn Smiths: A Century of Comb Making, 1775–1875," *Old-Time New England* (Winter–Spring 1978), pp. 59–68.

8. Information courtesy of Old Sturbridge Village, Sturbridge, Massachusetts.

9. Account Book of Nathan Cleaveland, Carpenter, Franklin, Massachusetts, 1810–1826. MS, Old Sturbridge Village Research Library. Account Book of Justus Dunn, Cabinetmaker, Cooperstown and Utica, New York, 1826–1831 (unpublished MS).

10. An advertisement dated 1830 that illustrates progressively sized hat and bandboxes appears in *The American Heritage History of American Antiques from the Revolution to the Civil War* (New York: American Heritage Publishing Co., 1968), p. 335.

11. Harriet H. Robinson, *Loom and Spindle or Life Among the Early Mill Girls* (New York and Boston, 1898), pp. 63–64.

12. Lilian Baker Carlisle, *Hat Boxes and Bandboxes at Shelburne Museum* (Shelburne, Vt.: The Shelburne Museum, 1960), p. 10, illustrates ten Davis labels, with an ambrotype of Hannah Davis in her later years.

13. "Aunt Hannah the Band Box Maker," reprinted by the Jaffrey Historical Society, New Hampshire, June 1977, from the *Boston Evening Transcript*, November 14, 1925.

14. Edward Rowe Snow, *Famous Lighthouses of America* (New York: Dodd, Mead, 1955), pp. 114–117.

15. Julia D. Sophronia Snow, "The Clayton's Ascent Bandbox," *Antiques* (September 1928), pp. 240–241.

Artists' Pencils, Brushes, and Colors

Since the early eighteenth century the decorative use of color has been an important element in American household arts. Overmantel landscapes, grained woodwork, and ornamented furniture are only a few examples of the painted decoration to be found in American homes from 1725 to 1850.

Most of the pigments used by professionals before the Revolution were imported from England. These could be obtained from city shopkeepers either as dry colors or conveniently ground in oil, and they were advertised by the hogshead or cask. On April 20, 1785, John Morgan of New York City announced in the *Independant Journal or the General Advertiser* that he had "erected a mill for the sole purpose of grinding colours." Country artisans, however, prepared their own paints from homemade dyes and ground them by hand with mortar and pestle.

Certain eighteenth-century shops that sold imported colors also advertised "painters' tools" that included camel's hair pencils, palette knives, bottles, vials, sieves, gallipots for mixing pigments, mortars for grinding,

and brushes of all sizes. Much paraphernalia of this sort has now disappeared but numerous boxes with compartments sized to hold such fittings still survive. Figure 118 illustrates a large box, 30½ inches in width, brown crotch-grained in the eighteenth-century manner and exhibiting on the lid a chinoiserie subject of the type favored by japanners. Landscapes after the Chinese taste were illustrated for copying in Stalker and Parker's book, *A Treatise of Japaning and Varnishing,* published in Oxford, England, in 1688. This early art instructor was available in America and a copy was included in the catalogue of the Library Company of Philadelphia in 1789.

"Japanners' prints," used as models for designs on furniture, were advertised for sale in New York City in 1748 and 1749.[1] Figure 119 pictures one view of a japanner's box with typical decoration, believed to be American, of around 1750. The tray contains dry paints in their original hand-blown bottles.

A country decorator's equipment was apt to include a good-sized wooden box, occasionally partitioned off at the end to accommodate his brushes. All necessary apparatus was packed and carried together in one container. A typical example appears in figure 120. This was originally owned by George Jewett, born in 1820, a carpenter, grainer, and coffin maker in Danbury, New Hampshire. Coffins were a basic stock in trade of most country carpenters, for which prices varied from 12 shillings in Townshend, Vermont, in 1803, to $1.00 in Cooperstown, New York, in 1827. Jewett's box, nicely painted by him in shades of brown and yellow, still

118. Artist's box, crotch-grained with a chinoiserie landscape subject on the lid. Late eighteenth century. W. 30½". Interior painted blue and divided into one lengthwise compartment for long-handled brushes, five assorted compartments, and sixteen small divisions for individual paints.

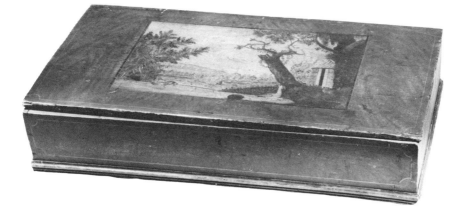

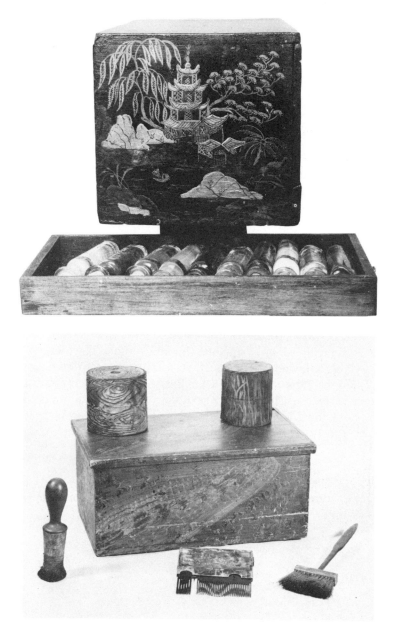

119. American japanner's box. c. 1750. W. 9⅝". Containing the original hand-blown bottles for dry colors. (Courtesy The Historical Society of Early American Decoration, Inc.)

120. Box with original graining rollers, combs, and brushes. c. 1850. W. 17¼". Belonged to George Jewett, Danbury, New Hampshire. The leather-covered cylinders were incised to produce grained patterns when rolled across a sticky painted surface.

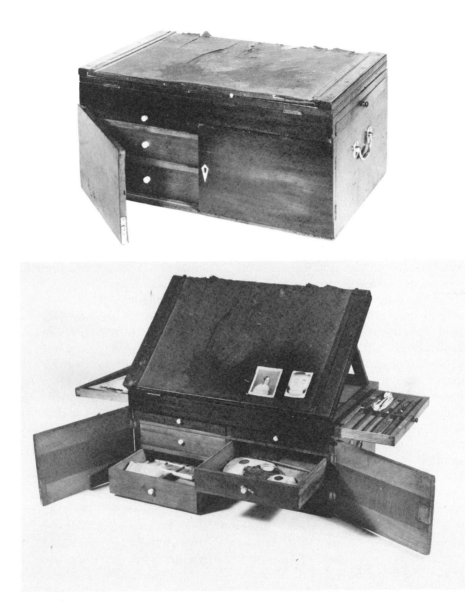

121. Mahogany-veneer artist's box. c. 1815–1820. W. 21″. Belonged to Caroline Shetky of Philadelphia and Boston, a miniature, portrait, landscape, and still-life painter.

122. Interior of the box in figure 121, showing the arrangement of drawers with ivory palettes, drawing pens, and completed miniatures. The cake paints are stamped *Winsor & Newton, Rathbone Place* [London].

holds many of the essential tools of the grainer's craft, several of which are illustrated. The box contains, in all, five brushes of various kinds, four bags of ground colors, and three leather-covered wooden cylinders incised to produce grained patterns when rolled across a tacky surface. There is also a large variety of coarse and fine-toothed metal combs used to create the striped effects seen on nineteenth-century woodwork. Many of the flat, tin cases of assorted combs used in America have Sheffield, England, labels. The particular set that forms part of the contents of this box is labeled *BERRY H. TAYLOR'S/GRAINING COMBS/FAMED FOR EXCELLENCE.*

Painting boxes owned by persons aspiring to be artists were considerably more sophisticated than the utilitarian examples used by professional house, sign, and fancy painters. English books containing art instruction for all were offered for sale in this country before the Revolution, and a number of American publications were available to academies and drawing schools during the first quarter of the nineteenth century.

One of the earliest and most comprehensive American treatises on the art of painting was titled *Elements of the Graphic Arts,* authored by Archibald Robertson and published in New York City in 1802. Robertson was Professor of Painting and Architecture at the Columbian Academy and his principles of drawing undoubtedly influenced the style of many artists and decorators during the early years of the nineteenth century. It is interesting, therefore, to read the following list of "Implements of Painting with Water Colours" that were prescribed for each pupil at the academy: a drawing board, paper, soft sponge, black lead pencils, raven-quill pens, and plates and cups to hold water and mix paints. Also required were four pairs of assorted brushes, including camel's hair; a marble, china, or queensware ink rubber, deemed "very important"; and a box of Reeves's water colors.

Miss Caroline Shetky's handsome mahogany-veneered box no doubt once contained most of the articles enumerated above (fig. 121). A portrait, miniature, landscape, and still-life painter, she arrived in Philadelphia from Edinburgh around 1818. After exhibiting at the Pennsylvania Academy, she moved to Boston following her marriage to Samuel Richardson in 1825. The top lifts up, and back supports create a convenient drawing board. Multiple drawers to accommodate paints, brushes, pens, palettes, and a mixing tray pull out at the front and at either end (fig. 122). A box of similar appearance is in the collection of the Essex Institute, Salem (fig. 123). It belonged to Miss Hannah Crowninshield (1789–1834), who painted portraits and scenes in watercolor and ornamented fancy boxes for her mother and sister.[2] Many original fittings are still intact and include bottles of colors, mixing saucers, drawings, and handwritten instructions. Hannah's

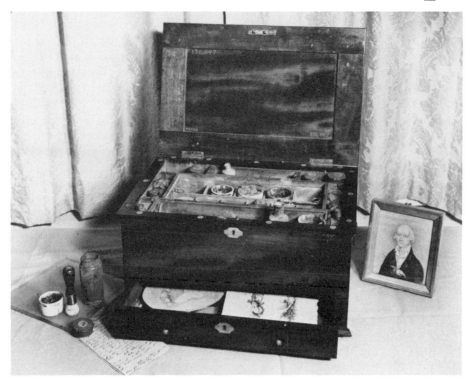

123. Mahogany paint box of Hannah Crowninshield, Salem, Massachusetts. c. 1815–1820. W. 18″. A pupil of Reverend William Bentley, Hannah painted portraits and scenes in watercolor. Many original fittings are still intact. (Courtesy Essex Institute, Salem, Massachusetts)

portrait of Reverend James Tyler, a visiting Scottish clergyman, appears at the right of the box.

Watercolor tints in ready-to-use cake form were invented in England by William Reeves around 1778.[3] Well established in America within five years, *Reeves Superfine Patent Water Colours* were advertised in New York City in 1783, in Charleston in 1796, and "Large sheet ivory [for miniatures] and Reeve's water colour, in boxes," were for sale by James Jacks of Philadelphia in 1797. For fifty years *Reeves* was the best known brand in America. Plate 18 illustrates an old drawing of a Reeves box that shows a full set of cakes, each molded with the Reeves's distinctive heraldic shield and swag. The label on the inside of the cover identifies William Reeves of

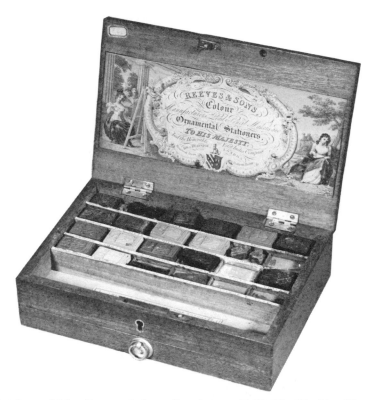

124. Paint box sold by Reeves & Sons, London. c. 1835. W. 8½″. For fifty years, following its introduction after the Revolution, Reeves's was the best-known brand of paints in America.

London. In 1802, the year when Archibald Robertson wrote that Reeves's paints are "deservedly held in the highest esteem for all small painting on paper," [4] the firm name changed to *Reeves & Inwood*, but the same device was impressed on the top of each cake. On the bottoms appeared the words, "Original inventors of superfine colours to the Royal Family." In later years artists' supplies were marketed by additional members of the Reeves family. In 1821 Elam Bliss in New York advertised "A large supply of Reeves and Woodyear's Water Colours and Toy Paints." By 1830 *Reeves & Sons* were selling boxes that contained their traditional cakes but they were now stamped with a different heraldic device (fig. 124).[5]

Eventually several English makers sold artists' equipment that included cake paints of sundry unnamed brands. W. *Hudson* offered a neat box complete with creamware mixing cup and tray in addition to sections for pencils and brushes (fig. 125), which he advertised on his label as for sale "Wholesale, Retail & for Exportation." Compact containers of this general style remained in use over a long period of time, and almost identical boxes were still illustrated in a trade catalogue issued by *Winsor & Newton*

of London in 1884. The name of this well-established old firm is imprinted on the early-nineteenth-century cake paints found in the Shetky box (see figs. 121, 122), and the publication of *Hudson's Art of Drawing in Water Colours and in Miniature* was advertised in the *Boston News-Letter* in 1761.

Reeves's colors and other English imports were expensive in this country because of a substantial British tax. Fortunately a breakthrough occurred in the early 1820s when a Philadelphian perfected the first American ready-to-use cake paints. At the first exhibition held by the Franklin Institute in Philadelphia, Osborne's Superfine American Water Colors "were judged to be of superior quality rivaling the best productions of Europe." A box of these paints was presented as a gift by Titian Peale to a young science student, James Curtis Booth, in 1826, and has luckily survived almost intact. It contains thirty-two original watercolor cakes, each marked on the top with an eagle and shield, and on the botom with the name of the color and the words, "Osborne, Philadelphia." [6]

Plate 19 presents an unusual glimpse of an artist's box painted by the

125. Paint box sold by W. Hudson, London. 1820'–1830. W. 8¾". Hudson's boxes were advertised to sell "Wholesale, Retail & for Exportation."

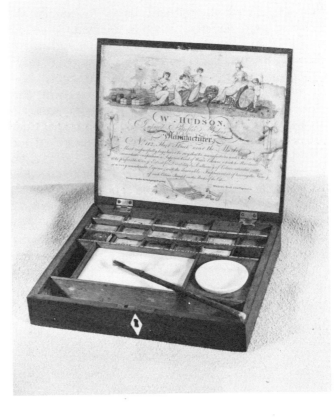

Englishman Edwin Whitefield who lived and worked in America from around 1836 until his death in 1892. Although perhaps best remembered for his sketches of ancient buildings in a series *The Homes of Our Forefathers,* Whitefield also illustrated books on American wildflowers. He likewise painted detailed topographical landscapes as sources for the fine lithographs that were made from his original drawings.[7] In this charming composition, signed and dated 1840, the artist has combined a romantic landscape, a nosegay of flowers, and a corner of the paint box with other implements of the watercolorist's art.

Judging by the various drawing books that were issued in America before 1840, flower painting was a very popular avocation of the amateur. In 1818 a booklet presenting a series of lessons on this subject proved to be one of the most attractive manuals featuring this aspect of art with an instructive text plus twelve engraved plates for practice coloring.[8] Carl W. Drepperd says of this treatise, "This book of lessons on flower painting started a movement marked by the publication of other excellent books of instruction in the same art and by the painting of an incalculable number of 'flower pieces' by an army of amateur artists . . . Teachers in flower painting were employed by most of the young ladies' schools." [9] The graceful spray in figure 126 is inscribed *Painted by Aunt Temperance Delano, 1806,* and is reminiscent of the flowers drawn by lady amateurs based on instruction book illustrations. Boxes to contain the tools for watercolor painting were, therefore, much in demand. Some of them were very simple indeed, their contents assembled at home. Others were sold by professional drawing teachers who also offered courses of lessons in watercolor painting.

A box of this type, illustrated in figure 127, carries the name of *M. MOULTHROP* of New Haven, Connecticut, and dates to around 1830. Born in 1805, Major Moulthrop began his career as a fruit and flower painter. In 1832 he issued a handbill advertising a free exhibition of "A New Style of Fancy Painting recently introduced from England" composed of pictures of "vegetables, fruit, flowers, birds, insects, landscapes etc." Apparently seeing the "handwriting on the wall" he changed his vocation late in life and by the 1870s had become a successful photographer.[10] Moulthrop's paint box is made of red-stained maple and is deceptively labeled *LONDON COLORS.* Eleven blown-glass bottles with cork stoppers still hold some of their original powdered contents. Each bottle exhibits the name *MOULTHROP* molded in the glass and each carries a tiny printed label identifying the color. These prepared pigments were ground ready to be mixed with "mucilage" or "gum water"—a viscous extraction obtained from seeds, roots, and gums mixed with water. On a printed sheet beneath the

126. Flower painting signed *Painted by Aunt Temperance Delano, 1806.* 9″ x 7″. Boxes holding bottles of dry colors were sold to artists who created "flower pieces" of this type.

bottles are Moulthrop's explicit directions for grinding, mixing, and shading the colors.

Shown also in figure 127 is an artist's box cleverly painted to give the appearance of a book. Inside are many implements used in monochromatic drawing, a method that combined black and white chalks applied to an

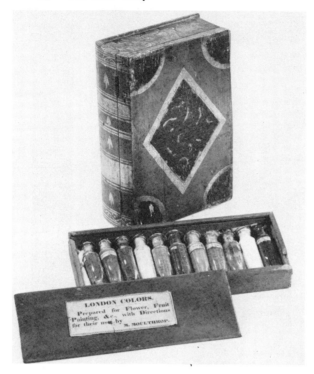

127. Top, paint box in the form of a book. c. 1840. W. 9″. Bottom, paint box sold by Major Moulthrop, New Haven, Connecticut. c. 1830. W. 9¼″. Dry colors prepared for fruit and flower painting are contained in bottles with the name *M. MOUL-THROP* blown in the glass.

abrasive ground. One way of producing this surface was to sift pulverized marble dust onto a sticky background, thereby attaining the effect of fine sandpaper. Soft outlines and dramatic shading could be obtained by correct application of the chalk. Instructions for the use of Wolf and Sons' *Creta Laevis* are set forth in a small 1840 booklet contained in the box. So-called sandpaper pictures were a favorite form of art for young amateurs from 1840 to 1860 (fig. 128).

Unexpected treasures are sometimes discovered in old artists' kits, especially small receptacles that were pressed into service to hold miscellaneous oddments. Two early match containers used with the box in figure 128 are still filled with sticks of black chalk. A third box labeled *SHAND'S COMPOUND CHINESE TABLET OF ALABASTER* contains gray and white pieces of a chalky substance with which to create picturesque highlights in monochromatic landscapes, as in the typical example shown. The box at left is imprinted with an eagle and the identification *WM. A. CLARK'S SUPERIOR FRICTION MATCHES*, which he began to manufacture in Connecticut in 1835. His small, paper-covered pasteboard boxes

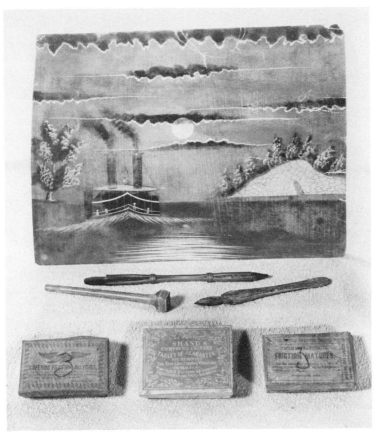

128. Contents of the book box in figure 127—implements for monochromatic drawing, an example of which is shown. The two early matchboxes are full of black chalk.

were made by women and children in their homes and carried abrasive paper pasted to the bottoms to serve as striking surfaces. Thomas Sanford, maker of the box at right, was marketing matches in Woodbury, Connecticut, by 1850.[11]

Painting in oil as well as in watercolor was taught in numerous private schools, where furniture and accessories were embellished with fruits, flowers, shells, trophies, and small romantic landscapes. Receptacles to hold the owner's painting equipment were favorite subjects for decoration, often signed by the youthful artist and dedicated to a special friend. The example in figure 129 is made of bird's-eye maple veneered on a base of pine,

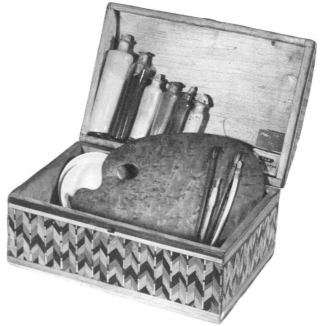

129. Young lady's paint box, bird's-eye-maple veneer. W. 16½". Inscribed on the front by the artist, *Consecrated to Friendship by Mary Morgan*; on the back, *Fanny Barber Northfield Sept. 6 1821.*

130. Straw-covered box with original stenciling equipment. c. 1834. W. 12¼". Used by Mary Nettleton who studied art at Wesleyan Academy in Wilbraham, Massachusetts. The box contains bottles of colors, boxes of pigments, mixing saucers, and brushes. The palette is not original to the box.

and is divided into eight compartments of assorted shapes. The dainty motif on the front consists of a tipped basket placed between two doves. At the left stands a truncated column on which is written in fine script *Consecrated to Friendship by Mary Morgan*. On the back, in stylish red calligraphy, appears the name of the recipient, *Fanny Barber Northfield Sept. 6 1821*.

By the early 1820s young watercolorists were turning their talents toward experimenting with a newly popular art form: the delineation of fruit and flowers accomplished through the use of theorems (stencils). Mrs. Saunders' and Miss Beach's Academy in Dorchester, Massachusetts, advertised in the *Columbian Centinel* on March 23, 1822, "*PAINTING BY THEOREMS* on velvet silk and paper with practical instruction in preparing the most brilliant colors, suitable for the same and the method of making the Theorems, Grooping [*sic*] Patterns, etc. etc. etc." [12] Figure 130 shows the painting box used by Mary Nettleton who was born in Bethany, Connecticut, in 1818. She later moved to Ohio, and when the box was recently discovered in the attic of her farm home, it contained, among other personal mementos, sixty stencils for flower painting, ten blown-glass bottles, two small boxes full of powdered pigments, two china mixing saucers, eleven brushes, and instructions for the use of "Improved Pink Saucers." According to these directions the coloring matter contained in a so-called *pink saucer* was a sort of dye to be mixed with water and lemon juice or cream of tartar. Thus either a pale or a deep pink tint could be obtained that was useful in coloring stockings, gloves, flowers, and delicate fabrics. Mary Nettleton was educated at Wesleyan Academy in Wilbraham, Massachusetts, and included is a tuition bill for the fall term of 1834 in the amount of $3.75. Another bill enumerates paints, brushes, and her pink saucer at a cost of 17 cents.

By 1830 the first definitive instruction book on painting by means of stencils was issued in New York City.[13] Written by Matthew D. Finn and titled *Theorematical System of Painting*, this little manual explains the method as the making of a series of hollow-cut patterns designed to be laid successively over the surface to be decorated. Through the apertures in each theorem different colors could be separately applied, thereby completing the finished design on the surface below. Figure 131 illustrates three cutouts from the Nettleton box that, when superimposed upon one another, completed the wreath at left. According to Finn, the implements needed for stenciling included a good set of brushes, a few camel's hair pencils, brightly colored paints with cups to contain them (the former obtainable from a druggist), a pencil, oiled tissue paper for tracing patterns, a sharp knife, and thin pasteboard from which to cut the theorems.

131. Series of hollow-cut theorems used successively to create the completed wreath at lower left. These are among the sixty stencils found in the Nettleton box.

NOTES

1. Joseph Downs, "American Japanned Furniture," *Old-Time New England* (October 1937), p. 63.

2. A sewing box decorated by Hannah Crowninshield is illustrated in figure 143.

3. Archibald Robertson, *Elements of the Graphic Arts* (New York: David Longworth, 1802), p. 8.

4. *Ibid.*

5. I am grateful to Christopher P. Monkhouse for consulting sources in London to ascertain the various titles used by the Reeves firm.

6. Marion Sadtler Carson, "Early American Water Color Painting," *Antiques* (January 1951), pp. 54–56.

7. Bettina A. Norton, "Edwin Whitefield, 1816–1892," *Antiques* (August 1972), pp. 232–243.

8. *A Series of Progressive Lessons Intended to Elucidate the Art of Flower Painting* (Philadelphia: M. Thomas, 1818) (No author).

9. Carl W. Drepperd, *American Drawing Books* (New York: The New York Public Library, 1946), p. 6.

10. H. J. Rogers, *Twenty Three Years Under a Sky-Light, or Life and Experiences of a Photographer* (Hartford, Conn.: American Publishing Co., 1873), p. 23. I am also indebted to William L. Warren for information about Moulthrop.

11. Herbert Manchester, *The Diamond Match Company, 1835–1935* (New York: The Diamond Match Company, 1935), pp. 15, 31.

12. Quoted by Betty Ring in "Mrs. Saunders' and Miss Beach's Academy, Dorchester," *Antiques* (August 1976), p. 306.

13. Matthew D. Finn, *Theorematical System of Painting* (New York: James Ryan, 1830). Carl W. Drepperd (in *American Drawing Books*, pp. 8, 9) writes, "other instructors and receipt books mention the method but Finn carries the system to new heights."

Fancy Needlework and Plain Sewing

When one considers the large amount of needlework, both plain and fancy, that was accomplished by young ladies and their mothers during the eighteenth and nineteenth centuries, it is understandable that personal sewing boxes should be among the truly cherished possessions of most American families. The art of embroidery was a prime requisite of a refined education, and formal instruction, beyond that given at home, was available through two main channels—independent embroidery schools and private academies.

Advertisements dating from the first quarter of the eighteenth century indicate that fancy sewing was taught by both men and women to numerous classes of day or boarding scholars, either at the home of the instructor or at some other convenient location. On October 19, 1767, an interesting

notice appeared in the *Boston Gazette* addressed "To the Young Ladies of Boston" by Elizabeth Courtney, who proposed to open a school of not less than fifty pupils for the purpose of teaching "French Trimmings, Flowers, and Feather Muffs and Tippets." Tuition was to be $5.00 upon entrance with instruction to be completed in six weeks. In Colonial Boston the daughters

132. High-style box with a mirror surrounded by a blue-and-white cord. Early nineteenth century. W. 8½". Many original fittings remain in place, including a painted velvet pincushion, ivory thread winders, a star-shaped bobbin, an ivory-and-gold needle case, a crochet hook, embroidery picks, and a gold-rimmed thimble with floral-painted border. (Courtesy The Henry Francis du Pont Winterthur Museum, Winterthur, Delaware)

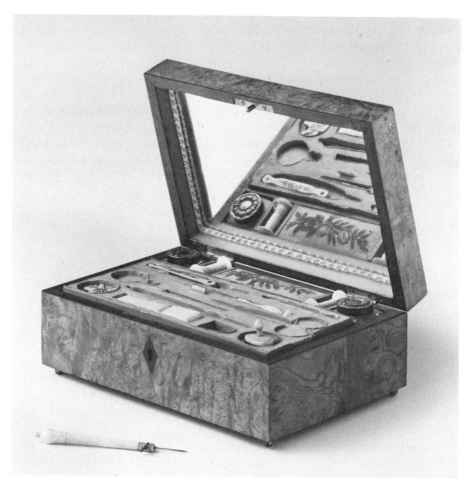

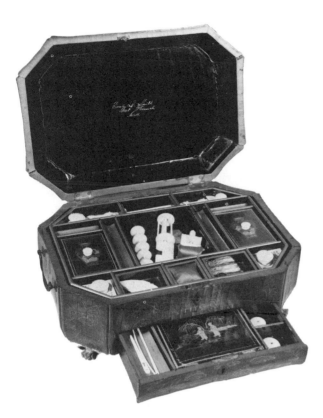

133. Red lacquer China trade sewing box with gold decoration. c. 1840. W. 13½". Made for Emily L. Smith of West Harwich, Massachusetts. Many of the ivory sewing implements are still intact.

134. Gold inscription inside the cover of the box in figure 133. An owner's name is rarely found on a Chinese sewing box.

of genteel families could also learn such specialties as turkey work, flourish-
ing (or embellishing), cross- and tent stitches on canvas, sprigging, darning,
needle lacework, French quilting, and many other ornamental stitches.[1]

In New York City, where many fashionable needlework schools flour-
ished before the Revolution, the "strictest principles of religion and moral-
ity were observed, and instructors tended to stress their English training
as a guarantee of superior ability to teach. Classes in tambour (which re-
sembled a chain stitch); sampler making; shading with silk or worsted on
cambric, lawn, or Holland; Dresden flowering on catgut (a coarse cloth
made of thick cord); and knotting for bed quilts were all widely adver-
tised. In 1774 one enterprising teacher offered to give instruction in the
ladies' own homes at a charge of 5 pounds currency per hour, or 5 shillings
per lesson.[2] Much of the catgut, crewels, and canvas, as well as ivory knot-
ting shuttles, were imported to New York, as were ladies' knitting and
workboxes, in 1794. Needle cases from France were advertised in 1786.
Figure 132 illustrates a box, either French or American in origin, typical
of early nineteenth-century style. Made of richly figured wood with inset
mirror, the interior is lined with bright blue paper and the several com-
partments contain many of the original fittings once used in various types
of fancy sewing.

From 1785 to the middle of the nineteenth century sewing boxes of
Chinese lacquer were also imported and were much prized for their Orien-
tal decoration and delicately carved ivory fittings. The example shown in
figure 133 has a red lacquer ground with gold ornamentation picturing
houses, trees, and figures. An unusual feature is the name of the original
owner, *Emily L. Smith. West-Harwich. Mass.*, painted in gold script on the
inner side of the cover (fig. 134). Various sizes and shapes of shuttles,
bodkins, needle holders, and thread winders still remain in the compart-
ments.

Private boarding schools where young ladies were taught needlework
along with the usual basics of history, geography, arithmetic, and spelling
flourished in both cities and small towns during the first half of the nine-
teenth century. At Mrs. Rowson's school in Boston instruction in needlework
was offered in her first advertisement in the *Columbian Centinel* of Novem-
ber 1797. After 1800 "Embroidery in its various branches" was offered at
$6.00 per quarter. Beautifully executed examples of her pupils' work in-
clude various pictorial subjects in silk stitchery, and a coverlet expertly
quilted with a center motif of a basket of flowers.[3]

At Miss Mary Balch's Academy in Providence, Rhode Island, samplers
with representations of important local buildings, together with memorial
pieces featuring willow trees having satin-stitched leaves, were specialties
of the school. Most of the pupils' bills contained items pertaining to needle-

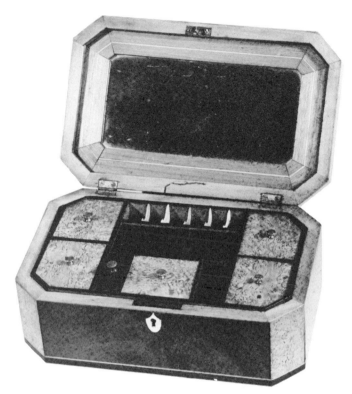

135. Mahogany and bird's-eye-maple sewing box with removable tray. W. 12″. Signed in pencil on the bottom of the tray with the owner's name and the date *1811*.

work supplies such as canvas, crewels, shaneal [chenille], needles, thimbles, and sewing silk and satin.[4]

When the first circular of the Moravian *Boarding School for Female Education* in Salem, North Carolina, was issued in 1804, plain needlework was one of the regular "branches" in the curriculum. Music and fine needlework were taught as extras "if expressly desired," and the school became famous for pictorial and floral embroidery as well as for samplers and mourning pictures.[5]

Many kinds of sewing boxes were available to meet the ladies' needs. Some exhibited a cabinetmaker's skill, others were obviously made at home. Many high-style examples, such as figure 132, could be purchased complete with velvet-lined compartments and basic fittings. These might include a pincushion, spools for thread, picks, punches, a bobbin, a thimble, a crochet hook, a needle case, and scissors. Other boxes were divided into various sections to be filled with the owner's own sewing equipment (fig. 135).

During the second half of the eighteenth century, expensive needle-work accessories were obtainable at goldsmith's and jeweler's shops in Philadelphia and New York. Many items included gold, silver, velvet, and silk needle books with looking glasses, gold and silver thimbles, and morocco thread cases, all imported from London. Some gold, silver, and pinchbeck thimbles, however, were American-made at Benjamin Halsted's thimble manufactory in New York, where he advertised in the *Diary: or Evening Register* on August 30, 1794, "Those imported [thimbles] are of the Slightest kind, I will engage that one of mine will do more service than three of them . . . Consider your interest and encourage American Manufactures." [6]

Similar to figure 135 in its octagonal shape and effective use of bird's-eye-maple veneer is the dainty workbox of figure 136, which dates to the early 1800s. Partially obscured in the foliage surrounding the conch shell on the cover are the initials *J.R.P.*, identifying John Ritto Penniman (1783–

136. Octagonal workbox, satinwood with bird's-eye-maple veneer. c. 1810. W. 10⅜". Disguised in the leaves below the conch shell are the initials *J.R.P.*, for John Ritto Penniman, a Boston ornamental painter.

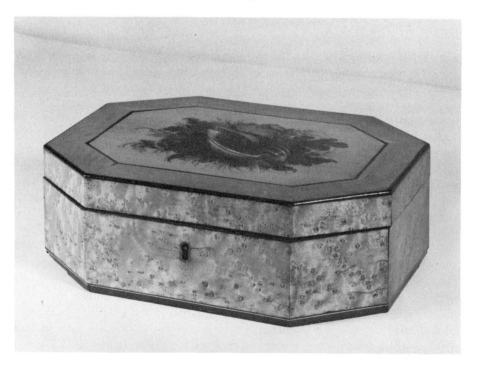

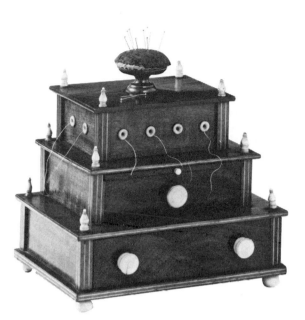

137. Mahogany spool box with ivory trimmings. c. 1830. W. 8¾". The drawers were intended for various items of sewing equipment. The upper section contains metal prongs to hold eight small spools, with eyelets for convenience in drawing out the thread. (Courtesy The Henry Francis du Pont Winterthur Museum, Winterthur, Delaware)

1837), a proficient and successful ornamental painter working in Roxbury and Boston during the first three decades of the nineteenth century. Signboards, fine furniture, clockfaces, military banners, ornamental pictorial subjects, landscapes, and portraits were only a part of his astonishingly diverse repertoire.[7] This box represents the combined workmanship of a master cabinetmaker (the shop of Thomas Seymour has been suggested[8]) with the artistic talent of Penniman, an expert decorator.

A particularly large workbox of maple and poplar exhibits outstanding quality and is illustrated in plate 20. The curly-maple ground is beautifully painted with a variety of colored flower sprays, and the removable mahogany tray and section below it were originally divided into many small compartments. Like the boxes previously illustrated, this one is also octagonal in form, but it differs in exhibiting eight sides of equal length, thereby necessitating the placement of the lock and key in a curious position at the corner of one of the front panels.

Early in the second quarter of the nineteenth century a new and innovative design for sewing boxes appeared on the market, which was so convenient that it retained its popularity well into the Victorian age (fig. 137). Inside the upper section of this stepped, three-tiered arrangement are metal prongs to hold eight spools, from which the thread is drawn through ivory

138. Portrait of a lady. c. 1850. 51½″ x 42⅜″. A box with thread and a needle stand rests on the table beside her. (Abby Aldrich Rockefeller Folk Art Center, Williamsburg, Virginia)

eyelets on each of three sides. A pincushion surmounts the top, and an adjustable sliding mirror forms part of the drawer in the middle section. One of the earliest storekeepers' inventories listing thread sold on spools is dated 1825.[9] It is unlikely that thread was generally available in this form until a few years later when, in March 1828, Nathan Cleaveland, a carpenter in Franklin, Massachusetts, entered in his account book the making

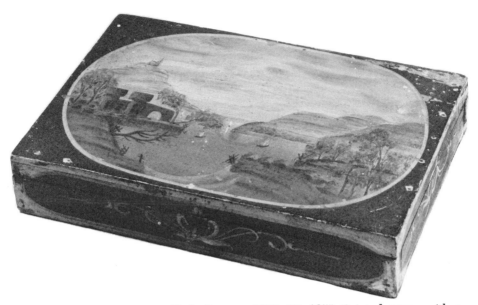

139. Sewing box from New York State. c. 1840. W. 13¼″. Painted green, with a river view and a castle, which are reminiscent of illustrations in drawing instruction books. The name *J. Miller* appears on the inside of the cover.

of a thread stand at the price of 62 cents. Pictured in the portrait of a lady, dated around 1850, a comparable box may be seen (fig. 138). The pair of scissors obviously fitted within the single drawer, but in this case the spools are in plain sight, set around a two-tiered pedestal that is topped by a cushion holding needles and pins.

A completely different style of box appears in figure 139—a country-made piece probably from upstate New York. The exterior exhibits a brightly colored landscape laid on a green ground. Although reminiscent of Hudson River scenery, the picturesque building at left appears to derive from a drawing book illustration. The artist's or owner's name *J. Miller*, heightened by a white scroll, is painted on the inside of the cover, the interior being colored a strong reddish-brown.

Boxes that display the most appealing designs were often those ornamented by amateurs whose workboxes were practical testimonials to their proficiency in the art of drawing and painting. Unlike those made by professionals, amateur receptacles were often small and simple, either homemade or acquired from a neighborhood shop or joiner. Painted decoration added by the owner usually followed the trends of contemporary fashion, but the execution, although painstaking, was apt to be ingenuous. One especially valuable attribute of ladies' work is the fact that many pieces

were inscribed, not only with the name of the decorator, but also with the place of origin and date.

In 1822 Miss Jane Otis Prior of Bath, Maine (one of four sisters of the artist William Matthew Prior), decorated the sewing box in figure 140. It was inscribed by her on the bottom as follows: *Miss Sarah McCobb's, painted by Jane Otis Prior March 1822. Remember your friend Jane when far distant from each other when you look at this.* Sarah lived in Waldoboro, Maine, and, on occasion, visited the Hezekiah Prince family in Thomaston. Each end of this box is ornamented with a picturesque English scene based on an illustration or engraving. One exhibits a view of the village of Ec[k]ington, the other of Hendon House, Northumberland. Even more interesting is the back panel that bears an original drawing titled *Sketch of Thomaston, Maine. Front Street* (fig. 141). The naïvely painted shell border is evidence of the popularity of this motif, found in many forms on decorative arts of the neoclassical period.

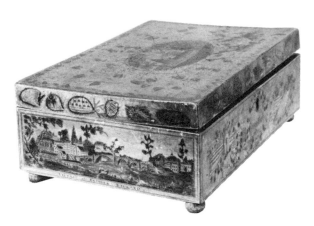

140. Sewing box decorated by Jane Otis Prior of Bath, Maine, sister of William M. Prior. W. 12″. Inscribed on bottom: *Miss Sarah McCobb's, painted by Jane Otis Prior March 1822. . . .* On one end is the *Village of Ec[k]ington England,* and on the top a free rendition of the Boston State House.

141. Back of the box in figure 140. Freehand drawing, *Sketch of Thomaston, Maine. Front Street.*

142. Small sewing box initialed *M. H. T.* c. 1820. W. 6¾". Mary Howe Thaxter was born in Worcester, Massachusetts, in 1793. The contents include nineteenth-century buttons, ribbons, beadwork, and embroidery patterns, together with poems, backed by death notices, clipped from a newspaper dated 1819.

Many sewing boxes have been preserved and handed down because of their personal associations. One modest example bears the following legend in faded ink: *This thread box used by S.M. Goddard 1811–1879* (see fig. 60). Over the years some have become repositories for sentimental souvenirs of several generations. One such box, illustrated in figure 142, is ornamented with a large building surrounded by a garden and trees. On the back, within a heart-shaped wreath, are the initials *M.H.T.* for Mary Howe Thaxter of Worcester, Massachusetts, who was born in 1793 and married Henry Wheeler in 1826. Owned by descendants until a few years ago, it still contains family treasures that date from the first to the last quarter of the nineteenth century. These odds and ends include fancy buttons, bits of colored ribbons, a tiny beadwork strip, embroidery patterns, a Victorian needle book in the shape of a flower, and a pair of dainty white silk gloves. Several folded scraps of paper reveal poems cut from a newspaper dated 1819. There is also a receipt for $1.50 from Henry Wheeler to Miss Thaxter as payment, in 1823, for a subscription to the *Missionary Herald,* for which he was the agent.

143. Sewing box, bird's-eye maple with fluted mahogany corners. 1810–1815. W. 12″. Decorated by Hannah Crowinshield of Salem, Massachusetts, for her mother, whose initials, *M L C*, appear on the front. Hannah's painting box is shown in figure 123. (Courtesy The Peabody Museum of Salem, Massachusetts)

144. Cardboard sewing box covered in gold-and-black printed paper. c. 1840. W. 4⅜″. Homemade accessories include a silk pincushion, a needle case, and a thread winder, with a box top and pin holders of velvet with theorem decoration. (Old Sturbridge Village, Sturbridge, Massachusetts)

145. A group of yellow-varnished Shaker sewing boxes resting on a Shaker stand from Enfield, New Hampshire. Nineteenth century. W. of boxes 5¾″–11″. The piece without a cover was known as a "carrier" and is filled with "white silk from Lebanon." Interiors were lined with figured silk and outfitted with pincushions, needle cases, emery bags, and wax.

Rather more sophisticated is the bird's-eye maple piece with fluted mahogany corner columns that was decorated by Hannah Crowninshield of Salem, Massachusetts (fig. 143). It bears on the front the initials of her mother, Mary Lambert Crowninshield. Hannah's artistic proclivities were encouraged by the well-known clergyman and diarist Reverend William Bentley, who boarded in the Crowninshield home during the first quarter of the nineteenth century. The lid is graced by two swans beneath an overhanging tree, and trophies representing music and the arts ornament the back and sides.

The example in figure 144 appears to have been entirely fabricated at home. The box is made of pasteboard covered with a gold-and-black patterned paper, and the cover (at right) exhibits a design stenciled on velvet. Velvet painting was one of the specialties taught at certain academies. At Miss Sarah Tinkham's School in Wiscasset, Maine, a "new system of painting on velvet" was offered at $3.00 to $6.00 per quarter in 1826.[10] The thin needle case fits into the center slot as shown here, and four compartments hold a silk-covered pincushion, a bone thread winder, and two pin holders, each with velvet cover. Fashioning accessories such as these was a specialty also to be learned in school, some were hand-painted and others exhibited needlework decoration.[11]

Shaker sewing boxes, or carriers, were crafted with the skill and attention to detail that characterized the making of all their furniture and household objects. During the late nineteenth century both round and oval containers equipped with convenient carrying handles were produced in the workshops of various eastern Shaker communities to sell to the outside world (fig. 145). Daintily lined with figured silk, the sides were pierced to allow the passage of ribbons to be tied in bows on the exterior. Held in place by the ribbons were pincushions, needle cases, wax for thread, and small emery bags fashioned in the shape of strawberries. These articles were sold by the Shaker sisters in many mountain and seaside resort hotels in New Hampshire and Maine until well into the twentieth century, and were still being produced at Sabbathday Lake, Maine, as recently as 1960.[12]

NOTES

1. George Francis Dow, *Arts and Crafts in New England, 1704–1775* (Topsfield, Mass.: The Wayside Press, 1927), pp. 273–276.

2. Rita Susswein Gottesman, comp., *The Arts and Crafts in New York, 1726–1776* (New York: The New-York Historical Society, 1938), pp. 275–280.

3. Jane C. Giffen, "Susanna Rowson and Her Academy," *Antiques* (September 1970), pp. 436–440.

4. Betty Ring, "The Balch School in Providence, Rhode Island," *Antiques* (April 1975), pp. 660–671.

5. Betty Ring, "Salem Female Academy," *Antiques* (September 1974), pp. 434–442.

6. Gottesman, *The Arts and Crafts in New York, 1777–1799* (New York: The New-York Historical Society, 1954), p. 69.

7. Mabel M. Swan, "John Ritto Penniman," *Antiques* (May 1941), pp. 246–248.

8. *Paul Revere's Boston: 1735–1818* (Boston: Museum of Fine Arts, 1975), p. 171.

9. Storekeeper's inventory, owned by Old Sturbridge Village, Sturbridge, Massachusetts.

10. *Thomaston* [Maine] *Register*, February 28, 1826.

11. Ring, "Salem Female Academy," plate III.

12. Milton C. Rose and Emily Mason Rose, eds., *A Shaker Reader* (New York: Main Street/Universe Books, n.d.), pp. 107, 108.

3. Boxes for Domestic Purposes

Convenient Storage of Salt

Saltboxes have always been basic household necessities since the seventeenth century, and allusions such as "box with some salt," "salt box and some salt," and "salt box in the hall" are typical of many early references. Apart from its appearance on the dining table, salt was widely used as a preservative for meat and fish. Little fresh meat was available because of spoilage in warm weather, or the necessity of keeping it over long periods of time. Most prosperous families, however, had their own "powdering tubs" for salting and pickling.[1]

In the eighteenth century there were two sources of common salt, one derived from seawater and the other from mineral deposits. The former process allowed salt water to flow slowly through "salt gardens" or reservoirs, during which time it evaporated under the heat of the sun, forming crystalline crusts that were raked up and sold for family needs. Saltworks were established in the Colonies soon after the first settlements, and obtaining sea salt became a successful business enterprise on Cape Cod following the Revolution. The second source of salt resulted from the mining of mineral deposits and this substance was known as rock salt.[2]

Salt, as it arrived in the home, was coarse in texture and required crushing in a mortar with a pestle or grinding between stones in the local grist mill. For the sake of convenience, or susceptibility to dampness, salt for daily use was stored in wall boxes traditionally identified by their slanting lids. They were usually hung in the kitchen or adjacent to the heat

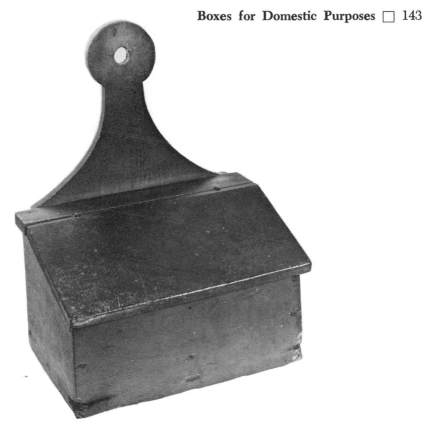

146. New England saltbox, red-painted pine. c. 1800. W. 11¾″. The sloping lid exhibits the traditional saltbox shape.

of a stove or fireplace. The modern term *saltbox* house, referring to a structure with a long, sloping rear roof, came into being within relatively recent times, and is believed by some to have been based on the shape of the utilitarian saltbox. Figure 146 illustrates a typical New England example made of red-painted pine with decorative backpiece to hang against a wall. The term gained local acceptance from the publication in 1900 of a small book titled *The Salt-Box House*. Therein the author described the lean-to structure of which she was writing as "more convenient and commodious than graceful or picturesque. Colloquially, it was called a 'salt-box house'; its lines repeating those of the wooden salt-box that hung in the kitchen chimney."[3] In figure 147 is pictured the Eleazer Arnold House, built around 1687 in Lincoln, Rhode Island, with roof line illustrating this terminology.

147. Eleazer Arnold House, Lincoln, Rhode Island. c. 1687. During the nine-teenth century a long, lean-to roof line gave this type of structure its picturesque designation of *saltbox* house. (The Society for the Preservation of New England Antiquities, Boston)

A pewter saltbox appeared as part of the kitchen furnishings of the Honorable Benjamin Prat, Esq., of Milton, Massachusetts, who died in July 1763. Prat, having come from New York City, left a very large estate including a valuable Hogarth engraving in a gilt frame and many pieces

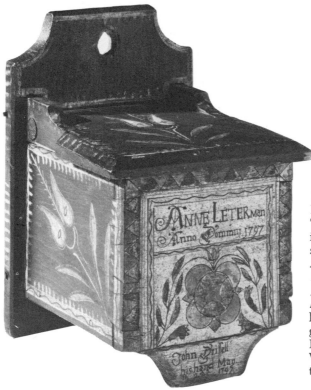

148. Good example of a Pennsylvania saltbox. W. 7¼". Painted red with stylized floral decoration. Inscribed on upper front: *Anne Leterman / Anno Dominni 1797*; at bottom: *John Drissell / his hand May / 22 1797*, in black lettering on a cream ground. (Courtesy The Henry Francis du Pont Winterthur Museum, Winterthur, Delaware)

of Chinese porcelain. It seems likely, therefore, that his pewter saltbox, included in a handsome array of kitchen equipment in brass, copper, pewter, and bell metal, was imported from abroad.[4] However, most of the American saltboxes of 150 years ago were made of wood and, particularly in Pennsylvania, have always been the subjects for gay painted decoration. A colorful example is illustrated in figure 148 that exhibits tulips and other motifs in white and other colors on a red background. The front carries the name of the owner *Anne Leterman/Anno Dominni 1797*. Below appears the inscription, *John Drissell/his hand May/22/1797* in black lettering on a cream ground.

A second piece of Pennsylvania origin is shown in figure 149 with the name *Mattie A. Hostetler* penciled on the back. She is believed to have purchased the box from Samuel Plank who was the maker and also the painter of the bird and flower design. Plank (1821–1900) lived in central Pennsylvania where there was a settlement of Amish Mennonites of Swiss extraction. He was a farmer, taught school, and could draw freehand sketches. He apparently made a saltbox for each of his eleven children,

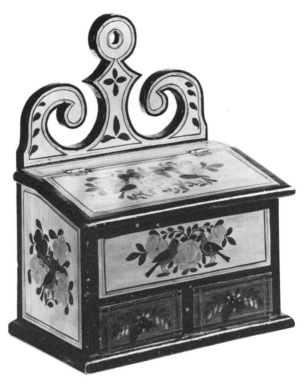

149. Saltbox with name *Mattie A. Hostetler*, of Mifflin County, Pennsylvania, penciled on the back. Second half nineteenth century. W. 12½". Made and painted by Samuel L. Plank, a teacher, carpenter, and farmer living in an Amish Mennonite settlement in the Kishacoquillas Valley, central Pennsylvania. (Abby Aldrich Rockefeller Folk Art Center, Williamsburg, Virginia)

and several additional examples are known.[5] Boxes with slightly sloping lids and one or two small drawers beneath were no doubt also used for the storage of articles other than salt, such as cutlery and spices.

NOTES

1. Alice Morse Earle, *Home Life in Colonial Days* (New York: The Macmillan Company, 1939), p. 153. ＇

2. Mary Earle Gould, *Early American Wooden Ware*, rev. ed. (Springfield, Mass.: The Pond-Ekberg Company, 1948), pp. 166–168.

3. Jane de Forest Shelton, *The Salt-Box House* (1900; reprint ed.; New York: Charles Scribner's Sons, 1929), pp. 17, 18.

4. Abbott Lowell Cummings, ed., *Rural Household Inventories, 1675–1775* (Boston: The Society for the Preservation of New England Antiquities, 1964), p. 202.

5. Information about Samuel Plank courtesy of the Abby Aldrich Rockefeller Folk Art Center, Williamsburg, Virginia.

Keeping Candles and Tinder Dry

The first illumination in the American home is said to have derived from the burning of pine knots, which were also referred to as candlewood. The pitchy substance that burned easily was tar, which yielded a satisfactory, if smoky, light.

With the increase of livestock for domestic use every scrap of tallow was saved for the purpose of candlemaking, although candles and wicking continued to be brought from England for some years by relatives of early settlers.[1] In country districts deer and hog suet, moose fat, bear grease, and any other bits of household fat were "tried out" for candlemaking.

In 1676 "Suet, greese and Candles" worth 8 shillings were stored in the cellar of John Farington of Dedham, Massachusetts. Twenty pounds of candles, a valuable household supply, were inventoried in Hingham, Massachusetts, in 1678, along with thirty pounds of suet. Both candles and suet were kept in the buttery (that is, the larder) and together were worth the considerable sum of 1 pound. Sixty years later tallow, grease, hog suet, and candles were still to be found in many New England cellars, and candles made of tallow were specifically noted in lists of household goods.[2] The homemade wicking was fabricated of spun hemp, tow, or cotton.

In candlemaking a correct proportion of water had to be added to the tallow, which was then scalded and skimmed to remove impurities. Strands of wicking were looped over thin wooden rods about eighteen inches in length, carefully dipped in the melted tallow, allowed to cool and harden, and then dipped repeatedly until the desired thickness of solid tallow was attained. In order to prevent discoloration and cracking, tallow candles

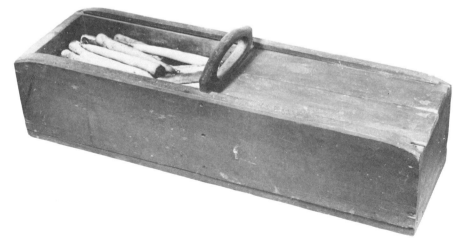

150. Red-painted storage box for candles. c. 1800. W. 28¼". Filled with dozens of hand-dipped tallow candles. There are two sliding covers, each one divided down the middle. A candle box and skimmer were purchased for $1.00 in 1821.

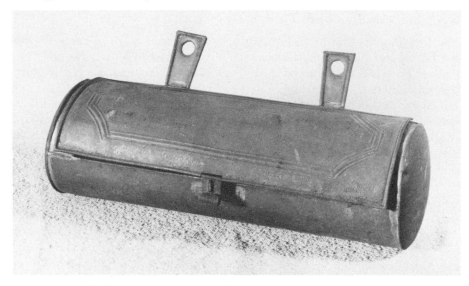

151. Tin candle box to hang against the wall. 1825–1850. W. 14⅜". For the dispensing rather than the storage of candles.

were stored in long wooden boxes; the larger ones were divided into two compartments. They were either fitted with lids, or the candles were covered and set in a dark place until ready for use.[3] "Candles and Box" were among the contents of the kitchen in the home of David Cushing of Hingham, Massachusetts, in 1724.

Candle boxes are hard to distinguish from boxes used for other household purposes, but the red-painted one in figure 150 is like many used by generations of American families. It still holds dozens of home-dipped tallow candles precisely laid in the two compartments, and each of the sliding covers is conveniently split down the middle to provide easier access to the contents. Smaller boxes with sliding covers, sized to accommodate the length of an average candle, were prevalent during the first quarter of the nineteenth century (bottom, pl. 6). In large cities, after the middle of the eighteenth century, commercially made candles were available, mostly packed in boxes by the pound. They were sold in chandlers' shops together with tallow by the barrel, and hard soap by the box.[4]

Superior candles were also fashioned from beeswax, bayberry wax, and spermaceti—a substance found in the head of the sperm whale. Candles made by a method other than dipping were poured into metal molds. In some districts itinerant candlemakers carrying tin molds, or pewter tubes set into wooden frames, went from door to door to aid the busy housewife.

Metal wall boxes intended to hold a few candles for quick convenience were made in the nineteenth century, both here and abroad. Handsome brass ones denote English workmanship. The sturdy cylindrical containers of tin—with hinged covers and pierced hangers—were designed to be suspended from a mantelshelf or to hang against a wall (fig. 151).

Before the days of friction matches the means of producing a flame were primitive indeed. An ember from the hearth was the most universal method, followed by the uncertainties inherent in the use of a flint and steel. These implements were kept in tinderboxes made of tin that were apparently universal in design, each having a cover that supported a short socket for a candle. The well-equipped box illustrated in figure 152 contains a loose inner lid to keep the contents dry, below which rests a piece of flint and a specially shaped implement of steel. When the flint was struck a glancing blow with the steel, a momentary spark resulted. A small piece of partially charred linen, or other prepared substance known as tinder, was always at hand in the box to catch the spark and thus, one hoped, to produce a flame. But this apparently simple procedure was often brought to fruition only through considerable previous experience or seemingly inexhaustible patience.

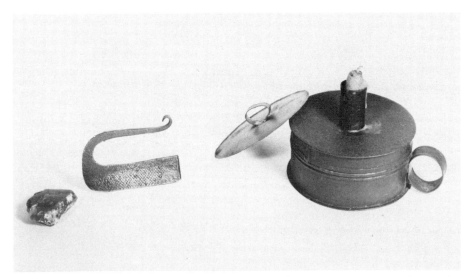

152. Tinderbox with assorted contents. First half nineteenth century. Diam. 4". The small piece of flint, when struck a glancing blow against the steel striker, created a spark that ignited the tinder. The tin damper was used to extinguish the tinder and help in keeping it dry.

NOTES

1. Alice Morse Earle, *Home Life in Colonial Days* (New York: The Macmillan Company, 1939), p. 34.

2. Abbott Lowell Cummings, ed., *Rural Household Inventories, 1675–1775* (Boston: The Society for the Preservation of New England Antiquities, 1964), pp. 11, 26, 132.

3. Earle, *Home Life in Colonial Days*, p. 38.

4. *Ibid.*, p. 37.

Pantry and Household Needs

Under this general heading are grouped the various kinds of boxes that held foodstuffs and other family necessities in the old-time American home. Before the days of glass jars, tin cans, and commercially packaged foods convenient wooden boxes served almost every household need. Of round or oval form, they came in sizes from twenty-four inches in diameter and over sixteen inches in width to tiny receptacles for pills or other small oddments. Local carpenters supplied a large majority of these containers before the advent of factory products.

Mary Earle Gould in *Early American Wooden Ware* divides household boxes into four main categories according to use and size, the largest of which held butter, cheese, and herbs.[1] Some butter boxes had sides made of pine staves held together by ash or hickory hoops with the ends entwined to form locked laps. A staved box would swell with moisture as needed, but nailed laps would not expand. In 1807 one Vermont joiner's account book lists the making of a butter box at 4 shillings, 6 pence.[2]

In 1669 "old cheese and a box" were valued in an estate at 2 shillings. By 1676 cheese and boxes in unspecified amounts were worth 15 shillings. Figure 153 illustrates an unusual piece measuring just under eleven inches —the proper size for cheese or butter. The long laps are fastened with large, round-headed nails, and the top is ornamented with a sunburst and two hand-carved concentric bands. What would appear at first glance to have been an individual item was apparently one of a set, as a duplicate box, slightly larger in size, is owned in a private collection. On the latter the carving on the top is worn almost smooth, presumably the result of many years of resting at the bottom of a pile.

So-called herb boxes were traditionally oval, either deep or shallow, and have not survived in such quantities as cheese and butter containers. The large example in figure 154 measures 16¼ inches long and came from Exeter, New Hampshire, complete with later contents of sixteen hand-woven, home-dyed linen handkerchiefs and towels. The wood of this early,

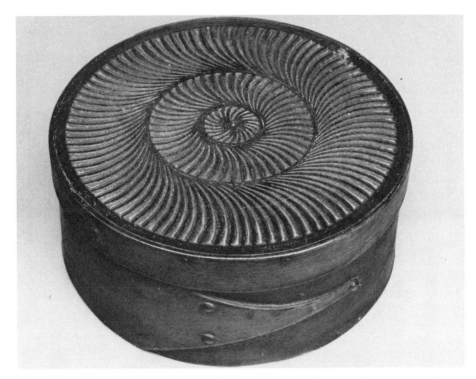

153. Cheese or butter box. 1825–1850. Diam. 10⅞". The carved concentric bands show the amount of handwork lavished on utilitarian objects. (Courtesy The Henry Francis du Pont Winterthur Museum, Winterthur, Delaware)

handmade box is entirely ash, and the nonmatching laps are secured by large, rose-headed nails clinched on the inner side. Herbs were an important ingredient in early food preparation and were commonly used for flavoring as well as medicinal purposes. Gathered while still green, they were tied in bunches and suspended from a beam in the storeroom or attic. After thorough drying, they were carefully laid in long trays or boxes, later to be crushed, ground, and sifted for eventual family use.

Next smaller in size (fig. 154) were the containers now regarded as having been used for sugar and various kinds of meal. Both round and oval boxes held the small quantities of dry comestibles that were kept in the pantry for convenience, following their removal from capacious tubs or barrels stored in the summer kitchen or shed. Corn, rye, buckwheat, and oats were the meals most used for mush, Indian puddings, bannock cakes, and bread baked in fireplace brick ovens.

By far the largest group of pantry boxes are the small ones generally identified as spice containers. Several kinds of wood were often combined in the tops, bottoms, and sides. These occasionally included beech, birch,

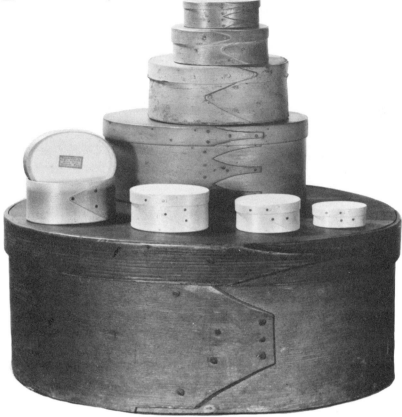

154. Group of pantry boxes for many purposes, the largest probably for the storage of herbs. Late eighteenth century. W. 16¼". The boxes in the pile were used for sugar, spices, or meal. The small nest of four is composed of well-made factory items. 1850–1875. W. 2⅛"–3⅜". The one at left bears the label of Samuel Hersey, Hingham, Massachusetts.

and hickory but more often ash, maple, and pine were used. The majority of examples found today are early factory products dating from the second to the third quarter of the nineteenth century. They are put together with lighter materials and exhibit laps and bottoms held by machine-cut metal tacks rather than wooden pegs or hammerheaded nails. In the 1820s superior boxes could be purchased from country carpenters such as Jonathan Loomis of Whately, Massachusetts, for 50 cents apiece.

In figure 155 the construction of three generations of boxes may be easily compared. The larger one is painted blue with an incised date of *1747*. Made of ash with a top of pine, the wood is heavy and the bottom

fits tightly within the sides without benefit of pegs. The thick, shaped laps are fastened with multifaceted nails. Next in size is a well-made early nineteenth-century piece with expertly beveled laps and a perfectly fitting cover, the natural finish of which has darkened to a deep brown with use and age. Beside it stands a commercially made little box of late nineteenth-century vintage—its thin, shaved wood having long since split away from the small metal tacks that once held it together.

Medium-size boxes served countless household needs, but if they ever held spices the lingering aromatic fragrance is always unmistakable. Spices were derived from many sources including roots, bark, and berries of

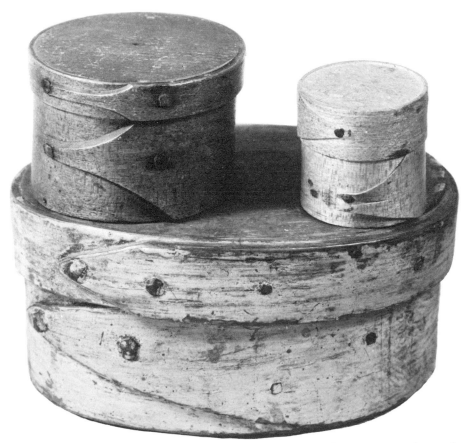

155. Three generations of household boxes. W. 1⅝"–6". The large example is of ash and pine, painted blue and incised on the top *1747*. At left, an early nineteenth-century piece with well-formed laps and wrought nails. The pillbox at right, third quarter nineteenth century, is of thin wood and poor construction.

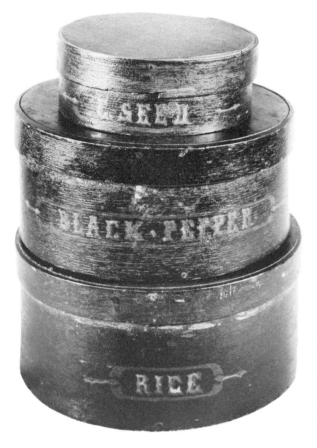

156. Three from a nest of round spice boxes. c. 1840. Diam. 4⅜"–7". Marked *RICE, BLACK PEPPER,* and *C.* [ardamom] *SEED,* in red and yellow lettering on a green ground. Many spice boxes fitted inside one another for convenient storage when not in use.

various plants and trees. Cargoes of them came home in overseas trade, but local varieties were frequently used as flavoring and preservatives. Fish and game were among the foods kept over the winter by pickling and spicing. "One days work on a pickling box" at $1.25 was charged by Daniel Richardson, carpenter and joiner, of Attleborough, Massachusetts, in 1829.[3]

Nests of matching boxes proliferated during the middle of the nineteenth century, although they had been in use since Colonial times. As early as 1636 a large and small "nest of boxes," undoubtedly graduated in size, were listed at 2 pounds and 3 shillings, respectively, in the estate of Sarah Dillingham of Ipswich, Massachusetts. Another nest "with things in them" is found in a Rowley, Massachusetts, inventory of 1647. "Sets of boxes" appear in seventeenth-century inventories of Essex County, England, from where many of the first New England settlers came. In 1660 an Essex County, Massachusetts, inventory listed a "sett of ould boxes" worth 13

pence. These sets probably comprised several matching boxes all of one size. By 1826 a set of handmade country boxes could be had for 75 cents.[4]

It is safe to say that the majority of nineteenth-century spice boxes being offered today were originally parts of nests or sets that have become separated over the years. Three examples from an incomplete nest may

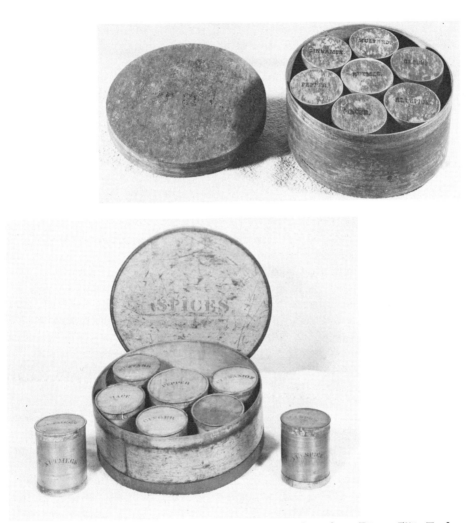

157. Set of seven wooden spice canisters with matching box. Diam. 7¾″. Each is stamped on the bottom with the patent date, *Nov. 16, 1868.*

158. Set of eight spice boxes banded in tin. Diam. 9⅜″. The bottoms are impressed *Patent Package Co., Newark, N.J., Aug. 31, 1858.*

be seen in figure 156 marked *RICE, BLACK PEPPER,* and *C.* [ardamom] *SEED.* The names are decoratively lettered in red and yellow enclosed by red striping, all on a clear green ground. Another graduated nest seen recently bears the designations *spice* and *cassia*, the third box being left unmarked. One whiff when the covers are lifted betrays the sweet scent of the long-vanished contents.

The interiors of some boxes were divided into four parts to accommodate different kinds of spices, but soon after the middle of the nineteenth century housewives began to use the latest convenience—circular boxes that held seven or eight small wooden canisters arranged beside one another for easy access to the spices most often needed. These sets were commercially produced, and the bottoms of the small receptacles are apt to bear a maker's name or patent date, which are easily overlooked because of barely legible marking. Each container in figure 157 is stamped in ink on the bottom with the patent date, *Nov. 16, 1868.* All eight boxes of a similar group banded in tin are impressed with the words *Patent Package Co., Newark, N.J., Aug. 31, 1858* (fig. 158). The spices most often named in these sets were cloves, cinnamon, mustard, nutmeg, pepper, ginger, allspice, and mace.

Oval boxes made by the Shakers are particularly noteworthy because of their fine workmanship and finish. The distinctive tapered laps (with blunt or pointed ends) invariably run in the same direction on the tops and the sides. Like other household boxes they were made in graduated sizes for innumerable domestic uses. One bears a penciled note, "Sisters' collar buttons." A broad, thin band of maple was cut at one end, by means of a template, into "lappers" or "fingers." To become the case of a box, this piece of wood was steamed and wrapped around an oval mold, and the projecting laps were fastened by shining copper or wrought-iron rivets.[5] Figure 159 illustrates three Shaker patterns for spice or workboxes. The central one adjusts by means of a sliding wooden insert to outline different sizes of molds. The two pine ovals were patterns for tops and bottoms.

Plate 21 illustrates a group of boxes. The four large ones in the left pile, and the yellow "spit box" at bottom right, are all of Shaker manufacture. The yellow one, third from bottom, belonged to Sister Sadie Neale and was punctiliously labeled by her, *Few balls of little worth.* The shallow pumpkin-colored box, which rests on top of it, is still full of fine silk thread identified as "White silk from Lebanon, 1870." Oval boxes were produced at Mount Lebanon, New York, at least as early as 1798, and in all the communities by 1825. They were available in either varnished or painted finishes and eventually became one of the most enduring of the Shaker crafts.[6] With other Shaker products they were sold to "the outside

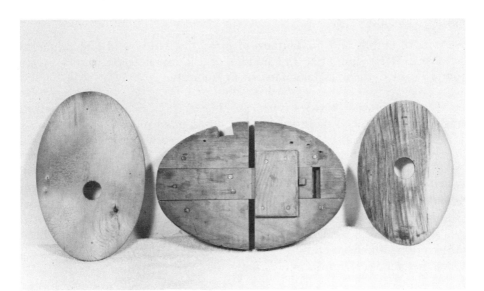

159. Shaker pine patterns for two sizes of spice or workboxes. Nineteenth century. W. 9⅛" and 7⅞". The length of the template in the center is adjustable from 9⅞" to 10¼".

world" from Shaker wagons, in village stores, and to vacationers in summer hotels into the twentieth century.

The tiniest containers, both round and oval, measure only 1½ inches to 2¾ inches and are known as pillboxes, although they were used for many items beside medicine. Black sand for blotting ink, small shells bored for wampum beads (so labeled), sealing-wax wafers, and short nails used long ago in carpentry are only a few of the treasures that have been found in little boxes forgotten in old desk drawers. Usually made of thinly shaved maple, with bottoms and tops of pine, hand-hammered tacks indicate the occasional example that predates the machine age. Prepared medications were popular in the eighteenth century.[7] One inventory of 1677 lists six boxes of Lockyer's pills and powders with the comment, "valued heare as money in N.E." Once in a while old pillbox labels going back more than a hundred years are found still intact. One reads "Dr. Phelps Compound Tomato Pills—Entirely Vegetable—Price 37½ cents." Another reads "J. H. Shenk—dose from 4 to 6 pills."

Nests containing four or five diminutive boxes are occasionally found bearing inside one of the covers a small printed paper reading "Manufactured by/ Saml Hersey/ Hersey Street/ Hingham, Mass." (fig. 154). The largest size measures only 3⅝ inches, and long exposure to light and air has mellowed the wood to a light golden brown. The tops are of birch,

the sides of maple, and the bottoms of pine. The Herseys at first produced handmade items but after the middle of the nineteenth century steam power enabled them to manufacture in quantity.

Even utilitarian articles such as cheese and spice boxes received finishes that enhanced their visual effect when piled on top of one another on old-fashioned pantry shelves. Some, however, retained a natural wood surface enlivened by a coat of protective varnish. In 1853 one Benjamin Twiss supplied to his wholesale customer 116 boxes, scraped and varnished for the modest sum of $1.78.[8] A great many others received plain coats of brightly colored paint, no doubt applied at home. The most popular colors included several shades of red, blue, green, and yellow as seen in plate 21. When box surfaces have darkened with age, the upper edge that has been protected by the rim of the cover will often reveal the original shade, which is sometimes surprisingly brilliant in hue.

Contrary to general belief, the Shakers used bright finishes (either painted, stained, or varnished) on many of their accessories. Reds and yellows predominated on the boxes, followed by the rarer shades of blue and green. Many other ornamental effects were used by boxmakers during the first half of the nineteenth century, especially sponging, mottling, and graining in reds, yellows, and browns. The large box in figure 160 is made with a shallow tray. The outside is painted a pleasing yellow with black striping, and the cover is mottled in a seashell pattern with several shades of brown. Plate 22 presents two colorful examples of naïve decoration. The box at the left, with its stenciled rose on a deep yellow ground, has a New England provenance. The piece at the right may be from Pennsylvania. The surface is dark olive green applied over a scarlet base coat, and the freehand basket of red blossoms is reminiscent of those found in schoolgirl art. Both items suggest the hand of an amateur.

Inscriptions revealing the contents, or the initials of the owner, always provide an element of added interest. The center container in figure 161 is handsomely initialed in gold on a green ground, obviously the work of a competent decorator. Some boxes received even more attention, as illustrated on the left in the same figure. The background here is black, and the red brushwork displays an ornamental branching motif surrounding a heart. Two circles at either side enclose the place name *Smithfield*, and the date *Sep. 13, 1815*, with the legend, *MERCY NEEDHAMS/BOX*, below them.

Painted decoration was frequently the work of females, but the carving of personal household items was often done by men in their spare time. Figure 153 exhibits the pinwheel with which someone lovingly ornamented the top of a utilitarian cheese or butter box. The spice box on the right of figure 161 is carved with a pinwheel and three stars. Made throughout of ash,

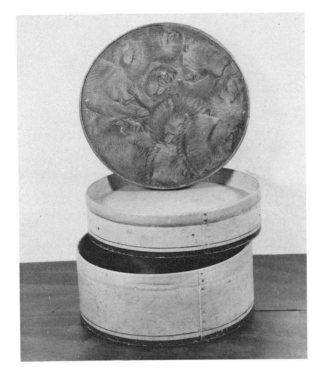

160. Box with a shallow tray. 1825–1840. Diam. 11⅜". Painted pale yellow with black striping, the cover is nicely grained in several shades of brown.

161. Decorated spice boxes. 1815–1825. Diam. left and right: 7"; center W. 4¾". The box at left is lettered: *MERCY NEED-HAMS/BOX* and dated, *Smithfield, Sep. 13, 1815.* The center box is one of a nest of three bearing the initials of the owner in gold on a green ground. At right, chip carving decorates the cover of an unpainted pantry box.

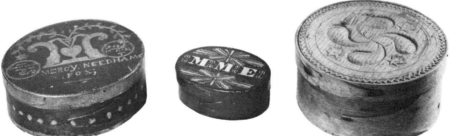

its unpainted surface is now mellow in color and smooth to the touch. Names boldly impressed on the bottoms or the lids of pantry boxes may signify either the owner or the maker, but many inscriptions do represent the names of owners. An early nineteenth-century spice box from the Waltham, Massachusetts, estate of Governor Christopher Gore is impressed *C. Gore* on both the top and the bottom. A later nineteenth-century example, once owned by George W. Adams of Byfield, Massachusetts, bears his name stamped on the bottom (fig. 162).

162. Pantry boxes stamped and impressed with their owners' names. 1810–1875. Diam. 8½″ and 6¾″. Many household boxes were identified in various ways with the names or initials of their owners. George W. Adams lived on an inherited seventeenth-century farm in Byfield, Massachusetts. Christopher Gore, elected Governor of Massachusetts in 1809, owned a large country estate in Waltham. His box was originally painted a soft gray-blue.

NOTES

1. Mary Earle Gould, *Early American Wooden Ware*, rev. ed. (Springfield, Mass.: The Pond-Ekberg Company, 1948), pp. 157–166.

2. Account book of Silas Ball, carpenter, 1819–1829, Townshend, Vermont.

3. Account book of Daniel Richardson, carpenter and joiner, 1814–1847, Attleborough, Massachusetts. MS, Old Sturbridge Village Research Library, Sturbridge, Massachusetts.

4. Account book of Jonathan G. Loomis, joiner–painter, 1821–1839, Whately, Massachusetts.

5. Edward Andrews and Faith Andrews, *Shaker Furniture* (New Haven: Yale University Press, 1937), p. 96.

6. Milton C. Rose and Emily Mason Rose, eds., *A Shaker Reader* (New York: Main Street/Universe Books, n.d.), p. 107.

7. Lockyer's pills retained their popularity over a long period of time. They were sold by Zabdiel Boylston in Boston in 1710 and, with Anderson's Pills, were still being advertised as late as 1760 (George Francis Dow, *The Arts and Crafts in New England 1704–1775* [Topsfield, Mass.: The Wayside Press, 1927], pp. 237, 239).

8. Account book of Benjamin Twiss, in account with Wiswall Morgan & Co., 1852–1853. MS, Old Sturbridge Village Research Library, Sturbridge, Massachusetts.

Liquor Bottles and Glasses

Probably no articles of domestic value are listed more frequently in early estates than the ubiquitous case of bottles. Bailey's *English Dictionary* of 1790 defines a *case* as "a little box or covering for anything." Boxes, or cases, were of two kinds, either plain wooden receptacles partitioned to accommodate various numbers of tall bottles, or handsome small chests containing wine glasses, tumblers, and squarish bottles of several sizes. The former were used for storing liquor, the latter for serving spirits to friends.

As early as 1647 the inventory of Leonard Calvert, Governor of Maryland, listed "an empty case without bottles & another old Case with 4 bottles." [1] In 1636 Sarah Dillingham's bottle case was to be found in the kitchen of her Ipswich, Massachusetts, home, but twenty-five years later a similar item owned in the town of Newbury, Massachusetts, was located in the family living room, or "hall."

During the eighteenth century, large numbers of householders owned cases of bottles, the majority probably having been of the storage type. With regard to their safekeeping, it is informative to examine a cross section of household furnishings, enumerated between 1711 and 1771 in Cummings's *Rural Household Inventories*. This study covers the small outlying towns that comprised part of Boston's Suffolk County. The survey reveals that out of ten inventory listings one bottle case was found in the cellar "with other lumber," five were noted in "lower rooms," and four were enumerated in bedchambers. The prices varied from 6 to 40 shillings, probably appraised by the number of bottles and also according to the contents of the containers. In 1756, and again in 1760, the *Boston Gazette* carried advertisements for what must have been some very large cases, holding square bottles of quart, half gallon, and gallon size.

In 1806 Captain Solomon Ingraham of Norwich, Connecticut, owned "one blue chest of bottles—15 bottles gallon size, 11 of which full of Geneva," at a value of $20.00. Geneva was the eighteenth-cenutry equiva-

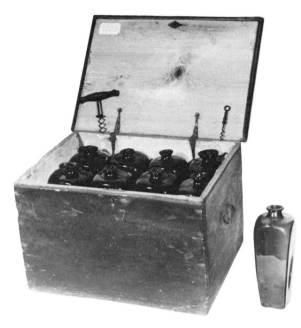

163. Pine box for twelve dark-green gin bottles. c. 1800. W. 18½″. Descended in the Adams family, Byfield, Massachusetts. Many bottles of this type were imported from England or Holland, but fragments have been unearthed at the old Glastonbury Glass Factory Co., which operated from 1816 to 1837 in Connecticut.

lent of gin, a spirit distilled from grain but flavored with juniper berries. In 1791 the "gin case" of Isaac Fitch of Lebanon, Connecticut, was only worth 6 shillings, perhaps because of missing contents? A shagreen case of bottles worth but 4 shillings was listed in the home of the Hon. Andrew Belcher, Esq., of Milton, Massachusetts, in 1771. Shagreen, when mentioned in the eighteenth century, was a rough, untanned leather, prepared from the skin of a horse, ass, shark, or seal its grainy surface being frequently dyed green.

Figure 163 illustrates a useful case partitioned to accommodate twelve dark-green bottles of a size to hold gin. The pine box is country-made, held together by hammerheaded nails. The long strap hinges that support the lid are delicately shaped with circular ends, and the stout bail handles are fastened by iron wires clinched on the inner surfaces of the ends. The box and its contents were part of the inherited furnishings of the seventeenth-century Adams farm in Byfield, Massachusetts, and when found in the attic of the house, the old corkscrew shown standing against the cover at the right was tied to one of the handles. On the left is another example with the handle made of wood. Always indispensable household appliances, many steel corkscrews, and others of "best quality," were advertised in newspapers of the Revolutionary period. One noted

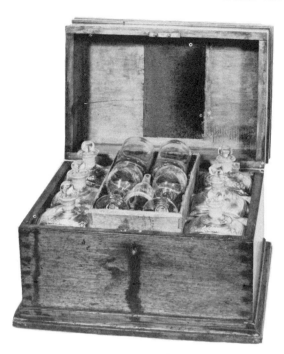

164. Mahogany liquor box of the type imported from England. 1790–1800. W. 15⅜″. The handsome bottles, tumblers, and wine glasses are all ornamented with gilding.

in an early nineteenth-century estate was valued at 34 cents.

Sir William Phipps owned a "case of crystall bottles" worth 100 pounds, probably brought from England by him in 1692, following his appointment as first Royal Governor of Massachusetts. They were undoubtedly housed in a handsome box, and were for the dispensing rather than the storage of liquor. By 1745, and perhaps earlier, complete liquor sets were owned in the Colonies. In that year a "case of Bottles and Decanters and Bowls" valued at 4 pounds was a notable item in the inventory of John Goddard, Gentleman, of Roxbury, Massachusetts.

Liquor sets reached the height of their popularity during the last quarter of the eighteenth century. Although useful in the home, they were particularly convenient when traveling, as an easily available nip in a creaking coach might provide the only relief from the tedium of a long, cold journey. In 1796 a notice in the *Daily Advertiser,* inserted by Harry Peters, a New York City china, glass, and earthenware dealer, advertised "Liquor cases with glasses and bottles for travelling."

In 1806 the estate of Captain Solomon Ingraham contained "1 Mehogany Case Gilt Bottles and Glasses" at $10.00, of which a similar example may be seen in figure 164. This set was originally imported from England as were the majority of high-style liquor chests. The substantial box con-

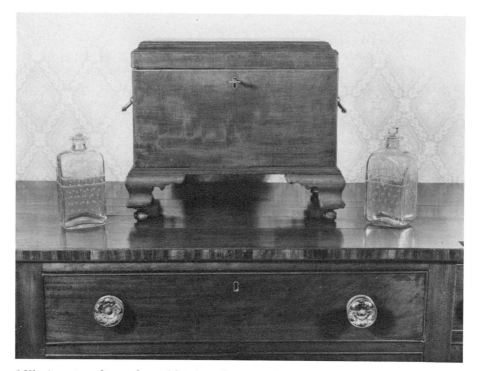

165. American liquor box of birch and pine with grain-painted finish. 1790–1810. W. 16″. Contains twelve clear glass bottles engraved with stars and the words *BRANDY* or *RUM*.

tains six large "case bottles" with gilded shoulders and stoppers, which fit snugly within compartments on either side. Resting in a removable tray in the center are two wine glasses, two tumblers, and a funnel protected from damage by padding attached to the underside of the lid. Below the tray are six additional bottles of smaller size.

Not all liquor chests were sophisticated examples made for a wealthy clientele. One heavy, blue-painted wooden box descended in a New England seacoast family with whose descendants it remained until dispersed at a recent auction of the estate. The decorative iron lock and corners reinforced with metal strips suggested a foreign provenance. Six bottle compartments flanked a removable tray fitted with spaces carefully shaped to fit two styles of wine glasses. Below the tray was a raised platform containing apertures to hold two small tumblers.

Figure 165 shows a chest with well-formed ogee bracket feet that appears to be a rare example of American manufacture, being constructed

of birch and pine with a mahogany grain-painted finish. Within are a dozen clear glass bottles, of which two are shown in the photograph. The bottles are decorated with stars and banding and engraved with the words *BRANDY* and *RUM*. Engraving of this type could be commissioned to special order in Philadelphia in 1773, when Lazarus Isaac, glass cutter, just arrived from London" announced in the *Pennsylvania Packet* that he "cuts upon decanters a name of the wine." [2] In 1795 one Mrs. Decamps from Paris, who designated herself as "glass engraver," also advertised in Philadelphia the cutting of "borders,, flowers, cyphers. . . ." [3]

Much of the glassware found in bottle boxes was of foreign origin, but some was without doubt of American manufacture. William Belcher, opposite the Old Brick Meeting House, Boston, sold cases of bottles manufactured by Joseph Palmer in 1760 at "Germantown in Braintree." [4] The Philadelphia Glass Works supplied bottles for cases made at Kensington, Pennsylvania, in 1775,[5] and Richard Wistar advertised half-gallon case bottles in the *Pennsylvania Chronicle* in 1769, "made at the subscriber's glass works." [6] Many of the tall, dark-green gin bottles, however (fig. 163), came from Holland or England, although fragments have been unearthed in recent years during excavations at The Glastonbury [Connecticut] Glass Factory Co., which operated from 1816 to 1837.[7] Some of the gilt, engraved glass currently found in liquor chests came to England from Spain through a brisk trade in the eighteenth century, yet most of it was of English manufacture.

NOTES

1. Esther Singleton, *The Furniture of Our Forefathers* (New York: Doubleday, Page, 1900), vol. 1, p. 230.

2. Alfred Coxe Prime, *The Arts and Crafts in Philadelphia, Maryland, and South Carolina, 1721–1785* (Topsfield, Mass.: The Wayside Press for the Walpole Society, 1929), p. 155.

3. Prime, *The Arts and Crafts in Philadelphia, Maryland, and South Carolina, 1786–1800* (Topsfield, Mass.: The Wayside Press for the Walpole Society, 1932), p. 153.

4. George Francis Dow, *The Arts and Crafts in New England, 1704–1775* (Topsfield, Mass.: The Wayside Press, 1927), p. 104.

5. Prime, *1721–1785*, p. 138.

6. *Ibid.*, p. 153.

7. Information courtesy of Kenneth M. Wilson, author, with Helen McKearin, of *American Bottles and Flasks and Their Ancestry* (New York: Crown Publishers, 1978).

Serving Green and Bohea Tea

Tea is one of the oldest beverages known to man, its legendary origin in China dates back many years B.C. By the eighth century A.D. tea was common enough to warrant the levy of a tax on its consumption. The Dutch are credited with introducing tea to Europe in the early seventeenth century and by mid-century it was well known in England, although its initial scarcity resulted in the prohibitive prices of 6 to 10 pounds per pound. Not until 1677 is the East India Company recorded as having taken steps to import tea directly to England, but by the 1690s, tea, coffee, and chocolate were all being sold in America.[1]

As the eighteenth century progressed, tea drinking became a popular social pastime in the Colonies. This continued until well into the nineteenth century, even though the custom was greatly curtailed during the Revolution because of patriotic reaction to the enforcement of the 1767 Townshend Act, which imposed a duty on tea along with other imported commodities.

Because of its relatively high price and the paraphernalia required for its proper dispensation, the formal serving of tea prior to the Revolution was largely confined to the upper classes and was often a ceremonious occasion. Tea tables were to be found in many parlors, those most often seen in contemporary paintings had circular tops supported on tripod bases. Unless the table was required for other purposes, the basic equipage (including pot, sugar bowl, creamer, cups and saucers, and hot water kettle) often remained set up and ready at all times.

In addition to the foregoing accessories, a tea box of some description was an important item in most eighteenth-century households. A prosperous Carolina planter owned a "mahogany tea box" valued at 3 pounds, 10 shillings, in 1736. That same year japanned tea boxes were listed at approximately the same price.[2] A box of this period appears in the English painting of figure 166. Tea was traditionally brewed by the hostess at the table and here the lady at the left is measuring the correct amount from one of the canisters contained in the chest on the floor. In New England Peter Cunningham's handsome shagreen tea chest, with silver canisters for tea and sugar, stored his cherished supply. It was highly valued at 100 pounds in 1748.[3]

During the last quarter of the eighteenth century tea caddies were often mentioned in American references and their appearance marked the transitional period when tea drinking was becoming more widespread. *Tea caddy* is defined in the *Encyclopaedia Britannica* as "a box, jar, canister or other receptacle for tea." The word *caddy*, however, did not originally refer to a container but signified a measure of weight derived from the

Malay *kati* or *catty*—the Chinese pound, which was equal to one pound and a fifth avoirdupois. Whether made of wood, ivory, tortoise shell, tin, silver, or other metal, most early tea boxes share the common characteristic of being fitted with a lock and key to ensure the safety of the contents.

In the eighteenth century the two most popular kinds of tea brought to England by the East India Company were known as "Green" and "Bohea" (black). Many wooden boxes, therefore, were fitted with canisters, or two tinfoil-lined compartments, to keep the types separate. Toward 1800 a third space was sometimes provided in the center to accommodate a sugar bowl. By the 1840s it was discovered that the designations green and black tea actually indicated two different variations of the same

166. Painting of an English tea party scene. c. 1720. On the floor at the left stands a tall box containing two canisters, from one of which the hostess is pouring dry tea preparatory to brewing it in the pot on the center of the table. (Reproduced by Courtesy of the Trustees of The British Museum, London)

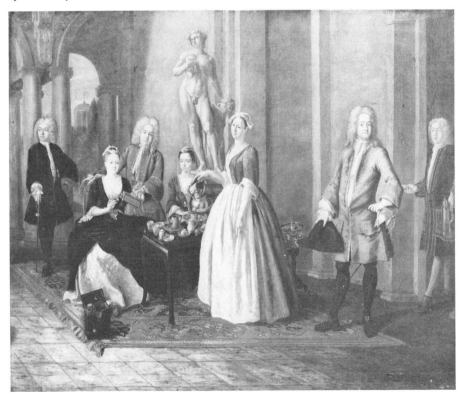

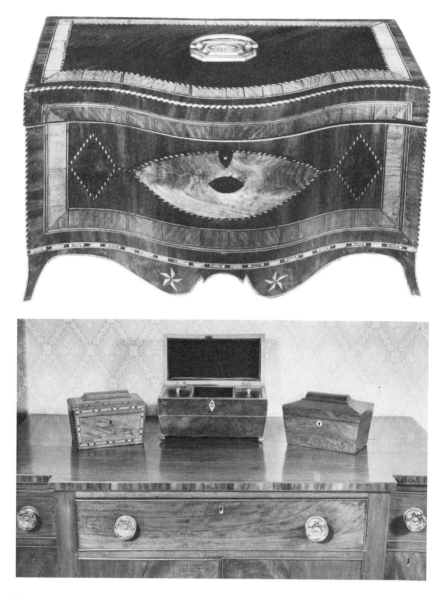

167. Tea box of mahogany and satinwood. 1795–1805. W. 12³⁄₁₆″. This sophisti-
cated example with a serpentine front and elaborate inlay is attributed to a New
York City or New Brunswick, New Jersey, cabinet shop. (Courtesy The Henry
Francis du Pont Winterthur Museum, Winterthur, Delaware)

168. Tea boxes imported from England. 1810–1830. W. left to right: 7½″, 11½″,
8⅛″. The box at the left is rosewood veneer banded with tulipwood inlay. At the
center, a mahogany veneer box, with extra space for a sugar bowl. The walnut
box at the right was used in Maine in the early 1830s.

plant, the black having been fermented and the green simply dried.

References to tea boxes, tea chests, and tea caddies turn up frequently in eighteenth- and early nineteenth-century inventories, usually associated with other tea equipment. An ivory caddy and two small tea boxes are enumerated in the estate of Captain Solomon Ingraham of Norwich, Connecticut, in 1806. After the marriage of Elizabeth Margaret Carter of Newburyport to William Reynolds of Boston on April 24, 1821, her household purchases included a Britannia metal teapot, sugar pot, pitcher, and a "tea cady" at the price of $2.60.[4]

In the final decades of the eighteenth century many handsome wooden boxes were both imported and locally made. "Elegant tea caddies, inlaid and engraved, with plated ladles" were advertised in the *Pennsylvania Packet* in 1793, and the serpentine-front piece in figure 167, with its profusion of stringing and satinwood inlay, is attributed to a New York City or New Brunswick, New Jersey, workshop.[5] Boxes of simpler design, such as those in figure 168, were popular in the first quarter of the nineteenth century. Many, including the inlaid example at the left, were imported from England, others were undoubtedly American-made. The piece in the center is mahogany-veneered, with ivory knobs and escutcheon. The compartments for green and black tea are foil lined and fitted with covers to ensure freshness of contents. The center space is covered in velvet

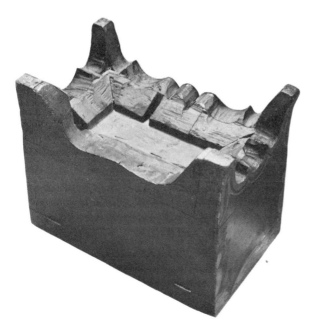

169. The bottom of the wooden tea box shown in plate 23. The marks of hand tools are clearly visible on the skirt and corner blocks.

170. Tin and paktong tea caddies. 1825–1840. W. 5¼" and 5½". Many of the decorated caddies used in America were products of the English tinplate industry. The piece at the left probably originated at the Walton factory in Wolverhampton, c. 1840. The caddy at the right is made of paktong, an alloy of copper, nickel, and zinc that was widely used in China for objects designed in the Western style for export during the eighteenth and nineteenth centuries.

to cushion a glass sugar bowl. The walnut box at the right has a keyhole surrounded by a circle of mother-of-pearl. It probably came originally from England, nevertheless it was used in the home of the owner's great-great-grandparents in Maine during the 1830s. A country version of pleasing design is illustrated in plate 23. With gay red swags and black striping on a dark brown background, the bottom shows the application of hand tools (fig. 169).

John Cook & Co., jewelers and hardwaremen of New York City, advertised in 1796 the receipt from India of "an elegant assortment of Tea-caddies, with one, two and three canisters." The Oriental trade provided American families with many impressive tea boxes, most of them lacquered and fitted with removable containers decorated in the Chinese taste. These tea boxes conformed in style to the contemporary China trade sewing boxes, one of which is illustrated in figure 133. Caddies of a metal called paktong were also brought home from China (fig. 170, right), along with

candlesticks and other small objects designed for the Western market. Because of their moisture-resistant qualities, caddies of metal were in constant demand. Paktong was an alloy composed of copper, nickel, and zinc and it radiated a soft sheen reminiscent of silver, albeit with a slightly yellowish tinge. One great advantage of this metal lay in its non-tarnishing quality, which obviated the need for polishing. Its popularity began to diminish during the late 1700s because of the obvious advantages of silver plate, and although it was exported to Europe until the 1840s, it was eventually superseded by another alloy known as German silver.

Many of the tin caddies used in America were products of the English tinplate industry, which came to the Midland towns of Bilston and Wolverhampton from Pontypool around the middle of the eighteenth century. The tin business increased in England following the opening of several local canals in 1791 and flourished throughout the nineteenth century. Among the articles manufactured there were numerous tea caddies of the form seen at the left in figure 170. These pieces, with their high-style paw feet and brass knobs, had graceful shaped covers stamped out by a press. They were variously decorated with candle-smoked backgrounds, or washed with transparent yellow and ornamented with medallions enclosing groups of fruits, flowers, or shells.[6] Only a few imported

171. English pearlware tea box. c. 1800. W. 5½″. A traditional form, with two compartments for green and black tea.

caddies were decorated by American tinsmiths. The domestic examples differed in being handmade, cylindrical or oval in shape, and fitted with cap lids.

By the end of the eighteenth century caddies were included as matching pieces in many china tea sets. Some resembled small jars, others copied metal models, but each took its place with the cups and saucers on wooden tea board or silver tray. A few still retained the form of the traditional tea box displaying two compartments for green and black tea (fig. 171). The later ceramic containers could not, of course, be locked. They illustrate the evolution from the sturdy tea storage box primarily concerned with security to the ornamental caddy that combined utility with beauty.

NOTES

1. Rodris Roth, *Tea Drinking in 18th Century America: Its Etiquette and Equipage* (Washington, D.C.: U.S. National Museum Bulletin 225, 1961), p. 64.

2. Esther Singleton, *The Furniture of Our Forefathers* (New York: Doubleday, Page, 1900), vol. 1, p. 129.

3. *Ibid.*, vol. 2, p. 363.

4. Barbara Adams Blundell, "Setting up House in 1821," *Essex Institute Historical Collections* (January 1977), p. 22.

5. Charles F. Montgomery, *American Furniture of the Federal Period, 1788–1825* (New York: The Viking Press, 1966), p. 432.

6. Shirley Spaulding De Voe, "The Japanned Tin Plate of Bilston and Wolverhampton," *Antiques* (June 1959), pp. 555–557.

Family Games and Pastimes

Tabletop games have played an important part in family life for many centuries, and some of the receptacles designed to contain them are almost equal in interest to the games themselves. Large compendiums often had a folding chessboard in the lid, with a tray below divided into compartments to hold chessmen, dominoes, and checkers. A shallow drawer held playing cards and counters.

The beginnings of playing cards are obscure. China is believed by many scholars to have been the place of origin, although the general introduction of cards into Europe did not take place until approximately the end of the fourteenth century. An inherited prejudice against indulgence on the Sabbath has persisted into the twentieth century in a few conservative families, and many of the early English settlers disapproved of any

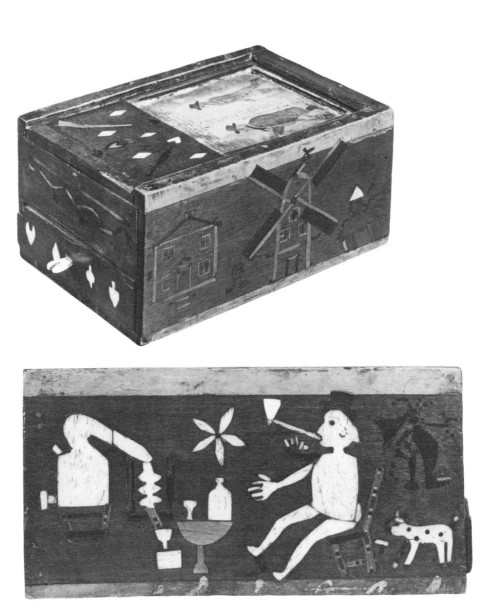

172. Walnut box with green-painted edges. c. 1800. W. 6½". Intended to hold playing cards, symbols of the four suits are inlaid in bone on the drawer end and top. (Collection of Dorothy and Leo Rabkin)

173. Inlaid bone detail from the box in figure 172. The still, wine glasses, and oversized pipe suggest the pleasures of spirits and tobacco. A diabolical tempter lurks in the upper background.

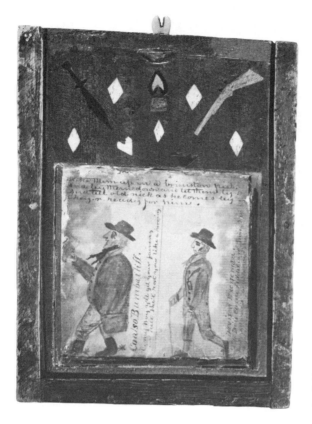

174. Watercolor inset on the box cover of figure 172. Humorous doggerel identifies the figures as the much-abused bailiff and the excise man.

cards and gaming, deeming them "pursuits of the devil." The inlaid bone decoration on the game box shown in figures 172 and 173 seems to relate to this belief. The dubious joys of imbibing illegal spirits and the distasteful indulgence in tobacco are graphically indicated by the gushing still, decanter with glasses, and the large and prominent pipe. Over the shoulder of the brazen perpetrator lurks the sinister shadow of a diabolical presence. On the box's cover (fig. 174) are depicted two characters most to be abhorred—the bailiff and the excise man, with the accompanying bit of sly doggerel:

Bake them up in a brimstone pie,
And lay them down and let them lie,
And tell old Nick as he comes by
They're ready for him.

175. Mahogany cribbage board with a box in the center to hold the cards. 1790–1830. W. 6⅞". (Courtesy The Henry Francis du Pont Winterthur Museum, Winterthur, Delaware)

A pack of cards cost 1 shilling at James Lyndell's Boston shop in 1720, and it is probable that cards were being printed by Benjamin Franklin's elder brother, James, in the same year.[1] "Best playing cards" were advertised in New York in 1741, and various novelty card games, such as Henry VIII, Merry Andrew, and Great Mogul arrived from overseas in the 1760s. On October 19, 1793, an American proposal for the publication of special sets of geographical cards for the instruction of young ladies and gentlemen appeared in the *Weekly Museum*. The subscription price of 6 shillings per pack was payable at the printer's or at Mrs. Philips' Seminary, 101 Broadway.[2] Card playing was a popular diversion with all classes. The inventory of Captain Solomon Ingraham of Norwich, Connecticut, "a gentleman of genius, enterprize and industry," listed in 1805 "1 card box with Pearl Counters, $4.00." An attractively designed container to hold cards and scoring pegs appears in figure 175. This octagonal mahogany box, dating between 1790 and 1830, could be of English or American manufacture. It has a deep well with sliding cover, and four of the cards are shown below.

176. China trade lacquer box with ivory fittings. Third quarter nineteenth century. L. 12½". Numerous games and pastimes fill the upper section. Below the removable tray are two original books of Chinese puzzles. (Courtesy The Peabody Museum of Salem, Massachusetts)

The early years of the China trade supplied American families with sundry useful lacquer boxes fitted for cards and gaming counters. Some superior examples were initialed in gilt script and ornamented with grape-leaf patterns. The black and gold box in figure 176 is appealingly lined with rose-colored fabric, and the compartments contain an unusual assortment of ivory games and puzzles. The tray lifts out to reveal two Chinese books of puzzles that fortunately have always remained with the box.

The game of dominoes has been enjoyed for many years as a favorite parlor pastime. Unknown until the eighteenth century, it was probably initiated in Italy where local tradition avers that the name derived from resemblance of the ebony backing of the white pieces to a domino, or black cloak. Dominoes were not always fashioned of ivory. The dots on a nineteenth-century homemade set of pine are burned into the unpainted surface, and the pieces fit exactly into their old green-painted box with a convenient sliding cover (fig. 177).

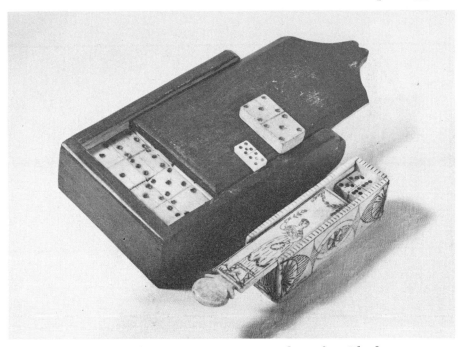

177. Handmade set of dominoes in a green-painted pine box. Third quarter nineteenth century. W. 8". Dots are burned into the surface of the unpainted dominoes. The small scrimshaw box holds a set of tiny dominoes. 1825–1850. W. 4½". The designs are colored in brown, green, and red.

Whalebone with scrimshaw decoration was employed in the making of numerous household objects, including several types of family games. The dainty cribbage boards, fitted with sliding drawers in which to store the pegs, were especially attractive. Tiny domino sets came in scrimshaw-ornamented boxes, the one in figure 177 exhibits a particularly well-shaped cover end. Geometric designs, combined with a female holding a wreath and an upraised flower spray, are reminiscent of nineteenth-century schoolgirl art.

NOTES

1. Helen Comstock, ed., *The Concise Encyclopedia of American Antiques* (New York: Hawthorn Books, n.d.), vol. 1, p. 245.

2. Rita Susswein Gottesman, comp., *The Arts and Crafts in New York, 1777–1799* (New York: The New-York Historical Society, 1954), p. 58.

4. Individual Boxes for Special Needs

Mention should be made of an interesting group of boxes that appear to be one-of-a-kind, as the majority were obviously handmade. Whether or not they are actually unique, they do not fall into large categories of similar objects as do the other boxes previously presented. Although the purposes of many are clearly self-evident, the uses of others are now obscure, but all are worthy of individual consideration.

Condominium for a Flock of Martins

Purple martins are the largest in size of the swallow family. Unlike many other migrant birds they prefer to build their nests of leaves, grass, straw, and twigs in bird boxes especially constructed for their convenience. Proper sized openings are required, and the boxes must be raised from three to fifteen feet above the ground. The martin is a gregarious visitor who enjoys nesting condominium style, and martin boxes, therefore, are distinguishable by multiple round openings that often give access to several levels. The white, unmarked eggs total four to six in number.

For many years before the Federal Migratory Bird Treaty Act of 1916 prohibited their sale, birds' eggs were obtainable in quantity, advertised through lists printed in respected ornithological journals such as *The Oologist,* published in Albion, New York. In 1882 F. T. Pember of New

York City offered purple martin's eggs of first-class quality priced at 20 cents apiece.

The martin has always been a welcome spring and summer resident on New England farms because of his dietary preference for flies, beetles, flying ants, and moths, and old-time martin boxes can still occasionally be seen perched atop a stout pole adjacent to a nineteenth-century barn (fig. 178). The building of bird boxes was a minor occupation of many country

178. Old-time martin box behind a New England barn. Martins, members of the swallow family, prefer to nest in birdhouses with multiple holes raised well above the ground on a pole or tree.

179. Waybill for the Keene and Boston Eagle Line, dated *1832*. Certain stage-coach lines carried United States mail with limited service for a few passengers only. Detailed information pertaining to destinations, monies paid, agents' names, etc., were entered for each traveler on this type of printed form.

carpenters before the day of mass production. In 1831 Jonathan Loomis, joiner of Whately, Massachusetts, charged a neighbor $1.25 "To making a martin box."

Safekeeping of Stagecoach Orders

Although intercity travel by stagecoach in America commenced in the eighteenth century, it was not until the construction of a network of good turnpikes in the early 1800s that stagecoach lines between smaller towns began to proliferate. This way of getting about soon became big business, and in 1818 all the lines in eastern Massachusetts, New Hampshire, and others in Maine and Rhode Island were joined in a syndicate called the Eastern Stage Company.

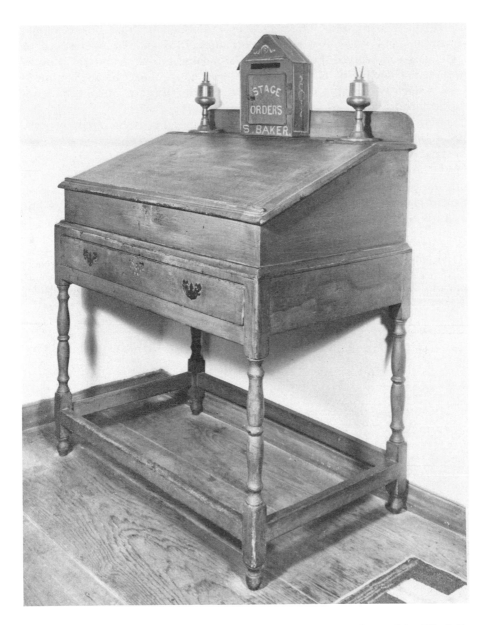

180. Red-painted tin box with name *S. Baker*. c. 1820–1835. W. 9¼". Waybills
and other stagecoach orders were deposited through the slot to be picked up by
agents or individual drivers.

Alice Morse Earle, writing in her 1900 *Stage-Coach and Tavern Days,* gave a good description of this mode of travel in nineteenth-century America. By 1832 there were 106 stage lines radiating out from Boston alone. Timetables and stage lists were issued after 1825 and large numbers of passengers were served, but the fast-approaching era of steam was soon to presage the decline of old means of public conveyance. In 1838, after a scant twenty years of successful operation, the Eastern Stage Company ceased to exist.

Mail was carried on many of the stage lines by special contract with the federal government. Mail coaches made their runs in faster time but the fare was proportionately higher. Some mail lines operated a so-called limited service in which only a few designated persons were transported on each trip and detailed lists of travelers were made up each day. A rare printed waybill for the Keene and Boston Eagle Line, dated *August 2, 1832,* is illustrated in figure 179. Separate spaces were provided on which to en-

181. Light pleasure wagon from Belfast, Maine. c. 1830. A cart, sleigh, or wagon "box" constituted the body of a vehicle. The removal of the seat created a practical carrying space for lumber and other farm equipment. (Old Sturbridge Village, Sturbridge, Massachusetts)

ter the passenger's name, place of departure, destination, price, agent's name, and notations of extra baggage. The tin box in figure 180 was for the purpose of holding similar lists, no doubt intended for pickup by individual stage drivers upon arrival at an inn or tavern.

Cutter and Wagon "Boxes"

Charges for making, painting, and installing vehicle boxes are encountered so frequently, especially in the nineteenth century, that it seems appropriate to clarify their function, particularly as they were not boxes in the generally understood sense of the word. Actually a sleigh or cart box formed the open body of the vehicle on which it was installed. A set of cart boxes appeared in a Massachusetts inventory in 1672 and during the ensuing years references to wagon, cutter, and sleigh boxes are to be found in many woodworkers' account books.

Silas Ball of Townshend, Vermont, charged 13 shillings in 1804 for mending a sleigh box. A small sleigh was known as a cutter, and in 1807 Ball made a pleasure box for a cutter at 2 pounds, 8 shillings. Lumber boxes for wagons were also in demand, and other accounts list prices for "wedging," "wrigging," repairing, and "putting in" boxes for carts and wagons.

Figure 181 illustrates a light pleasure wagon from Maine dating to around 1830. The seat is supported on wooden cantilevers that fit into a frame on the floor of the box. Seats were easily removable, enabling the box to be used for carrying lumber or other farm equipment. The making of a "sleigh box for lumber" cost 12 shillings in 1818. During the early twentieth century Sears, Roebuck catalogues were advertising farm wagons and specifying the different sizes of bodies that they still designated as "boxes."

Fashioned in the Form of Drawers

During the 1640s "cases of boxes" began to appear in inventories of sundry Massachusetts estates. Other references to similar articles include a "chest of boxes" in 1648; a "cabinet of boxes" in 1679; and a "box of drawers" listed in the inventory of one William Bowditch and found in "the chamber of the brewhouse" in 1681.

One may surmise that such designations referred to sets of multiple drawers built within a plain outer casing. When a horizontal board between each row was dovetailed into the sides, the closed drawers became

182. Red-painted box of drawers. 1750–1775. W. 24″. "Cases of boxes" and "boxes of drawers" were often enumerated in early household inventories. When a small drawer was tightly closed, it served the purpose of a self-contained box.

183. Carrying box. 1800–1825. W. 10⅜″. Initialed *A N L*, the interior is divided into two compartments, and the shape suggests a modern lunch box.

in fact separate, self-contained boxes.

A red-painted pine piece, with its exterior still bearing evidence of the depredations of squirrels or other rodents, illustrates a box of drawers as the form had evolved by the mid-eighteenth century (fig. 182).

For Carrying Things About

The substantial, well-formed handle secured by four small handmade nails suggests that this box was intended to carry considerable weight with ease and convenience (fig. 183). At first glance it resembles a modern lunch container in size and shape, but it is doubtful if that was the primary function. The interior is partitioned to create two small compartments that could have served a variety of uses.

It is the exterior, however, that received particular embellishment, consisting in part of incised geometric patterns on either end. Two quite graceful foliate sprays emphasize the three initials, A N L, that probably represent the name of the owner. It is only when one carries the box in hand and looks down upon it from above that the letters appear right side up. Even then the N is backward, betraying indecision on the part of the carver concerning the correct formation of this confusing letter.

To Protect a Miniature

The miniature in figure 184 was a precious family treasure as proved by a faded handwritten inscription that appears on the bottom of the box: "Mary H. Huntington oldest daughter of Rev. Daniel Huntington Born on June 20th 1813 Died on Feb. 20, 1820." Mary was painted by an unknown artist in 1814, at the age of one year.

The handmade cardboard box that contains it is covered with green embossed paper and its dimensions correspond to the dainty watercolor that obviously needed protection from the light. A thin layer of old cotton batting cushions the picture, and the inside of the cover is padded and lined with cream-colored silk.

Small boxes were often adapted to serve unusual purposes that were quite personal to the owner. Illustrated in *Early American Wooden Ware* is a small oval spice box, carefully lined with calico, in which to keep jewelry.

Traveling with a Grease Lamp

There is no doubt about the original purpose of the box in figure 185 as it still carries the small block-tin grease lamp that it was made to contain. The lamp itself is an unusual specimen. The open reservoir exhibits a goodly residue of dried oil that once impregnated the partly burned flat wick that still remains in place.

184. Paper-covered box to hold a miniature. c. 1825. W. 2¾″. Small boxes were often repositories for precious family treasures. Silk-lined and cotton-padded, this box contains the watercolor of Mary Huntington, painted at the age of one year, in 1814. She died in 1820.

The box was fashioned from a solid chunk of pine, which was hollowed out to conform to the contour of the lamp. A groove on the inside supports the sliding cover and when this is firmly closed, the lighting device is held tight and immovable.

Although speculation about the owner and maker of this useful contrivance is futile, one may presume it must have been used by a country doctor, a midwife, or some other nocturnal traveler whose particular occupation required a ready light that could be safely and easily transported.

For a Purpose Undetermined

One may only guess at the original purpose of the extraordinary box shown in plate 24. Made of pine with a hinged lid, the piece is shaped in the form of a lectern with a carved, green-painted cover heightened by red and yellow tassels.

Mounted on the top is a wooden book opened to a poem titled "The Rock of Liberty." This obviously refers to Plymouth Rock, and part of the first stanza reads as follows:

Oh! the firm rock, the wave-worn rock,
That braved the blast and billows' shock;
It was born with time on a barren shore,
And it laughed with scorn at the ocean's roar.

The name *P. F. Coist*, inscribed in yellow below the volume, may indicate either the owner or the maker.

For the Enjoyment of Children and Others

Boxes sometimes come in the form of miniature chests. Carefully scaled to the proportions of their full-size prototypes, they follow a chronological sequence of traditional styles. Although some were no doubt intended to hold small trinkets, others were certainly children's toys made at home by family or friends.

185. Box hollowed out to fit a lamp. 1825–1850. W. 8". The tin hand lamp becomes immovable when held in place by the sliding cover.

The box in figure 186 has incised lines to suggest carving, a molded top, wooden peg construction, and dates around 1790. It bears remains of the original vermilion and black finish, and the initials *H.C.*, identifying Henry Crary of Groton, Connecticut, born in 1780, are painted on the back. When in 1814, Henry moved with a one-horse wagon to live in New York State, the little box went with him and was handed down as a family heirloom.

Two of the boxes in figure 187 are miniature copies of typical nineteenth-century chests. The piece at the left is earlier, secured with large wrought nails and fastened with a homemade iron hasp.

Collecting for Missions

The first Baptist church in America was founded around 1639 in the Providence settlement on Narragansett Bay under the leadership of Roger Williams, and as time went on, small groups gradually spread into Massachusetts and others of the original Colonies.

186. Box in the form of a miniature chest. c. 1790. W. 4¾". Initialed *H.C.* for Henry Crary of Groton, Connecticut, born in 1780. Wooden pegs are used instead of nails.

187. Three boxes copied from full-size chests. 1790–1825. W. 6½"–10¾". The piece at the left is unpainted and has large, wrought nails. The boxes at the top and right are painted red and put together with small handmade brads. The till with a hinged lid is an unusual feature in a miniature.

During the beginning of the nineteenth century the Baptists began to evince a strong interest in foreign missionary work in India, sparked by the enthusiasm of Adoniram Judson, a convert from Congregationalism, who with his wife sailed for Calcutta in 1812. In January 1813 "The Baptist Society for the Propagation of the Gospel in India and other Foreign Parts" was formed in Boston, and Judson soon appealed to his American brethren to support him, and through missionary societies to awaken interest in his work. Judson remained in India until his death in 1850, during which time he completed a translation of the Bible, compiled two dictionaries, and worked for years on a Burmese grammar.

The collection box in figure 188 was at one time affixed to a wall of the First Baptist Church of Westerly, Rhode Island, for the purpose of receiving monies for the support of foreign missions. The words INDIAN, TRANS-LATION, and JUDSON establish a direct connection with the raising of funds for the type of work carried on by Judson.

188. Collection box for Judson's Indian Missions used in the First Baptist Church, Westerly, Rhode Island, in 1847. W. 10″. Pine grained to resemble mahogany, with decoration in yellow paint. The cover slides from front to back so the contents were not removable without unscrewing the box from the wall. (Collection of Museum of Art, Rhode Island School of Design, Providence)

189. Scrimshaw ditty box with top and bottom of wood. 1825–1850. W. 7¾″. The designs depict a ship, a large building, and on the reverse an arrangement of flags; the etching is emphasized by the addition of red, green, and black coloring. (Courtesy The Peabody Museum of Salem, Massachusetts)

The church in Westerly was gathered in 1835, and the name of Reverend Frederic Denison, minister in 1847, appears on the underside of the lid. Nevertheless, the style of decoration suggests that the box itself may date to the 1820s, years when Judson was particularly active and seeking additional support for his building program and other activities in India.

To Fill Time Between Whales

The whaleman's spare-time art—scrimshaw—produced a great quantity of decorative objects between the years 1825 and 1865, the period of its greatest popularity. Life aboard a whaler included many idle hours between sightings and has been characterized as "the most boring and uncomfortable occupation that has ever been known."

Scrimshaw pieces were made in part or in whole either from the teeth of the sperm whale, from the "pan bone" of the sperm's lower jaw, or from the dark-colored baleen or "whale bone" taken from the upper jaws of whales other than sperms. Things made on shipboard consisted of personal effects, such as jewelry or trinkets, play items like toys and games (see fig. 177), working tools, and household equipment that included jagging wheels, swifts, and ditty boxes.

Many varieties of wood were also utilized in scrimshaw, much of it procured in foreign ports. It was combined to good effect with ivory or bone, especially for the lids and bottoms of boxes as shown in figure 189. Box sides and cover rims were cut from pan bone into slices that might range from one-eighth to one-quarter of an inch in thickness. After softening by boiling, the strips could be bent into a circle. If the ends of bone were fastened together while still pliable, they would harden permanently after becoming cool.

A jackknife was the principal tool used in accomplishing the decoration, after which came polishing and buffing. Of the many designs employed, ships, whaling scenes, and large unidentified buildings were among the favorites. The color, as found on this box, derived from India ink, lampblack, or juices of tropical berries and plants rubbed into the surface etching.

Assemblage of Family Heirlooms

During the third quarter of the nineteenth century a treasured group of old family pieces was packed away in a little wooden dome-top box, and

190. Red-painted dome-top box containing eighteenth- and nineteenth-century heirlooms of the Benjamin Gardner family. W. 8″. The two linen caps, apple scoop, snuffbox, and printed "neck handkerchief" belonged to Benjamin Gardner (1729–1821). The potholder is initialed *H G* for Hannah Gardner (1774–1803). The patchwork pocketbook is initialed *L B* for Leah (Gardner) Bennett, married in 1826. The hand-knitted stockings, theorem garters, the lace handkerchief, and other items belonged to two later generations of Gardner descendants.

ever since that time they have remained together (fig. 190). Some initialed, others labeled in faded script, they comprise an unusual assemblage of early and interesting heirlooms preserved by successive family members for a period of about 200 years. From homespun linen caps to velvet theorem garters, personal possessions of sentimental significance were gathered together in this box and came down from one Benjamin Gardner, born in 1729, through five generations of his descendants.

The box itself is identified on the bottom as once the property of Hannah Gardner (Bennett) Keen of South Abington, Massachusetts, and later of her daughter Mary Jane (Keen) Poole of Bridgewater, who was born in 1843. The earliest items in the collection belonged to Mary Jane's great-great-grandfather Benjamin Gardner in the second half of the eighteenth century.

Selected
Bibliography

Among numerous sources consulted, the following have afforded particularly helpful references to the history, materials, and uses of boxes and their contents.

Primary Source Material

PROBATE RECORDS

The Probate Records of Essex County, Massachusetts, 1645–1681. 3 vols. Salem: Essex Institute, 1916–1920.

Cummings, Abbott Lowell, ed. *Rural Household Inventories, 1675–1775.* Boston: The Society for the Preservation of New England Antiquities, 1964.

Kihn, Phyllis. "Captain Solomon Ingraham." Hartford: *Connecticut Historical Society Bulletin* (January 1964).

Steer, Francis W., ed. *Farm and Cottage Inventories of Mid-Essex* [England] *1635–1749.* Colchester: The Essex County Council, Essex Record Office Publications No. 8, 1950.

Warren, William Lamson. "Isaac Fitch of Lebanon, Master Joiner, 1734–1791." Hartford: *The Connecticut Antiquarian* (December 1976).

COURT RECORDS

Records and Files of the Quarterly Courts of Essex County, Massachusetts, 1636–1683. 8 vols. Salem: Essex Institute, 1911–1921.

Advertisements and News Items from American Newspapers

Dow, George Francis. *The Arts and Crafts in New England, 1704–1775.* Topsfield, Mass.: The Wayside Press, 1927.

Gottesman, Rita Susswein, comp. *The Arts and Crafts in New York, 1726– 1776, 1777–1799.* New York: The New-York Historical Society, 1938, 1954.

Prime, Alfred Coxe. *The Arts and Crafts in Philadelphia, Maryland, and South Carolina, 1721–1785, 1786–1800.* Topsfield, Mass.: The Wayside Press for the Walpole Society, 1929, 1932.

ACCOUNT BOOKS, MS

Silas Ball, joiner, 1797–1808, Townshend, Vermont.

Nathan Cleaveland, carpenter, 1810–1826, Franklin, Massachusetts.

Philip Deland, turner, carpenter, cabinetmaker, 1812–1846, West Brookfield, Massachusetts.

Justus Dunn, itinerant cabinetmaker, 1826–1831, Cooperstown and Utica, New York.

Chapman Lee, joiner, 1803–1850, Charlton, Massachusetts.

Jonathan G. Loomis, joiner–painter, 1821–1839, Whately, Massachusetts.

Daniel Richardson, carpenter and joiner, 1841–1897, Attleborough, Massachusetts.

Solomon Sibley, cabinetmaker and repairer, 1793–1840, Ward [Auburn], Massachusetts.

Benjamin Twiss, in account with Wiswall Morgan & Co., 1852–1853.

STREET DIRECTORIES, *first half nineteenth century*
Boston, New Bedford, New York, Providence.

MISCELLANEOUS REFERENCES

An Universal Etymological English Dictionary, by N. Bailey. 25th ed., enlarged and corrected by Edward Harwood, D.D. London, 1790.

Encyclopaedia: or a Dictionary of Arts, Sciences, and Miscellaneous Literature, the first American Edition, in eighteen volumes greatly improved. Philadelphia: Printed by Thomas Dobson, 1798.

Vital Records of Augusta, Maine to the year 1892. Portland: Maine Historical Society, 1933.

Town Records. Ipswich, Massachusetts, vol. 1 (unpublished).

de Laittre, Rosamond. *Diary of John Bertram of Salem, Massachusetts, 1807–1876.* Santa Barbara: privately printed, 1964.

Books

Andrews, Edward, and Andrews, Faith. *Shaker Furniture.* New Haven: Yale University Press, 1937.

Bryant, Seth. *Shoe and Leather Trade of the Last Hundred Years.* Boston, 1891.

Buhler, Kathryn C. *American Silver 1655–1825 in the Museum of Fine Arts, Boston.* Boston: Museum of Fine Arts, 1972.

Carlisle, Lilian Baker. *Hat Boxes and Bandboxes at Shelburne Museum.* Shelburne, Vt.: The Shelburne Museum, 1960.

Crossman, Carl L. *The China Trade.* Princeton: The Pyne Press, 1972.

Dow, George Francis. *Every Day Life in the Massachusetts Bay Colony.* Boston: The Society for the Preservation of New England Antiquities, 1935.

Drepperd, Carl W. *American Drawing Books.* New York: The New York Public Library, 1946.

Earle, Alice Morse. *Home Life in Colonial Days.* New York: The Macmillan Company, 1939.

——. *Stage-Coach and Tavern Days.* New York: The Macmillan Company, 1900.

Earle, Walter K. *Scrimshaw, Folk Art of the Whalers.* Cold Spring Harbor, N.Y.: Whaling Museum Society, 1957.

Fales, Dean A., Jr. *American Painted Furniture 1660–1880.* New York: Dutton Paperbacks, 1979.

Fales, Martha Gandy. *Early American Silver for the Cautious Collector.* New York: Funk & Wagnalls, 1970.

Finn, Matthew D. *Theorematical System of Painting.* New York: James Ryan, 1830.

Garnett, Edna Bailey. *West Stockbridge, Massachusetts, 1774–1974.* West Stockbridge, Mass.: Bicentennial Committee and Friends of the Library, 1976.

Gould, Mary Earle. *Early American Wooden Ware.* rev. ed. Springfield, Mass.: The Pond-Ekberg Company, 1948.

Harbeson, Georgiana Brown. *American Needlework.* New York: Bonanza Books, 1938.

Kauffman, Henry J. *Pennsylvania Dutch American Folk Art.* New York: Dover Publications, 1964.

Kettell, Russell Hawes. *The Pine Furniture of Early New England.* Garden City, N.Y.: Doubleday, Doran & Co., 1929.

Klamkin, Marian. *The Collector's Book of Boxes.* New York: Dodd, Mead & Co., 1970.

Lichten, Frances. *Folk Art of Rural Pennsylvania.* New York: Charles Scribner's Sons, 1946.

Lipman, Jean. *Rufus Porter.* New York: Clarkson N. Potter, 1968.

Little, Nina Fletcher. *American Decorative Wall Painting 1700–1850.* New enl. ed. New York: Dutton Paperbacks, 1972.

Lockwood, Luke Vincent. *Colonial Furniture in America.* 3rd ed. New York: Charles Scribner's Sons, 1926.

Lyon, Irving Whittal, M.D. *The Colonial Furniture of New England.* New York: Dutton Paperbacks, 1977.

Manchester, Herbert. *The Diamond Match Company, 1835–1935.* New York: The Diamond Match Company, 1935.

McClelland, Nancy Vincent. *Historic Wall-Papers: From Their Inception to the Introduction of Machinery.* Philadelphia: J. B. Lippincott, 1930.

Montgomery, Charles F. *American Furniture The Federal Period, 1788–1825.* New York: The Viking Press, 1966.

Nash, Charles Eventon. *The History of Augusta.* Augusta, Me., 1904.

Nason, Emma Huntington. *Old Hallowell on the Kennebec.* Augusta, Me., 1909.

Nutting, Wallace. *Furniture of the Pilgrim Century.* Framingham, Mass.: Old America Company, 1924.

Pinto, Edward H. *Treen or Small Woodenware Throughout the Ages.* London, New York, Toronto, Sydney: B. T. Batsford, Ltd., 1949.

Robertson, Archibald. *Elements of the Graphic Arts.* New York: David Longworth, 1802.

Robinson, Harriet H. *Loom and Spindle or Life Among the Early Mill Girls.* New York and Boston, 1898.

Rogers, H. J. *Twenty Three Years Under a Sky-Light, or Life and Experiences of a Photographer.* Hartford, Conn.: American Publishing Co., 1873.

Rose, Milton C., and Rose, Emily Mason, eds. *A Shaker Reader.* New York: Main Street/Universe Books, n.d.

Roth, Rodris. *Tea Drinking in 18th Century America: Its Etiquette and Equipage.* Washington, D.C.: U.S. National Museum Bulletin 225, 1961.

Shelton, Jane de Forest. *The Salt-Box House.* 1900. Reprint. New York: Charles Scribner's Sons, 1929.

Singleton, Esther. *The Furniture of Our Forefathers.* 2 vols. New York: Doubleday, Page & Co., 1900.

Smith, Nancy A. *Old Furniture, Understanding the Craftsman's Art*. Boston: Little, Brown & Co., 1975.

Snow, Edward Rowe. *Famous Lighthouses of America*. New York: Dodd, Mead & Co., 1955.

Thomas, M. *A Series of Progressive Lessons Intended to Elucidate the Art of Flower Painting*. Philadelphia: M. Thomas, 1818.

Weiss, Harry B., and Weiss, Grace M. *Early Tanning and Currying in New Jersey*. Trenton: New Jersey Agricultural Society, 1951.

Wilcox, R. Turner. *The Mode in Hats and Headdress*. New York: Charles Scribner's Sons, 1948.

Periodicals

Carson, Marian Sadtler. "Early American Water Color Painting." *Antiques* (January 1951).

Davidson, Ruth. "Tobacco, the Crop That Saved a Colony." *Antiques* (January 1957).

De Voe, Shirley Spaulding. "The Japanned Tin Plate of Bilston and Wolverhampton." *Antiques* (June 1959).

Downs, Joseph. "American Japanned Furniture." *Old-Time New England* (October 1937).

Fales, Dean A., ed. "Essex County Furniture." *Essex Institute Historical Collections* (July 1965).

Fraser, Esther Stevens Brazer. "Pennsylvania Bride Boxes and Dower Chests." *Antiques* (July 1925).

———. "Pioneer Furniture from Hampton, New Hampshire." *Antiques* (April 1930).

———. "The Tantalizing Chests of Taunton." *Antiques* (April 1933).

Garrett, Wendell D. "Paraphernalia of Smokers and Snuffers." *Antiques* (January 1968).

Giffen, Jane C. "Susanna Rowson and Her Academy." *Antiques* (September 1970).

Huster, H. Harrison. "Scrimshaw: One Part Whalebone, Two Parts Nostalgia." *Antiques* (August 1961).

Kane, Patricia E. "The Joiners of Seventeenth-Century Hartford County." *Connecticut Historical Society Bulletin* (July 1970).

Landis, D. H. "Pennsylvania Decorated Boxes." *Antiques* (May 1935).

Lyon, Irving P., M.D. "The Oak Furniture of Ipswich, Massachusetts."— Part I. *Antiques* (November 1937); Part II. *Antiques* (December 1937).

McClinton, Katharine Morrison. "Brass Tobacco Boxes." *Antiques* (September 1946).

Musser, Mary. "Massachusetts Horn Smiths: A Century of Comb Making, 1775–1875." *Old-Time New England* (Winter–Spring 1978).

Nash, Chauncey C. "A Carved and Decorated Box." *The Walpole Society Note Book* (1944).

Norton, Bettina A. "Edwin Whitefield, 1816–1892." *Antiques* (August 1972).

Park, Helen. "Thomas Dennis, Ipswich Joiner: a Re-examination." *Antiques* (July 1960).

Porter, Rufus. "The Art of Painting." *Scientific American*, vol. 1, nos. 3–30 (1845–1846).

Ring, Betty. "The Balch School in Providence, Rhode Island." *Antiques* (April 1975).

———. "Mrs. Saunders' and Miss Beach's Academy, Dorchester." *Antiques* (August 1976).

———. "Salem Female Academy." *Antiques* (September 1974).

Robinson, Margaret C. "Hannah Davis, a Pioneer Maker of Bandboxes." *Boston Evening Transcript*, November 14, 1925. Reprinted by the Jaffrey [N.H.] Historical Society (June 1971).

Roe, F. Gordon. "In the Likeness of Books." *Antiques* (February 1940).

Snow, Julia D. Sophronia. "The Clayton's Ascent Bandbox." *Antiques* (September 1928).

[Straw] Editor's Attic. "Ornamental Straw." *Antiques* (November 1923).

[Straw] Random Observations. "Straw Marquetry." *Antiques* (September 1933).

Swain, Margaret. "Moose-Hair Embroidery on Birch Bark." *Antiques* (April 1975).

Swan, Mabel M. "John Ritto Penniman." *Antiques* (May 1941).

Woodhouse, Samuel W., Jr. "Old Sheffield Plate." *Antiques* (December 1927).

Index

Page references for illustrations are in **boldface type**.

For many years Nina Fletcher Little has been recognized as an outstanding scholar in the field of American folk painting and American decorative arts. Her great fund of knowledge has been shared with innumerable collectors, students, and museum curators through her talks at the Williamsburg Antiques Forums, the Cooperstown Seminars on American Culture, and the Collectors Weekends at Old Sturbridge Village. In addition, she has written many articles on a wide variety of subjects for The Magazine *Antiques* and has organized several notable exhibitions of Americana at museums. Her books, of which *Neat and Tidy* is the most recent, include: *Some Old Brookline Houses* (1949), *Floor Coverings in New England Before 1850* (1967), *American Decorative Wall Painting 1700–1850* (1952), *The Abby Aldrich Rockefeller Folk Art Collection: A Descriptive Catalogue* (1957), *Country Arts in Early American Homes* (1975), and *Paintings by New England Provincial Artists* (1976).